The House on First Street

The House on First Street

MY NEW ORLEANS STORY

Julia Reed

ecco

An Imprint of HarperCollins*Publishers*

HarperCollins books may be purchased for educational, business, or sales promotional use. For information, please write: Special Markets Department, HarperCollins Publishers, 10 East 53rd Street, New York, NY 10022.

FIRST EDITION

Designed by Cassandra J. Pappas

Library of Congress Cataloging-in-Publication Data
Reed, Julia.
 The house on First Street: my New Orleans story/Julia Reed.—1st ed.
 p. cm.
 ISBN: 978-0-06-113664-1
1. New Orleans (LA.)—Description and travel. 2. New Orleans (LA.)—
Social life and customs. 3. Reed, Julia—Travel—Louisiana—
New Orleans. 4. Reed, Julia—Homes and haunts—Louisiana—
New Orleans. 5. New Orleans (LA.)—Biography. I. Title.
F379.N54R39 2008
917.63'350463—dc22 2008000713

08 09 10 11 12 OV/RRD 10 9 8 7 6 5 4 3 2 1

For John

"*Times are not good here. The city is crumbling into ashes.
It has been buried under a lava flood of taxes and frauds
and maladministrations so that it has become only a study
for archaeologists. Its condition is so bad that when I write
about it, as I intend to do soon, nobody will believe I am
telling the truth. But it is better to live here in sackcloth
and ashes than to own the whole state of Ohio.*"
LAFCADIO HEARN, WRITING ABOUT NEW ORLEANS
TO A FRIEND IN CINCINNATI, 1877

"*I came down here about a month ago and am living
in the old French Creole Quarter, the most civilized
place I've found in America.*"
OHIO NATIVE SHERWOOD ANDERSON WRITING TO
GERTRUDE STEIN, 1922

1

WHEN I WAS a child, maybe eight or nine, every few months the phone would ring and I would answer, and on the other end a man named Noel Parmentel Jr. would be playing a bugle into the receiver. He would be drunk, of course, and my father would take the phone and laugh a lot, and my mother would roll her eyes. She was not a big fan of Noel, who always stayed too long when he came to visit. Later he turned out to be at least partial inspiration for the rather dissolute character of Warren in Joan Didion's *The Book of Common Prayer*, and reading that book in the cold light of adulthood, I can certainly see my mother's point. At the time, though, I thought Noel was just about the coolest human being on the planet, and, at the time, Noel lived in New Orleans, a place I imagined was full of a lot of heavy-drinking, horn-playing bad actors just like him. I could not wait to go. But even in my childhood fantasies, I had no intention of staying—it was clearly a place to visit.

In those days, pretty much everybody I knew visited—a lot.

They'd go down and eat well and drink too much and generally live it up. They might go for the architecture or the music, and they almost always brought stuff back home: old cypress mantels, jumbo lump crabmeat, evening sandals from Maison Blanche. They might step back in time, or out of it altogether, but nobody ever stayed for good. It would be too dangerous, too indulgent. Even Noel didn't stick around long. The only person I knew who did was Walker Percy, our neighbor's brother, but he was a writer after all, and, more to the point, one on a search.

I grew up in the Mississippi Delta, in Greenville, a once-thriving port city 442 miles up the Mississippi from New Orleans. We were linked by commerce—from the mid-1800s until just after World War II, steamboats brought everything from fine chandeliers to sacks of oysters upriver and toted countless bales of cotton back down—as well as tragedy (both cities were devastated by the 1927 flood). There was also a certain worldliness, marked in part by an easy consumption of whiskey, along with a shared isolation from the rest of the Deep South with all its morals and mores. In *King Cotton*, a history of the Delta's heyday, Robert Brandfon writes that by the end of the nineteenth century, the expanded railroads made the trip from the Delta to New Orleans faster and far more convenient, a development that nurtured the Deltans' already healthy "sense of cosmopolitanism," as well as our feeling of separateness from (or, more accurately, superiority over) the rest of the state.

The Delta's legendary economy and lifestyle were attributable to the fact that the land was the richest alluvial flood plain in the world. Well into my adolescence, there was a distinct—if sometimes laughable—Gatsby-esque quality to some of the social doings there. One of my more entertaining childhood duties was the morning-after collecting of evening bags lost so often, and so far from where they should have been, they required "If found, please call" notes safety-

pinned onto the satin linings. But whatever we got up to—and we got up to a lot—New Orleans was always our far more storied older sister to the south, a genuinely cosmopolitan city, and one where everything, from world-class restaurants to transvestite hookers, was available. By the time I was born, steamboats and railcars had mostly given way to small planes and automobiles, but the traffic was just as dense and the field reports endlessly interesting. My father went to a towboat convention with his friend Johnny Kirk and returned with one of my favorite artifacts, an eight-by-ten of the two of them taken with, not by, the pretty girl photographer on the patio of Pat O'Brien's. One of the running "jokes" of my youth involved the fact that every year my best friend's grandfather flew Mississippi Senator "Big Jim" Eastland to New Orleans for the Sugar Bowl, and every year—diverted, apparently, by the more interesting goings-on in the Royal Sonesta bar—they missed the game.

Things happened in New Orleans that didn't happen anywhere else. Walker Percy wrote, not entirely in jest, that he moved across Lake Pontchartrain to Covington, for fear of falling victim to "a variety of French flus," the symptoms of which included "turning fey and pottering about a patio," but there were far greater dangers. The beautiful Maury McGee got married in the Delta and during the course of the reception, a great many of the guests decided to accompany the bride and groom on their honeymoon. When they woke up, hung over, in New Orleans the next morning, they found themselves barricaded in their hotel rooms. A sniper on the roof of the nearby Howard Johnson's had already killed eight people and the whole area was in lockdown. A Greenville lawyer trying a case in New Orleans celebrated a particularly triumphant day in court with a prostitute who shot him in his room at the St. Louis Hotel just before taking all his money. He told his wife he'd been an innocent victim of foul play, but our local paper—and everybody else who knew anything

about it—dropped plenty of hints as to what actually happened, a story confirmed years later by one of my husband's law partners who had been with him at the defense table.

To me this kind of stuff only added to the city's allure, but no more so than descriptions of slightly tamer stuff—a jacket set on fire by a tipsy waiter serving flaming *café brûlot* at Arnaud's, say, or exotic breakfasts of powdered-sugar-covered beignets and chicory coffee at Café Du Monde. The suppliers of all these details—my parents, their friends, just about everybody I grew up around—were not visitors to New Orleans so much as regular out-of-towners. Just like the locals, they ate their oysters at either Felix's or the Acme but would never patronize both; they had their own waiters at Antoine's, where I longed to try souffléed potatoes and baked Alaska, and at Galatoire's, where I was determined to learn, firsthand, the difference between trout *meunière* and trout Marguery. They knew that everybody still called the Fairmont Hotel the Roosevelt even though the name changed in 1965, and they were well known in the hotel's Blue Room, where you went for music (Benny Goodman, Peggy Lee), and its Sazerac Bar, where the cocktails included, naturally, Sazeracs, which were said to have been invented there, along with an excellent Ramos gin fizz made with real egg whites.

For a year during World War II, my grandfather was stationed in New Orleans, and in the fifties, he and my grandmother returned to board the *Stella Polaris* for a holiday in Havana. Even though the photograph of them boarding the ship is in black and white, it is clear that they are a tad greener than usual—they had celebrated their departure the night before with my newlywed parents in a private room at Antoine's. When my grandfather came alone on business he always stayed on Royal Street at the Monteleone Hotel, which his insurance company held part of the note on, and sent me treasured pull-out postcards of Bourbon Street. When my own father first came to New

Orleans in the summer of 1947, between his freshman and sophomore years in college, he and a buddy hitched a ride into town on a truck driven by a banana broker and had big dreams of getting work on a ship bound for South America. Rebuffed at first for being too young and inexperienced (they had naively thought their summers working on dredge boats on the Mississippi qualified them as pros), they won spots on a freighter bound for Dublin after a bad batch of moonshine had killed four members of the original crew and everyone became convinced the ship was cursed. To this day, my father does not come to town without making a mini-pilgrimage to the old maritime union hall, at the corner of Decatur and Conti, where he slept outside on the deep windowsills hoping for his chance. Years later, he took my brother and me to the Famous Door on Bourbon Street, where we heard an albino clarinetist named Hollis Carmouche lead his orchestra in a searing version of "St. James Infirmary" and watched Pork Chop, a local fixture who had to be well into his nineties by then, tap dance on the bar.

When I was finally old enough—sort of—to make the trip on my own, my good friend and most stellar running buddy McGee and I would pile into my black Toyota Celica, roll back the sunroof, and blast out of the Delta at ninety-five miles an hour, stupid and stoned and dying to get to the city, where we stayed, on the floor, with her sister Elizabeth, who'd had the good sense to go to college at Tulane and very little interest in serving as our chaperone. No one in their right mind would have wanted to—we hit every bar on Bourbon Street, including the Gunga Den, a grungy place where we realized after the second or third Hurricane (sickly sweet, fuchsia-tinted concoctions served in souvenir glasses we dutifully toted around in our large purses) that we had been watching boys who had taken just enough hormones to pass as girls. Though we came to town essentially to drink, we knew, even then, that eating was a big part of the

point. On Sundays, Elizabeth dressed us up and took us to "Breakfast at Brennan's," the thing to do in those days, and for us, barely seventeen, the height of sophistication. I thrilled to the quail served in a nest of shredded fried potatoes, followed by flaming bananas Foster. We took the streetcar to the all-night Camellia Grill for chocolate freezes and chili omelets and ate oysters by the bushel at the late lamented Tyler's Beer Garden.

By the time I was in my twenties, I too had become a "regular out-of-towner." Firmly in the Felix's camp, I'd start the day there with a Dixie and a dozen raw before getting a Bloody Mary to take around the corner to stand in line for a lunch table at Galatoire's. (It is perfectly legal to drink on the street in New Orleans, so that the Galatoire's line—a thing of the past since they added an upstairs bar and waiting area—was always festive.) I loved late nights at Cosimo's in the lower Quarter (I once left a red satin Gianfranco Ferre evening coat there, and two years later when I went back to reclaim it, the male bartender disappeared for a minute and came back out wearing it). I knew to grab a Lucky Dog to soak up the booze on my way home to my lovely room at the antiques-filled Soniat House; I bought my first fine Champagne flutes at Lucullus on Chartres Street and struck up what became a close friendship with its proprietor Patrick Dunne. The trips were no less excessive, just marked by slightly higher caliber establishments—the Gunga Den, alas, was no longer.

It was on one of those trips that I started down the long and very winding road that ultimately led me to the house on First Street. I'd been living in New York, where I wrote for *Vogue*. It was the first weekend of Jazz Fest and I'd come down to go to what I knew would be some wild parties, and to catch up with Elizabeth, who was married by then to a man we all loved, with two young daughters, Katie and Lizzy. I ate at Upperline for the first time, heard Miles Davis play for the last. The music was great, the weather was warm—it was not

much different from any other really fun, fairly debauched weekend I'd spent in New Orleans, except that by the time it was over I'd fallen, hard, for a man I knew I shouldn't have. At one of the wild parties, I heard myself saying I was coming back in the summer to cover what promised to be a historic governor's race. It was three o'clock in the morning, but as soon the words were out of my mouth I knew that they were true.

I'll never know for sure what it was that made me come back—the man, the city, or the opportunity to watch Edwin Edwards, the notorious three-term former governor, stage his final comeback. It was probably a bit of all three, and certainly Edwards was a draw—he had survived two corruption trials (he'd been accused by the Feds of selling state hospital contracts, but the first trial was declared a mistrial and the second ended in acquittal). He was running for an unprecedented fourth term in a wide field that included the incumbent Buddy Roemer, his nemesis, and David Duke, the ex-Klansman. Until he dropped out of a clearly unwinnable run-off with Roemer in the previous election, Edwards was famous for saying that to fall out of favor with the voters of Louisiana he'd have to be found in bed with "a dead girl or a live boy." He retired his 1983 campaign debt with a fundraising trip to France, which included a dinner for 600 at Versailles and party favors in the form of gold lapel pins with the moniker "the Sun King" engraved below Edwards's profile. He would likely be the last of a long line of flamboyant populist Louisiana politicians who included Huey and "Uncle Earl" Long. Covering the race was the chance of a lifetime for anybody remotely interested in Southern politics or in having fun.

I was interested in both, so I bought a one-way ticket, shipped a few boxes of books ahead of me, and arrived in town just before noon on July 13, a Saturday. Elizabeth's husband, Mike, picked me up at the airport and dropped me off in the Quarter, at a windowless

"temporary" apartment on St. Philip Street, across from the red Mc-
Donough schoolhouse, where Elvis shot part of *King Creole* and just
around the corner from Lafitte's Blacksmith Shop, a bar housed in the
early eighteenth-century building said to have been the headquarters
of Jean Lafitte, the pirate who helped Andrew Jackson win the War
of 1812 in return for a pardon. It was 97 degrees outside and steamy
as hell; when I opened the apartment door it felt like a blast furnace.
There were two small rooms, very little furniture, and a whole lot of
dust, but there was a noisy air-conditioning unit, a narrow bed, and a
table that could double as a desk. I could stand it until the election was
over—a few months at the most. I kept it for more than a year.

I couldn't possibly leave. I spent my days having long romantic
lunches at Galatoire's, where I soaked up vodka martinis and a culture
in which returning to one's office was not of paramount importance, or
blowing through the state with Edwards and his cronies, for whom I
had become something of a girl mascot. We mingled with the adoring
masses at bingo halls and bait shops, while in between, the boys made
prodigious football bets and spoke in Cajun French when they didn't
want me to know what was going on. I was having the time of my life.

After more than ten years of self-imposed exile, first in Wash-
ington and then in New York, I had no idea how much my Southern
soul had all but shut down. Now, suddenly, I couldn't get enough
of the heat and the swampy terrain, the eccentricity and the humor,
the music and the food. I realized how much I had missed the slower
rhythms of life in general and even the oft-cruel rhythms of the Mis-
sissippi, which I had grown up alongside. Simple things like riding
around in a big car with the air conditioning blowing and the radio
blaring and all the windows rolled down brought me immediately
back to the reckless summers of my youth; sitting down in a bar with
the newspaper, a cold beer, and a bowl of gumbo for lunch was a
joyous interlude. It felt like home because it was, but it was also for-

eign enough, and still fresh enough in those days, to be dazzling. This wasn't the South or even the Delta—people always comment on the New Orleans Caribbean connection, but the late Johnny Apple once wrote that he found it more similar to Marseille, with "a civic culture marked by crime, corruption, humidity, poverty, and poor education on one hand, and a love of good food, good drink, and good times on the other." Either way, it was at once familiar and entirely exotic, and I realized that even the most regular of out-of-towners could not begin to understand New Orleans with all its mysteries and complexities—good and bad. You had to stick around, so I did.

In the decade or so after I first opened that door on St. Philip Street, Edwards would win the election in a landslide, stand trial for extorting money in exchange for riverboat casino licenses, and receive a ten-year sentence to the federal penitentiary, which he is currently serving five hours north of New Orleans in a place called Oakdale, which is also the home of Enron's Andrew Fastow. The man for whom I had fallen, A., came in and out of my life for long stretches, and I took a series of increasingly better apartments in the Quarter, including one in a former stables which had been renovated by Clay Shaw, the New Orleans businessman who stood trial for conspiring to assassinate JFK. Another, on the third floor in the 1200 block of Royal, had eighteen-foot ceilings and was so high up I could see the lights of the river bridge from the balcony at night, and so infested with termites that my high heels punched holes in the floor.

I still wrote for *Vogue*, where I'd worked since 1988, and I still had my apartment on the Upper East Side. But as the months and years passed, I realized that I was spending far more time in New Orleans than in New York, where I voted, paid taxes, and—occasionally—turned up at an office. It made no sense but it was a ratio that became more or less permanent when I found my last apartment on Bourbon Street.

2

I HADN'T REALLY been looking, but on the street one day I ran into Betty, a woman I knew from Mississippi who owned three fabulous places in the Quarter—an apartment was available in one of them, would I like to see it? Of course I would, so off we went to a not very interesting, mostly residential block on Bourbon Street, but when she opened the green painted gate and led me down a moss-covered brick walkway, we were in an entirely other world. There, behind the seemingly simple red Creole cottage that fronted the street, was an enormous courtyard shaded by an even more enormous stand of banana trees, a two-story slave quarter with a balcony across the front and a breezeway running through the first floor, and a back courtyard walled by bamboo. I told her I'd take it before setting foot inside.

My part of the compound, the slave quarter, was built in 1810 as the kitchen and living space for the slaves, and later paid servants, for the family who lived in the house up front. (A Creole cottage, consisting of four large square rooms with no halls and a rear gallery, is a

relative of the French half-timber house, and would've been the home of a middle-class merchant, as opposed to the grander, more formal townhouses that were the city residences of River Road sugar planters.) When I was there, the cottage apartments were taken by mostly absentee renters, so the whole place was, in effect, mine.

I reined in the bamboo, planted six kinds of jasmine, and put huge pots of lemons and satsumas, kumquats and Key limes any place there was room. I had never gardened in my life, but the courtyard, bounded by tall old brick walls and the always damp, smooth stucco finish of the houses, was like a terrarium. When wind or hail or a bit of cold would cause the tops of the bananas to die off, Betty would come over with her giant machete and we'd hack them down. Within months, they'd be back, their trunks the size of telephone poles, their leaves grazing the top of my second-story roof. Betty maintained they were so big because they were planted on the site of the former outhouse, and it's true that everything we put beneath them— gingers and ferns, elephant ears and Kashmir bouquets—grew like crazy, but so did everything else. "If it smells like sex, it grows here," Ellen Gilchrist once wrote, and the best embodiment of that was my night-blooming cereus, whose leather-like leaves belied the mysterious, otherworldly beauty of the luscious, bowl-like blooms that lasted for a single night, appearing a few hours after sundown only to close, spent forever, at sunrise. Mine put out as many as a dozen at a time and their musky scent so overpowered the rather more rank odors of Bourbon Street that I could tell it was blooming from a half a block away. In the summers, deep pink Rose of Montana vines appeared out of nowhere to crisscross the entire courtyard; when a rare freeze killed off the blue plumbago covering one wall, rosemary, which had been lurking somewhere in the mortar, emerged in a tumble of branches to take its place. Within a few years, the place was so overgrown that when the normally unflappable François Halard arrived

to photograph it for *Vogue*, I heard a sharp intake of breath before he recovered. "We'll simply shoot it at night," he said—the plan being that the interior lights might define the house enough so that you could actually see it.

But outside the gates was where the real jungle lay. Willie Morris once said about the South that "it's the juxtapositions that get you," and nowhere are they greater than in New Orleans. Behind the back courtyard was the Cathedral Academy, which meant that I woke up to a tone-deaf nun singing "My Country 'Tis of Thee" over a loud-speaker, and, since I was also in between the two biggest gay bars in the city, I fell asleep lulled by the bass beat of "I Will Survive." The night Tammy Wynette died, they played the disco version of "Stand By Your Man" in a touching tribute for twelve hours straight. Just one block up, the neon crassness, topless bars, and karaoke hell that is straight Bourbon Street began. (There are plenty of juxtapositions there too—at one tourist restaurant, depending on the day, the all-you-can-eat-fried-shrimp-for-$4.99 sign is held up by either a white male midget or a young black woman, each wearing the same filthy "antebellum" hoop skirt.)

During Mardi Gras and other such indigenous holidays as South-ern Decadence (a gay Labor Day weekend celebration that draws thousands from all over the world), the crowds on my block were so thick it was impossible to get in or out of the gate, which was just as well. One sunny Mardi Gras morning I opened it to find three men— one giving another a blow job on the steps, and the third filming it. In his 1968 essay for *Harper's*, "New Orleans Mon Amour," Walker Percy wrote that "the tourist is apt to see more nuns and naked women than he ever saw before." Had he spent any time in my neighborhood he would have been forced to add "naked men," but the residents are mostly inured to them. When a guy on my corner dropped his pants at five o'clock one afternoon for the benefit of the patrons of Lafitte's

in Exile on the balcony across the street, not a single person passing on the sidewalk so much as even slowed down to look.

Still, for all the mayhem outside, the inside of Bourbon remained my own private island. I worked, most days, in my nightgown; when I needed to clear my head, I'd simply wander through the French doors of my office and hack away at the bamboo or pluck the yellow leaves from the gardenia. I ate and entertained almost exclusively on the stone-topped table in the back courtyard and left the whole house open to the outside for seven or eight months out of the year. I wrote a lot, threw great parties, and spent indulgent afternoons with A. playing "tropical nurse" (she restored the patient back to health with homemade Hurricanes featuring mango syrup, a lot of rum, and the juices of the citrus from the courtyard trees).

The place was less a house than an elaborate stage set—with oriental carpets and slip-covered sofas, collections of coral and shells and birds' nests, the odd French chair, a four-poster black iron bed—but I found a better way to live there than any I'd found so far. Tennessee Williams, who had a place around the corner, called New Orleans his "spiritual home" and said, "I found the kind of freedom I'd always needed." Sherwood Anderson was said to have lived in my very house in the 1920s, and deemed New Orleans "the most civilized place" he'd found in all of America. Anderson was from Ohio, so of course he did, but he and Williams were both right about what the place could do for you. The *Oxford English Dictionary* defines "to civilize" as "to instruct in the arts of life." The time spent on Bourbon afforded me plenty of instruction.

I had lived there for more than five years when John, my husband, and I began seeing each other, but we had met much earlier, almost two years before I arrived in New Orleans. It was at a wedding in Atlanta, when he was married and I was engaged. He was with his group of friends and family and I was with mine, and we all desper-

ately wanted to leave the reception and get back to our mutual hotel for a drink and to parse some of the stranger aspects of the evening, which included dead ducks and hares decorating the food tables, in keeping with the medieval theme of the festivities. We arrived to find the bar tragically closed, but John didn't miss a beat. He palmed the young desk clerk some folded bills, created a bar on the lobby table from the ample array of whiskey and mixers he'd brought up from New Orleans—just in case—and sat down at the piano to bang out all seven rock-and-roll numbers he remembered from his days as lead singer in a band called The Mersey Shores (the Beatles were from Liverpool and Liverpool is on the Mersey). I thought he was sexy as hell and I've always been a big fan of anyone who can so effortlessly save the day (or the night, as it were). My fiancé was passed out on a sofa, John's wife was huddled in a corner with her sister, and I would have run off with him right then and there, except that John is a far more upstanding human being than I.

We stayed, chastely, in touch. I got disengaged, came to New Orleans, and ran into John occasionally, but not a lot. He'd spent his adolescence in a big house on St. Charles Avenue, where his uncle, a prominent heart surgeon had raised him as his son; he was a partner in a well-known law firm. I, on the other hand, had been spending most of my days wafting around a Bourbon Street courtyard and some of my nights at such rough-and-tumble Ninth Ward bars as Markey's and Vaughan's with the newly divorced McGee. Our worlds only occasionally collided. Once, I joined him at lunch with his wife and some friends, and then, out of the blue, he asked me to lunch alone, at Galatoire's, to tell me he was getting a divorce. He started dating (a lot—there are very few eligible bachelors in New Orleans), but every few months he'd turn up. He insisted that I meet his uncle, who was dying, though I didn't know it. He insisted that I meet him for lunch—on Valentine's Day. On my birthday, he showed up at the

party McGee gave me with a bouquet he'd assembled by collecting bits of arrangements from every hotel on his route to her apartment. One afternoon he showed up as I was leaving for the grocery store, insisted that he drive me, and then went on his way when I was done. I was always really glad to see him, but the signals were so weird and so intermittently urgent there seemed no point in trying to read them. I was deep in my own romantic quagmire, and John had already told me late one night that he thought unhinging his whole life had made him a little crazy. I believed him. He had two almost-grown children—a man like him doesn't just pack up and go without sustaining a little damage. So we continued our sporadic dance. Finally, A. took an ill-timed trip out of the country, and John asked me for what sounded like a real date. I went.

The three years from that dinner to the altar were rocky ones, for John, that is, who had to put up with me. Three months into it, he asked me to marry him, in Las Vegas, of all the unimaginative places, and I begged him never to bring it up again. He waited almost a year and asked me a second time, in New York the day after Thanksgiving, and I burst into tears. I was scared—of commitment, of a settled life, of narrowing my options. For more than half my life I'd been living on my own, like a man really, doing exactly what I wanted to do with few encumbrances. There was also the lingering fact of why I'd come to New Orleans in the first place. It was long past time to let go, but historically I have had a hard time in that regard—what if I never played tropical nurse again?

I had to do something, so I decided to take off for Spain for three months, a decision John, who has a great deal of wisdom and even more patience, supported. And in truth, it wasn't a bad idea. In a city where much of the activity is based largely on what has been done before, an inertia you're not even aware of can settle in your bones. People inherit houses, waiters, positions of royalty at Mardi Gras

balls from the generation before them. They eat fish (or shrimp po-boys) on Fridays and red beans and rice on Mondays and the men don seersucker and poplin the week after Easter (but never, ever before) for the duration of the spring and summer. When a great many of life's decisions, big and small, are dictated by ritual or blood, free will, gumption, even the tiniest bit of initiative can go right out the window.

Most of the rituals are charming, but even the most unrewarding ones are diligently maintained. "Oh, balls are such a bore, anyway, I don't know why we keep on doing it," a female character says, refer-ring to the grueling social obligations of Mardi Gras in Ellen Gil-christ's *The Annunciation*. Her male companion is quick to respond: "We have to do it. It's our responsibility. I mean, after all, sweetie, it's what we do." A few years ago, when I asked a real-life character here, who is technically in the steamship business, why he had taken on the leadership of one of the more exclusive debutante cotillions, he said, "Daddy," before asking and answering my next question. "How did he get into it? Daddy. I'm fifth generation. That's how these things happen." New Orleans is a place, don't forget, where you are con-sidered an upstart, or worse, if you call a hotel by the name that it currently goes by, as opposed to the one it hasn't had in more than forty years.

The flip side of this religious adherence to old habits is that a big segment of the city's population has turned living for the moment into an art form. We live between a notoriously restless river and a forty-mile-wide lake, and if "the Big One"—a Category 5 hurricane barreling up the mouth of the river—ever does come, FEMA's in-competence will be the least of our problems. This is not Scarlett's South, where tomorrow is another day—tomorrow may not come at all. We also have a consistently high murder rate and a life expec-tancy that ranks with the people of North Korea and Uzbeksitan. The

thinking, then, is to let the *bons temps rouler* while we can. In either mind-set, good decisions about one's future are not always made.

Spain turned out to be a fine choice. Absence may or may not make the heart grow fonder, but it definitely makes the mind clearer. I went, ostensibly to learn Spanish and take in the bullfights. But mainly I knew I needed to step off the cliff or at least the curb, and go, alone, to a dramatically different place. At heart, I am a dutiful soul—I worked all through high school and college; there were no summers exploring Europe or bumming around Telluride. Simply taking off for no real good reason was a radical act. I ate and drank a lot, worked a little, and generally roamed around in my self-imposed exile until John came over to Madrid for a weekend. I was exhausted, just off the train from Seville, when he handed me a box with a ring in it. I hit him, hard, on the head with a pillow. When he left he didn't take the box with him. I put the ring on and it fit. I wore it around town; I wore it in my sleep. I got so used to it—and what it meant—that I realized I'd had it backwards about my options. Marrying John meant I'd open myself up to a lot more than I'd be closing off. I flew back to New Orleans and wondered what the hell had taken me so long.

McGee told me later that she had wondered too. "Elizabeth and I talked about it all the time." Talked about what? "What the hell was wrong with you." My mother displayed uncharacteristic reticence, but then she hadn't told me until rather late in the game—after I'd called off what would have been my first wedding—that she never thought I should marry the man in question. That had proved so successful she had no intention of opening her mouth this go-round, though I could tell it was driving her crazy. Patrick Dunne displayed no such restraint, taking almost every opportunity to declare: "You need to marry that man and buy a big house." John himself told me on our third or fourth date that he thought we'd end up together in a

sprawling kitchen. That had sounded especially nice, even then, but I had not wanted the reason we tied the knot to be better appliances. (Though, God knows, I needed them.)

At Bourbon, the tiny kitchen featured a refrigerator with no inside light and missing drawers, a dishwasher that wasn't hooked up to a water line, and a tin can of an oven that was barely twenty-four inches across. When the first cake I baked never rose, I attributed it to the damp weather or mismeasurement of baking powder and made it again before figuring out that there was simply not enough room for air to circulate around the thing. This was a problem for a person who loves to cook and entertain as much as I do, so I became adept at making whole meals on the grill or on the lone large eye of the tiny stovetop. For all the charm of my various residences, I had never even had enough counter space to own a microwave. Suddenly, settling into a house, a real one, as opposed to a stage set, began to sound like nirvana. I started envisioning a laundry room, the big kitchen of John's imagination, a kennel for a dog—an entirely different kind of package than the one that entailed gay bars and nurses' outfits, as entertaining as they had been.

John's apartment had plenty of appliances—a toaster, toaster oven, microwave, washer/dryer, everything—but not a modicum of charm. When he left his marriage, he took the first apartment he saw in the paper that had room enough for his son and daughter to spend the night, and then he never left. It was near the airport, in one of those overpaved anonymous stretches that could be Anywhere in America. Within sight of the place there was a Sports Authority, a Home Depot, a Petco, a Starbucks. The only tip-off that you might be near New Orleans was that the cineplex across the street sold frozen margaritas, daiquiris, and Jack and Cokes along with the usual selection of soft drinks. The name of the apartment complex was Citrus Creek, but there was no citrus and no creek and all the

units were so identical that no matter how many times I visited I still had to call from the car so he could guide me to the right one. After more than five years of camping out in no-man's-land, he was ready for a real house too. But first we needed to get married.

I was forty-two when we did it—so advanced in years that my boss called me and said she wanted me to write about "what it's like to be an old bride for the first time." I wasn't in the least bit offended. It felt wonderful to be so sure after so long and I said so. We got married on my parents' front lawn in Greenville, surrounded by our closest friends and family. I wore a pale green dress and when I walked out with my father, the crowd burst into spontaneous applause—I don't think for me so much as in recognition of the fact that I was finally doing such a good and right thing. Our rehearsal dinner, at an abandoned cotton gin we'd cleaned up and electrified, featured a Louisiana-centric feast of fried catfish, *boudin*, crawfish *rémoulade*, roast suckling pig, and mirlitons stuffed with jumbo lump crabmeat. On the day of the wedding, friends gave us an outdoor lunch with fried chicken, ham biscuits, and pimiento cheese sandwiches, and at our reception, John sang "Hey There Little Red Riding Hood," one of the conditions of our engagement. It was perfect, but we were only halfway there. We still needed a place to start our lives together, a point driven home to us when we returned from our honeymoon.

We arrived, after dark, to find scaffolding and sacks of mortar everywhere—Betty had finally decided to repair the crumbling courtyard wall that leaked water into our increasingly unhappy next-door neighbor's house. At 6:30, on our first morning as a married couple in our own bed, eight masons peered at us through the enormous fanlight window on the second floor, a routine that continued for two more months. They dropped bricks on all the plants; they blared not one but two radios—so much for peace and privacy and hanging around in my nightgown, but it had been bound to happen.

We'd finally been visited by one of the "triage units," the name a friend of mine once gave to the battalions of workmen who trundle in every morning in their beat-up vans and pickup trucks, charged with the mission of keeping the entire French Quarter more or less standing. The place is old after all, and constantly visited by a lot of very bad things—extreme heat, ceaseless damp, subterranean termites, flying Formosan termites. (The latter swarm at night and eat wood nine times faster than their cousins—during a single horrifying night at Betty's, a colony ate an entire beam in the attic.) A hurricane destroyed the handful of palmetto huts that comprised the first "Quarter" in 1719, just a year after Jean-Baptiste Le Moyne, Sieur de Bienville, founded the place. Despite the pleadings of his engineer (who possessed the improbably stripper-esque name Le Blond de La Tour), Bienville refused to move his city to a less precarious spot, and two years later another hurricane came and wiped it out again.

So it followed that as soon as the bricklayers left, the roofers came. Two years earlier there had been a hailstorm that had sent golf-ball-sized hailstones beating down onto the original clay tiles of the slave quarter's roof. While Betty had no intention of reusing them, she thought she might be able to sell the ones still intact, and demanded that each individual tile be removed by hand, as opposed to just knocking the damn things off in one fell swoop and getting on with the business at hand. This absurdly slow, almost slapstick process was further exacerbated by the season. It was late July, about a million degrees by nine in the morning, and then there was a tropical rainstorm every afternoon. The roofers worked for about two hours a day, long enough to lower a stack of about twenty tiles, then they'd leave and it would rain all through the house. They forgot to tarp holes, they inverted the gutters so that water gushed into the house instead of out. Rugs were soaked, books and prints were ruined, the white cotton duck slipcovers were so splotched with brown the sofas

and chairs looked like giant calico cats. Three months into a roughly 1,000-square-foot job, they still weren't done. The Bourbon Street idyll was definitely over.

The plan had been to stay at Betty's at least another year or two after we married and save our money for the house with the big kitchen that had by now firmly taken hold in our collective imagination. But as our first anniversary came and went, it became clear that in addition to every other increasingly irritating thing about Bourbon Street, two things paramount to a successful union were in dangerously short supply. There was no space (more than half of John's stuff was in storage and the two closets had been cramped since well before he got there) and absolutely no privacy (in addition to the steady stream of workmen, there was also Betty, whose daily arrival—to putter, to water, to change what had to be the cleanest air-conditioning filters on the planet—was announced by a great clanking ring of keys and a sporadic off-key whistle). It was time to call a realtor.

The first part was easy—we already knew where we wanted to go. Tired of the urban confines of the Quarter, we decided to follow the path the Americans who arrived in New Orleans more than 150 years before us. Like them, we sought serenity and safe haven just a few miles up the river in one of the earliest "suburbs" of the city—in the comparatively bucolic and extraordinarily lush environs of the Garden District.

The Garden District began life as the sugar plantation of Jacques-François Esnould Dugue de Livaudais, a powerful landowner who also built the city's first racetrack. Livaudais had been building a plantation house intended to be the grandest in all of Louisiana when especially severe spring floods destroyed his crop as well as the house's beginnings. His wife, Celeste de Marigny, daughter of an even more illustrious planter, chose that moment to leave her husband and move to Paris; when she got the plantation in the divorce settlement, she

sold it in 1832 for the then-whopping price of $490,000. The purchasers hired one of Napoleon's former engineers to divide the property into a fourteen-square-block area with spacious lots they marketed to the growing population of Americans making fortunes off of everything from lumber and cotton to the manufacture of jute-sacks. After the Louisiana Purchase in 1803, New Orleans had become an increasingly commercial city. Its port was the natural point of entry for coffee and European manufactured goods, and the natural point of shipment for goods coming down the river from the Midwest and the East, as well for all those commodities making the Americans rich. By 1850, New Orleans was the wealthiest city in the South and its most recent denizens needed places to live.

The French Quarter, the original city, was controlled and populated by Creoles, old-line aristocrats of French origin who had held sway over New Orleans for more than a hundred years and who had no use for the tacky, nouveau riche Americans. Until the Livaudais lots became available, the newcomers had been crammed in a narrow strip between Canal Street, the eastern boundary of the Quarter, and Jackson Avenue, where the Livaudais plantation began. Though some tourist brochures still subscribe to the romantic portrayal of the area as having been settled by a stable, Southern-born, agricultural aristocracy, the majority of the houses were built by ambitious businessmen who hailed from such distinctly un-Southern climes as England, New York, Maine, Philadelphia, and New Jersey, and who often lost their fortunes as quickly as they made them. In the interim though, they managed to show off plenty, building elaborate Greek revival mansions or Italianate villas and creating the first real gardens in the city. Until then, most of the gardens in New Orleans had existed within the walls of courtyards, much like mine on Bourbon, small and hidden from view; now there was not only lavish space, but land made rich by seasons of floods like the one which had been

Livaudais's downfall. The sudden profusion was, apparently, a dramatic sight. Mark Twain, a frequent visitor to the Garden District house of his friend the writer George Washington Cable, wrote that "the mansions stand in the center of large grounds and rise, garlanded with roses, out of the midst of swelling masses of shining green foliage and many-colored blossoms. No houses could be in better harmony with their surroundings, or more pleasing to the eye, or more homelike and comfortable looking."

John and I had not been in harmony with our surroundings, or even remotely comfortable, since we returned from our honeymoon, and "homelike" was definitely not the first word that came to mind in describing life at Betty's. We looked for a year, spending the majority of our weekends crisscrossing the neighborhood block by block, house by house. "What do you think that one's like inside?" one of us would ask. "Will it ever be for sale?" Nothing that turned out to be for sale was right, of course, and then, finally, we found it, the house we knew should be ours, on the corner of First and Chestnut.

~ 3 ~

I N RETROSPECT, THE house seemed almost destined. Not only did it have the requisite big kitchen with an enormous commercial stove (one of the very few things in the almost 6,000 square-foot house that did not need to be replaced), but for more than twenty years, from 1955 to 1977, it had been occupied by Billups Phinizy Percy and his family. Like his brothers, Walker and LeRoy, he had grown up in Greenville, the adopted son of the planter and poet William Alexander Percy. (When Shelby Foote was asked why there were so many writers from Greenville, he said, "If Will Percy had lived in Tupelo, there would have been a lot of writers in Tupelo.") I had grown up two doors down from LeRoy, the middle brother, and taught his grandchildren in day camp. (When both my paternal grandparents were killed in car wreck when I was seventeen, LeRoy handed me a martini at eleven o'clock in the morning with the words, "I think we could all use one of these.") And though I had visited Walker in Covington, I had all but forgotten that the youngest brother, Phin, had come to New Orleans and stayed.

Phin had been a PT boat captain with JFK in the Solomon Islands and spent the rest of the war in the Pacific in a submarine, where he won the Bronze and Silver Stars. He graduated from the University of Virginia Law School and was recruited by the CIA, but gave up on that idea—and the cover it would have required—after meeting Jaye Dobbs, the heiress to the Dobbs hat fortune, at the World Series in New York. They married and ended up in New Orleans, where Phin taught constitutional law at Tulane and became a constant presence in the "Letters to the Editor" section of the *Times-Picayune* under his first name, Billups. In another coincidence, our real estate agent was a life-long friend of the four Percy children and had practically grown up in the house. Walking through it with Ricky was like having a docent—he showed me the spot in the dining room where the stylish Mrs. Percy had placed the marble bust of Venus, the wall in the second parlor where William Alexander Percy's portrait had hung. And then there were the stories: the time young Phinizy bought a python and turned it loose in the neighborhood, causing considerable panic (it was never found) and making the local news for days on end; the time Phinizy (again) started a fire in the potting shed, but was prevented from burning down the house by the acute senses of his visiting deaf cousin, Walker's daughter Ann, who alerted folks before it got out of hand.

By all accounts, the Percys lived well on First Street, but in the years since they'd sold the place, things had gone generally to hell. The house needed complete rewiring, all new central air and heating, and complete re-piping (the water coming out of the taps on the third floor was little more than a drip). The bathrooms were vintage disasters and contained such never-before-seen wonders as the "half-tub," a ceramic tub the size of a shower stall, and the corner toilet (an innovation which enabled the door of the minuscule powder room to be opened). Also, whoever had carved out the space for them had done

it badly—in one bedroom, the spacious closet had a window, while the tiny bathroom did not.

The house had settled so much and so weirdly over the years that there was a seven-inch differentiation in the dining room alone and most of the doors slammed shut behind you. As the post-Katrina world now knows, the diluvial soil along the river in New Orleans most closely resembles pudding. There is a reason why the shoring specialist Abry Brothers is one of the two oldest businesses in the city (the other is Antoine's restaurant), though clearly there had been no attempt over the years to contact them. There was so little room to maneuver underneath the house, the inspector—and later, the electrician, the air-conditioning man, and the plumber—had to call in his skinniest helper.

Outside was just as bad. Most of the shutters and much of the siding needed to be replaced, and the whole thing was in desperate need of a paint job. The chimneys were crumbling and the first time I leaned against the second-floor balcony the railing gave way completely—I would have fallen to certain death had a friend not been there to grab me. On one side of the house, there were hulking exposed air-conditioning units and a crumbling asphalt drive big enough for a dozen cars, thereby rendering it a giant parking lot rather than a garden. On the other side, there was a malaria breeding ground in the form of an ugly, algae-ridden brick fountain, pretty much everything in the ground was dead or dying, and what little was still alive made no sense. There was a four-foot gap between the brick boundary wall and the hedge planted alongside it, for example, narrowing the yard considerably and providing an excellent bed for weeds.

The couple we bought the house from had owned it for little more than a year, thrown one splashy Mardi Gras party (we're three blocks from the St. Charles Avenue parade route), and never moved in. Their lone "improvement" was to cover every inch of the interior with a

really sloppy coat of dead-white high-gloss paint, and all the beautiful heart-pine floors with high-gloss polyurethane, two more things we'd have to undo. The effect, though intended to spiff things up for prospective buyers, was blinding, but they'd originally had far more elaborate ambitions. The house, they told us blithely at the closing, had never been quite "grand enough" for them (an admission that left us slack-jawed, as we were at that moment handing over the biggest check either of us had ever written). To that end, they'd commissioned a set of plans that were included with the house—one room, a laughably blatant attempt by the architect to give the clients what they wanted, was actually called "Grand Dressing Room." It featured all manner of plaster scallop shells, pearls, and rosettes, motifs that were to be repeated on the master bedroom ceiling. While there was no question that the charming flag-stoned, screened-in porch of the Percy era needed some work—the same people who had allowed the wiring to crumble had replaced the screens with hideous plate-glass windows—we had in mind something slightly less over-the-top than the ornate, marble-tiled "Palm Court" on the plans. (Our version became a comfortable "sunroom," with French windows that actually open and bookshelves on the opposite wall.) The garage was to become an "Exercise Room" and "Carriage House," and the potting shed (which still contained the charred beams from Phinizy's fire) would be a "Wine Room" and "Staff Area."

When I saw those plans I knew we had been sent to rescue the house—a potting shed happened to be the one thing in addition to a real kitchen that I'd always aspired to. More important, the structure was one of the earliest in the Garden District, built in 1847 in classic Greek Revival style, before the heavier and more ornate "fruit basket" Victorian elements began to creep into mantels and plasterwork. It was designed for a man named John W. Gayle by prominent Irish-born architect James Gallier Sr. who designed the original City

Hall (now called Gallier Hall) and whose son James Jr. was also a noted local architect. (Their name originally had been Gallagher but, like a lot of Irish immigrants, they Frenchified it before their arrival in order to fit in.) The doors are Greek key, the mantels black marble, the plaster cornices handsome and streamlined, and the medallions not overly flowery. The original windows are Greek key too, and enormous, so that the whole house is filled with light. We both fell immediately in love with its lavish proportion, airy simplicity, and ample corner lot. The plans had been an attempt to make a sow's ear into a garish silk purse, and in this case the lovely sow's ear was eminently preferable.

By the time we closed in August, I felt like we'd owned the house forever—and not just because poor Ricky had already let me in at least a hundred times after our offer had been accepted. On those occasions, I wandered around daydreaming, scribbling endlessly in my orange speckled notebook, but I already knew what I wanted. I'd been preparing for owning some house, somewhere, sometime, for so long that I'd saved every *World of Interiors* and *House & Garden* magazine since I was twenty, moving them in increasingly battered boxes from apartment to apartment, city to city. I'd been carrying around a swatch of Bennison "Crewelwork" linen like a talisman for almost fifteen years; I was well versed in the subtle differences between Farrow & Ball's "Straw," "String," and "Matchstick" paint colors. More than a year before we laid eyes on the house, I had bought (on the layaway plan at a local antique store) the parcel gilt bamboo Regency benches I now knew would go in the front parlor. As a child, I never cared a whit about Barbie, it was her dream house I was obsessed with. Now at last I had my own.

After the closing, we went straight to First Street to open the door with our own key for the first time, and then continued on to my friend John Besh's restaurant August for lunch. We took a table in a

front corner by the window and John ordered a bottle of my favorite Billecart-Salmon Champagne; as we raised our glasses I realized I wasn't just toasting the house, I was toasting all that went with it. Here I was, well past forty, and until this moment the word "home" had still meant the house on Bayou Road, the town of Greenville. In my early twenties, I knew at the time that the cities where I went to work—Washington, Atlanta, Orlando, Washington again—were only stops along the way to some future home I assumed would be permanent. What I had not planned on was to live like a vagabond for fifteen more years after that, going back and forth between New York and New Orleans, never really committing to either place, becoming a true citizen of neither.

In New York, my "community" was mostly comprised of fellow journalists and my clubhouse Elaine's (there are worse fates), but I belonged to nothing. I turned up occasionally at the Madison Avenue Presbyterian Church (I happen to be a Presbyterian, but there was also the fact that it was a convenient six blocks from my apartment), and in New Orleans I went to Trinity Episcopal because it is Elizabeth's church and I only ever went with her. Once, I volunteered in one of New Orleans's worst housing projects—a valiant nun was trying to start a student-run newspaper—and my heart would break when I'd return from New York and listen to the messages from children who had needed my help while I was gone. I couldn't volunteer—I couldn't even get a dog. Until my (Manhattan) cat died, I paid my Jamaican cleaning lady Carmen to watch TV with him every day just to keep him company—and to assuage my considerable guilt. Maintaining such a dual existence had been a lot like my hesitance about marriage. My much-vaunted mobility and freedom had, in fact, been denying me the richness of a settled life, of being a productive member of a community and all that it entails. I had been a woman without a country—or at least a city—for too long.

It was time for me to dig in and if there was ever a place that needed civic involvement, New Orleans was it. The only problem was that it had been so messed up for so long that it was hard to know where to begin. The school system had been looted by its board and was on the brink of being taken over by the state; classes were conducted in buildings that had been condemned. The administration of the previous mayor, Marc Morial, like those of his predecessors, had been rife with corruption, and the police department had a similar history. Since I'd been in New Orleans, officers had been prosecuted for crimes ranging from being on the take to kidnapping, rape, and murder. Violent crime, most of it crack-and-gang driven, was rampant; the day we closed on the house there had been 170 murders so far, and there were four months left in the year.

Worse, amid this seemingly intractable mess, much of the white population, in the minority since the late 1970s, had either given up, or had never been involved in the wider life of the city in the first place. There were notable, hardworking exceptions, but among many of the so-called ruling classes, a complacency had set in that allowed most of the city's institutions—other than their beloved Mardi Gras organizations called krewes—to rot. When controversial black councilwoman Dorothy Mae Taylor introduced an ordinance in 1992 that essentially required the integration of the krewes (they are private social clubs but parade on public streets), it was the first time I had seen a certain segment of the population muster outrage over anything. When I'd tried to raise money for the housing project newspaper among some of the same folks—most of whom lived within walking distance of the now-razed project and who would have been among the chief beneficiaries of a productively engaged young population—I was roundly rebuffed, usually with the line "I pay my taxes." When Taylor's ordinance passed, two of the city's

oldest and most exclusive organizations, the Mistick Krewe of Comus and Knights of Momus, simply chose not to ride at all.

Very little, it seemed, was worth fighting for. Though New Orleans was once thought of as an "oil capital," a great many of the oil companies began leaving in the 1980s, driven by the depressed oil and gas market, but also because of the deplorable state of the city's schools and services, and the fact that their executives were generally treated as social outsiders. Barred from the more exclusive clubs, they started their own, the now-defunct Petroleum Club. By the 1990s, the New Orleans economy was almost entirely dependent on tourism, which was a mixed bag at best. The great majority of the hotels, for example, were owned by out-of-town corporations that paid the bulk of their employees minimum wage.

Added to the mix was the fact that the newspaper was hardly a crusading organ or even a conscientious voice for change—settling instead on a policy best described as benign boosterism. During the 1991 governor's race, I asked a top editor why they had held back on some of the most damning coverage of David Duke in his race against Edwin Edwards, and he told me he had not wanted to "rile" the populace. I was speechless. The populace was in desperate need of riling.

I had known all this for years, obviously, but during those years I'd been primarily an observer, perfecting mordantly amusing tales to tell in print or in conversation to people who wanted to know: "What's it like down there?" I'd always felt a little like I had during a typically merry lunch at Galatoire's one Friday (the day lunch almost always runs into dinner) when I'd been mesmerized by a table of guys either celebrating or forgetting—it was hard to tell which—their impending bankruptcies. It could well have been the booze—each man had at least five glasses at his place—but they did not seem particularly

bothered by their misfortune and I certainly wasn't. Galatoire's, like New Orleans itself, was a theater, a place in which time, context, and the rest of the world had little meaning, and they were the show—a good one. Before they left they asked their waiter to fill huge "to-go" cups with cognac, so that they could make their way down Bourbon Street to the Absinthe House and watch *Jeopardy!* on the bar TV, a ritual they referred to as "Jeopardizing."

Now, suddenly, I was no longer the wry observer, but heavily invested in the city and its citizens, along with the serious flaws and entertaining foibles of both. There is nothing like a big chunk of real estate to immediately focus the mind, but I had no regrets. The things that had drawn me to the city in the first place were still right here. So that night, our first night as homeowners, McGee came over and the three of us sat cross-legged on the kitchen counters, eating take-out Chinese and drinking more Champagne out of the heavy glass Lucullus flutes I'd brought over from Bourbon Street. McGee had lived in New York for most of the time I had; when she left her husband—and the suffocating confines of Westchester County—she came straight to New Orleans and eventually bought her own house, a lovely Uptown duplex with a garden in the back and a couple of cats. Now here we were, the former Gunga Den-goers, finally (sort of) grown up. I don't think I'd ever been so content. It was August 2004, a little over two years since we'd married and a month shy of my forty-fourth birthday. Before we left that night, I washed the glasses and put them, a tad prematurely, in one of the kitchen cabinets. I didn't know it yet, but it would be almost a year before we'd actually move in.

4

THERE WAS A lot to do, but one of my strengths, which can sometimes be a serious weakness, is that I think I can make pretty much anything happen by the sheer force of my will. Also, my instincts about people are usually on the money. I was convinced, therefore, that I would be the only person in the universe who would have an on-time, under-budget, and stress-free renovation working side by side with a brilliant contractor whom I adored. I'd done it before, in New York of all places—though the job, admittedly, had been far smaller. Also, we had survived the debacle at Betty's with our marriage and our mutual sanity intact—how much worse could it be?

There was also the fact that our contractor, Eddie, had been recommended by Patrick Dunne, whose taste I respect enormously and who had successfully worked with him on smaller projects in the Quarter. Patrick had brought Eddie to another house we'd looked at but did not buy, and I liked him immediately. He was tall and thin with longish gray hair, a laid-back affect, and what seemed to be

a sense of humor—at one point, he told me, he'd been a stand-up comic in L.A. and had appeared in a movie of the week. More to the point, he responded to everything I asked about that day with "doable" or "no problem." He wore faded blue jeans and scribbled constantly on a legal pad, and I decided he was totally cool. In the car, John's response, as always, was more guarded—which, as always, irritated me. What is your problem, I wanted to know. I'm the one who'll be dealing with him every day, he's clearly the guy, why look any further? In our marriage, the joke—and the truth—is that John's the tortoise and I'm the hare and when we bought the house I didn't want to waste another minute on pesky tasks like screening other possible contractors. John didn't object, so I called Eddie. A week after the closing, he turned up with his crew, and the nightmare began.

The first phase, demolition, actually went pretty well. We had hired my friend Lewis Graeber, a Mississippi architect who had practiced in New Orleans for years and who specializes in period houses, to tell us what to undo. We restored all the interior doorframes back to the same—large—size, gave a 1930s jalousie window in the entrance hall its original Greek key shape, and reopened a second door leading outside from the sunroom that had been Sheetrocked over. Out went hollow interior doors, hollow "brass" doorknobs, and a dozen bad light fixtures. Out went the glass-shelved wet bar in the library, the flimsy French doors to nowhere in a second-floor bedroom, a nook for a sculpture in the second parlor that rendered the powder room behind it so tiny the door barely opened.

Eddie's guys were great at ripping everything out, mostly because they were so big. The team was led by Abel, a naturalized American fireplug from Honduras who'd gotten thrown out of the Marines for punching his superior officer, and who spent the great majority of his off time at Razoo's, a Bourbon Street bar known for frequent and oc

casionally deadly altercations. His most regular helpers were Tony, a sweet teddy bear of a man who had never worked for a contractor before but was strong and very eager, and Felipe, a short, very round kid from Ecuador, who was forever penning caricatures of himself and the others on unpainted bits of Sheetrock and pieces of lumber he left for me as presents. (I still have a particularly well-rendered drawing of himself as a nude sybarite eating grapes and wearing a crown of laurel.)

They ripped out, reframed, and Sheetrocked so fast I was heartily encouraged, so when it came time to tackle the five bathrooms, I told Eddie to go for it. They were all disasters, but originally we had discussed doing over only the downstairs powder room and our two master baths in the interest of "going slow" and "saving money," two terms that were becoming more and more quaint by the day. Once I saw the dust and general havoc wreaked by ripping out the tubs and toilets and sinks in our bathrooms, I knew the time to do everything was right then. Also, I was armed with an especially dangerous piece of pornography known as the Waterworks catalog. I had already picked out an Empire corner tub, Crystal sponge and soap basket, and Easton étagere for one bathroom, and an Exeter pedestal lavatory, elongated water closet, and Etoile double robe hook for the next. All the showers were going to get elaborate temperature gauges and pressure valves; John would have no less than three different showerheads in his alone. I was on a roll.

Still, when I came home and announced that we were gutting all the bathrooms, we both had a sort of dip in our stomachs. The next morning I went back to tell Eddie to hold off, but it was too late—the guys were in their speedy demo mode and everything was already in a pile in the driveway. I have to say that when I saw all those ripped-out Formica-topped vanities, the bizarre half-tubs, the Hollywood-bulb mirrors, the ancient toilets, and mottled glass shower doors, I

was secretly delighted; John, ever the tortoise, told me later that for him, it had been cause for a major silent freak-out.

It turns out that it is just as easy to gut a yard as to gut a house. The same day I called Eddie, I also called my old friend Ben Page, a landscape architect in Nashville whose work across the country I had long admired. I'd wanted a garden for almost as long as I'd wanted a house, but the one we got was almost more than I'd bargained for—there was what amounted to a whole separate lot on the left side of the house and on the right, in the current "parking lot," there was tons more space to landscape. Ben arrived early one morning, studied the site from every indoor window, and spent another hour walking the grounds before we broke for lunch. By the time we'd finished our first glass of wine he'd sketched the whole thing on the white butcher paper covering the table. There would be separate garden rooms, he said, the front "room" alongside the house, would be a formal lawn; the second, alongside the "porch," would be a mad tropical "hidden garden" around a central fountain modeled after one Ben and John and I happened to love in the south of Spain. Beyond that, on the site of the infested fountain and a too-small terrace, there would be a spacious stone terrace and a dining pergola; at the back door there would be a kitchen garden, with herbs and fig trees and a pineapple guava, along with a smaller stone terrace where John could put his beloved grill.

The asphalt jungle on the other side would be blasted up and the bricks from the existing terrace would be used to make a semicircular drive. The space in front of the garage would be green again with flowering trees and bulbs and climbing roses; the garage door would be replaced by two real windows with a garden bench between them. We needed new limestone front steps, new brick back steps, and limestone steps and landings outside both sunroom doors. It was major, major stuff, but we both immediately loved it. What

can I keep? I asked Ben, meaning which plant materials still in the ground were worth working with. He didn't miss a beat: the live oak and the magnolia. Right, the two ancient and enormous trees framing the house in the front that were sort of the whole point of living in New Orleans, in the Garden District, and that was it. A week or so after our meeting, the lunch-table scrap was replaced by a gorgeous hand-colored plan that arrived in the mail in a giant tube. It was accompanied by an a multi-paged, itemized document titled "Opinion of Probable Cost." Before I got past page two, I had to stop and pour myself a vast tumbler of straight Scotch.

After I recovered, I called John Benton, owner of Bayou Tree Service whom I'd interviewed years earlier for a piece I did on New Orleans's ongoing infestation of Formosan termites. The termites were eating all the city's magnificent live oaks from the inside out and they were snapping in two like twigs. He'd been quoted in the newspaper so I'd gone to see him in his office, where he kept what looked like thousands of the nasty little Formosans in an aquarium. To demonstrate their chewing power, he dropped his business card inside and within minutes it had vanished. The termite show was memorable and he was funny, so I quoted him, a lot.

When I called him I could tell he didn't remember our meeting but his interest was piqued by the size of our job (when you take out whole truckloads of trees and shrubs you eventually have to replace them), and by my mentioning that the piece he was quoted in had ended up in my first book, a collection of essays about the South. When he arrived the next morning, the book was on the dashboard of his truck and he'd already read the whole thing. Right off the bat, he told me he was obsessive compulsive, and given his recent speed-reading, I believed him. As we walked through the yard, he also told me he wanted to be a writer, he'd been reading books about words, was thinking about taking a course or two. I knew, for better

or worse, I'd just met my new best friend. Within the week, a team of guys in Bayou Tree hardhats arrived with a fleet of equipment, and just as fast as Eddie's crew had gutted our bathrooms, our semi-green yard was made into desert.

In the meantime, progress inside had slowed down considerably. We were still living at Betty's, but I had—hilariously—promised the couple taking our place there that we would be out by the end of October. The plan had been to move into the third floor of the house, which we had refigured into a bedroom, sitting room, and bath, and which the guys would finish first, but we were well into October and it was nowhere close to being ready. Instead Eddie was busy refinishing all the floors and forcing me to choose downstairs paint colors. I did not yet know better, I figured this was some kind of secret contractor logic—maybe it was normal to get the walls and floors in pristine shape while battalions of people stomped in and out carrying things like bathtubs and table saws.

We would end up doing the floors two more times, and we had to do the walls again anyway because the painters had no idea what they were doing. Countless dead bugs, nap from their cheap rollers, spiderwebs, you name it—they were all painted onto my parlor walls along with the gorgeous Farrow & Ball paint in "Sutcliffe Green" I had ordered all the way from their North American plant in Canada. (I spent at least a thousand dollars on shipping and paint before I realized that the local Benjamin Moore store could easily color-match Farrow & Ball, but then, that was before I realized a whole lot of stuff.) At my insistence Eddie fired them and the next round was even worse. One day I walked in to find a guy painting the powder room with a roller that could only have been made with the very long hair of a Tibetan mountain goat. The walls looked like stucco and paint stalactites hung from the ceiling. Nice, neat short-napped rollers were, apparently, very, very difficult to find, and brushes, requiring

as they did a modicum of skill, were obviously out of the question. I managed to get my hands on one, but when I held it up to stucco boy, he was blank faced: "*Qué es?*"

When this crack team got done with the second-floor front bedroom I'd claimed as my office, I walked through with Eddie marking the numerous mistakes he had failed to notice with a red wax pencil. About five minutes into it, I was so irritated that I quit making my marks and scribbled instead a big red and very profane message to the painters that immediately became legend. Within days, Benton reported that he had heard about it from one of his clients who had heard about it from one of her friends who happened to be my most ladylike neighbor. After much consultation between Eddie and the chief painter, new rollers were brought in, everybody was going to pay attention. They dutifully sanded down the powder room and reapplied its pretty, rich red, but not just on the walls—they painted the woodwork, the ceiling, everything. The effect was like being inside a bloodbath and I was ready for one. Instead, I marched out of the house, removed the paint contractor's sign from our iron fence, threw it in the middle of First Street, and stomped on it repeatedly. Shortly thereafter, a paint moratorium was declared.

Even before my street tantrum, we were something of a curiosity. Abel reported frequent sightings of determined ladies in workout suits, walking through the house on uninvited tours. I'm sure they, along with everyone else in the neighborhood, were wondering what in the world we were going to do to the place. By local standards I was an unknown quantity, viewed, I think, as something of a "bohemian," a journalist who lived in the Quarter and then not even all the time. I was spotted on TV occasionally, at Galatoire's a lot, and at "nice" parties rarely—in my life so far I'd attended exactly one Mardi Gras ball and that was in the interest of anthropological research. For years the only people in the city I knew well enough to put on

my Christmas list were a small handful of close friends, including the McGee sisters, and the gatekeepers at what were then my most frequented restaurants: Arnold at Galatoire's, Patrick at the Bistro, and Lee at Peristyle, who was also invited to our wedding. During our house hunt I ran into a realtor, a *grande dame* of sorts who knew my mother through the Garden Club of America, and the first thing she asked me was why I had not tried to join the local chapter. I had no idea what to say, but in retrospect I should have been flattered that she thought I might actually be allowed in.

John was far better integrated than I. His musical career had come to an abrupt end when he was drafted and shipped off to Vietnam, and though he is famous in very select circles for his late night renditions of "Gloria," he spends far more time practicing law. He's the managing partner of his law firm, has served on boards ranging from Children's Hospital to a group that provides pro bono representation to indigent defendants, and was long ago inducted into one of the city's oldest krewes. When he was married to his first wife, he went to the balls, wrote lyrics for skit nights at his club (that was, of course, affiliated with his krewe), played tennis at the New Orleans Lawn Tennis Club, and was a member of Trinity Church. But after his divorce he went slightly off the radar—unless, that is, the waves were being transmitted in the general direction of the Rib Room restaurant or the Polo Lounge at the Windsor Court.

John and I are both sociable beings and by the time we started going out, we could get into almost any restaurant at almost any time, but that had far more to do with John's generous tipping habits and my growing friendships with the great majority of the restaurateurs, chefs, and maitre d's in town (as well as the not unimportant fact that I often wrote about food) than with any exalted social standing. In any case, we certainly weren't part of New Orleans "society," which is something that happens to you at birth. In *The Romantic New Or-*

leanians, Robert Tallant writes that a great number of the more "exclusive" society folks "unconsciously believe that the city belongs to them" and they "seem to resent" everyone else. "Socially prominent New Orleanians frequently behave toward the rest of the population as if they were a ruling white colony temporarily residing among the natives of the Fiji Islands."

So here we were: humble Fijians set down in the midst of people whose families had owned the same houses for generations. Much had changed in the fifty or so years since Tallant wrote his book, and many of our most immediate neighbors were almost as new to the area as we were. Still, just two blocks away sits the oldest house in the Garden District, a raised "cottage" where the descendants of the family that bought it just after the Civil War still live. A block from us in the other direction is the house where Jefferson Davis breathed his last. When I was out there stomping on that sign I might as well have been wearing a grass skirt.

We got a look into our own house's history when a very polite woman actually knocked on the door (as opposed to jogging on in) and told me she had lived there in the thirties and forties. As a girl, she said, her job had been to stand on a ladder and polish the crystals of the chandelier in the front parlor; she remembered going with her mother to a Royal Street antiques shop to buy the brass lion's head doorknocker on the front door. She was charming and generous and wanted to know if I'd like her to send me what information on the house she had. Of course, I said, and the following week a package arrived with photocopied photos of the thirties interiors (I loved that there was a print of the *Mona Lisa* on the wall of the second parlor), and a page from a little book called *The Great Days of the Garden District*, which is how I discovered when the house was built and by whom (though sadly there is little known about Mr. Gayle or the "bride" who inspired the project).

I was gratified to read that our house, "majestically situated on a large corner lot" is "a fine example of Greek Revival style," with its "double galleries, fluted Corinthian columns, and a deep but simple cornice above the upper porch"—though it had certainly been some time since the grounds "abounded in typical shrubs and towering magnolia trees." The outdoor photos showed that there had been another live oak that must have been crowded out by the huge one on the corner, as well as at least two more impressive magnolias—enough, at any rate, to have given the place its name. In the package was also a bookplate with a sketch of the Greek key front door—complete with the lion's head doorknocker—beneath the moniker "Magnolia Manor." I had no intention of calling the house by any name at all, much less one that sounded like a retirement home modeled after Tara, but it was nice to know and good news for Benton—I immediately called him and replaced the comparatively cheap Japanese plum trees on Ben's plan with four sweet bay magnolias.

In return for our former resident's trouble, I removed the lion's head and sent it off to her with a note, but I didn't have the heart to tell her I was selling her beloved chandelier at auction, along with one in the dining room that featured a few too many bronze rosebuds. By this time it was November and there was no end in sight. To buy us another month at Betty's, I told the increasingly impatient incoming couple they could have the custom sofa that fit perfectly beneath the upstairs windows, and threw in a sea grass rug from my downstairs office. Eddie and I were still speaking—we all were, I shared after-work Budweisers with Abel and the boys, and an occasional glass of wine with Eddie, who lived not far from us in the Quarter. I was still under the vague illusion he knew what he was doing. He had found me an enormous cache of gorgeous old marble tiles from an Italian palazzo, for example, and they made the bathrooms look as though they'd been there for years. I loved him for finding them—I

just didn't realize at the time that the decision to use the sunroom's flat roof as the staging area for about a thousand pounds of the stuff was maybe not the smartest idea. (As I write, despite numerous costly attempts to repair it, the sunroom roof is still leaking.)

In December I sold my apartment in Manhattan (a major part of the commitment process and the one that gave me most pause), which meant that two more storage PODS were added to the burgeoning collection out front. I gave Eddie some Champagne glasses and a magnum of Veuve Clicquot for Christmas and told the couple waiting for Bourbon Street they could have my fabulous iron bed for half of what I paid for it.

By January we were out of time, not to mention items to use as bribes, so we rented two more storage units, packed one suitcase each, and moved into Elizabeth's guesthouse for what we promised would be just a few weeks, maybe less. Mike, Elizabeth's husband, had committed suicide two years earlier, and we all—John and I, McGee, Elizabeth and her two girls—had become even more of a family. Poor Elizabeth had been putting up with me since McGee and I first availed ourselves of her floor. When I came to New Orleans to cover Edwards, Mike, an incredible cook, fed me most nights along with Elizabeth and the girls at their kitchen table, and created a still-memorable menu for a party they threw to welcome me to town. Now she was again providing comfort and hospitality far beyond the call of duty—or family. This time, at least, it was I who did the cooking for our hostess and Lizzy, thirteen. (Katie was in her freshman year at the University of Virginia.) But in the end, no amount of meals or the weekly cases of wine John carried in could justify our long tenure. We moved in just before Mardi Gras, which fell early that year, on February 2. It would be almost six months before we left.

In March, though only four rooms—the front parlors, the dining room, and the kitchen—were operational, I threw a book party for

my friend Roy Blount. In September he had told me he had a book about New Orleans, *Feet on the Street*, coming out in the spring. "Great," I told him. "Our house will certainly be finished by then, good Lord. Please let us host a book party." By that time, McGee, a superb decorative painter who had worked on my apartment in New York, was busy transforming the hideous dark wood panels in the library (which turned out to be pieces of plywood and old flooring stained a dull mahogany) into a lighter and much more beautiful faux bois, and she enlisted one of her helpers to throw a coat of paint up in the dining room, whose walls were still under much discussion. (Before it was all over we put up at least ten coats of paint, including two shades of coral, one shade of gray, three shades of brown, and four shades of blue—this was the third blue.) We had already bought a dining table that seats twenty-four from Patrick Dunne, so we moved that in along with John's grand piano, ignored the bare bulbs hanging from the ceilings and the plywood ramp that doubled as front steps. My buddy Ken Wells, a Manhattan-based novelist and editor who originally hails from Houma, recruited his brothers and the three of them, who call themselves "Crawdiddy," played Cajun music in the second parlor, while my best friend Jessica Brent, a gifted singer and songwriter who had driven down from Greenville, sang and occasionally sat in on piano and guitar. I filled a silver punch bowl with the lump crab salad I know Roy loves, assembled a vast bar, and welcomed Roy's list and our friends, which at this point included John Benton and his wife and Eddie and his girlfriend.

When Jessica laid eyes on Eddie, she was incredulous. "That's your contractor?" she asked me. I became immediately defensive and not just a little afraid. Jessica can be a tiny bit paranoid but she is also blessed with a highly developed sense of the telling detail. "Yeah, that's Eddie. What's your problem?" The problem, she said, is his hair, and she had a point. Eddie is extremely proud of his wavy, sil-

very mane and he had clearly taken extraordinary care in styling it for the evening. He imagined himself a player of sorts, not a contractor, and he'd been telling everybody who'd listen, with the exception of John and me, that ours was his last job. He was producing a virtual reality CD tour of the French Quarter with an Australian partner, and lately he was spending most of his time at our house in the relative luxury of his air-conditioned truck, talking on his cell phone and working on his laptop, rather than keeping anything but the loosest of tabs on his workforce.

The workforce, whose members did not happen to be sitting in an air-conditioned truck, were getting cranky. They also seemed to have lost anything remotely resembling a ruler or a level. Every cabinet knob was higher or lower than its partner; none of the locks turned because they weren't lined up. Doors—expensive, newly milled, solid cedar doors—were either hung crookedly or the frame hadn't been measured properly, mistakes that didn't faze Abel or Tony or Ernesto, the Mexican carpenter who looked like an evil Jesus, in the slightest. They just lopped them off with a saw until they fit. The "invisible" doors of the vast storage closets we were adding to the third floor were a particular conundrum, as well as one of the reasons we hadn't been able to move up there yet. So far they had been installed and painted three different times and every time they either fell off or there was a minimum of one-inch gaps between them.

In April I arrived to find that the stone for the terrace—the gorgeous thick slabs of bluestone that had come all the way from a quarry in Pennsylvania—hadn't been laid according to Ben's plan, which was so simple a three-year-old reasonably good at puzzles could have followed it. Each stone had been cut to the specified dimensions and numbered; the numbers penciled on the stones matched the numbers printed on the plan. But the team Eddie had hired for the outside work had plunked them down in a pattern of their own devising in-

stead, cutting the generous slabs into L-shapes and slivers to make it work.

Eddie assured me he would replace the stone but it meant blasting up the whole terrace with a jackhammer, waiting for a new shipment, and starting over. Somehow, I handled it. I was more interested at that point in why, if you put your hand on our master bedroom doorframe, you could feel vibrations from the air conditioning so powerful it felt like a plane was about to take off through the wall. "It's an old house," was Eddie's stock response. I told him I didn't think it was age that was also causing every vent in every room upstairs to gush so much water they looked like mini waterfalls. "It's normal condensation," he said. "It's because the doors are open so much." I could only assume he thought I was blind, but then it dawned on me that he actually believed his own bullshit. Working under that theory was enormously liberating; I quit begging him and called his air-conditioning guy myself. When he finally deigned to turn up, he found that the clumsy, roly-poly Felipe had stomped on the ducts months earlier when he sprayed insulation in the attic and most of the airflow had been drastically restricted. Within an hour the waterfalls were staunched and the vibrations quieted.

It wasn't until May that I completely lost it, and then it was over the comparatively minor debacle of wrongly installed doorknobs. I had spent literally hundreds of hours looking for the perfect doorknobs and thumb-turn locks, and when they finally came I walked in to find that Abel and Tony had installed them all upside down, which is the way, they said, Eddie had told them to. This meant that they would have to take them out, Bondo all the holes (we were starting to have more Bondo-ed surfaces than wood), sand and repaint the doors, and reinstall the hardware. I knew it was not the end of the world, and if Eddie had not condescendingly informed me that it was not the end of the world, I wouldn't have snapped. But he did. When I

called him he said, "It's not like the roof fell in, Julia." No, that would come later. Meanwhile, I was supposed to be thrilled it wasn't a catastrophic mistake, just yet another one that was unnecessary, stupid, destructive, time-consuming, and expensive. (I had now found my own very meticulous, but insanely pricey painters who charged by the hour.)

Then came the clencher: "You told me to do it that way." I didn't care if this was more of the bullshit he believed or not, I knew it wasn't true, and I also knew that if he repeated it I might actually have a stroke, so I asked him please not say it again. Then he told me he was coming right over, and I told him that if he did I would kill him. More than anything in the world at that particular moment, I did not want to have Eddie in my line of vision. "I'm coming," he said again. "Eddie, I don't think you get this. If you come over here, I swear to God, I will kill you. I am not kidding." I was standing on the front porch, screaming into my cell phone, giving the neighbors another show, and I knew I should stop but I couldn't. By the time I had assured Eddie that I was serious, cars were slowing down and front doors were opening.

I called John. Eddie called John. And John, in the end, went downtown and smoothed over what Eddie described as his "hurt feelings" with several cold beers at Lafitte's. My own feelings—along with my nerves, our bank account—were shot all to hell. I had waited all my life for what I thought would be the privilege of creating the home I wanted. And while I still felt as though it was a privilege, it was also all-consuming slow torture and there was more than one moment that I longed for the occasional unencumbered loucheness of my long-ago life on Bourbon Street. Eddie, on the other hand seemed perfectly fine. A few days after John defused our standoff, his partner asked me if would I provide a blurb for their CD; Eddie himself asked if I thought maybe the Ogden Museum of Southern Art, whose board

I had recently agreed to join (more commitment), would be interested in a virtual reality tour of their collection. I did not tell him to dream on; in fact, I told him I'd see what I could do. Both John and I had obviously lost our minds, or maybe we were suffering from the Stockholm syndrome. It was the only explanation. A sane person would have fired our "captor"—hell, our torturer—the night of the doorknobs rather than appeasing him. His mistakes, the ones we knew about, that is, had already cost us a literal fortune in paint alone.

In fact, it was the painters we should have consulted—they had better insight into Eddie and the increasingly sloppy way he and his subcontractors did business than anyone. They were the folks I called in to repair the messes; they heard the daily conversations and witnessed the daily screw-ups. I was the novice—they were far more familiar than I with how a professional job is done. Their boss, Billy Dupré, was a light-skinned Creole who was such a gentleman that months passed, and many, many dollars changed hands, before I could bring myself to call him anything but Mr. Dupré. His guys— Byron, PeeWee, Sean, and James—were really good at what they did and they respected each other, but I could tell they did not have much use at all for Eddie. Unfortunately, they were also polite and minded their own business. None of them, Mr. Dupré included, told me what they really thought until it was way too late.

So we stayed the course, and in early July, ten months after the process began, the third floor was ready enough for us to occupy. We bought a box spring and a mattress, said good-bye to Elizabeth, Lizzy, and Honey, the loyal yellow lab to whom I'd become hopelessly attached, and toted our suitcases "home." Two weeks later, a dead body was found a block and a half up the street, shot in the head, and dumped on the curb. In August, four weeks after that, came the biggest natural disaster in the country's history. So much for a settled life.

5

IKE MANY PEOPLE in New Orleans, I had not paid a whole lot of attention to the increasing likelihood that Katrina was heading our way. I was, as usual, far more focused on the house: There was the refreshing fact that my new team of outside painters, the hilarious Joe Wallis and his right-hand man, Freddy, was doing an excellent job, and the enduring fact that Eddie's team was not. (On the Friday before Katrina's arrival, his outdoor guys had laid the stones for the front walk—but at the wrong elevation, a fitting, for them, swan song, which meant it was no longer possible to open the front gate.) Also, we had already been through one hurricane (Cindy, who arrived in early July was upgraded from a tropical storm to a hurricane after the fact), and evacuated for another—but only as far as the downtown Marriott. Even before we checked in, it was clear that Dennis would bypass New Orleans and bear down on Pensacola instead, but we had paid in advance (the rule during hurricane season) and I was eager to try out the hotel's heavily promoted new down bedding. It did not disappoint—our weekend on Canal

Street was the closest thing to a holiday we'd had since the renovation began.

As pleasant as that particular "evacuation" turned out to be, I remember thinking: There is no way this city can keep beating these odds. Just one season earlier, the Florida Panhandle and the Alabama coast had been pounded with no less than four catastrophic storms—Charley, Frances, Ivan, and Jeanne—and now Dennis was dealing another blow. In the years since I'd first arrived in New Orleans, we had dodged the bulk of Andrew's heavy artillery, and Opal and Georges had missed us altogether. Since then, the warmer waters in the Gulf had made hurricanes not just more plentiful but a lot more powerful. My father, a successful but prudent gambler, had warned me long ago that the house always wins. In this case the house was nature and there was no way our luck could hold.

As moments of clarity go, it was a brief one. It had taken me more than twenty years to decide to commit to a city—the daily imagining of its destruction (not to mention the destruction of a house into which we'd just sunk pretty much everything we'd ever had) was hardly a recipe for sanity. For years the nightmare scenario of "the big one," a Category 4 or 5 storm barreling straight up the Mississippi from the Gulf, had been played out in series after series in the newspaper and on television, with lurid graphics showing the "bowl" that is New Orleans completely awash in floodwater and petrochemicals—"a massive tomb," they'd always say, containing dead by the tens of thousands. Most of us watched with a half-wary eye and went on about our business, having already made the necessary bargain that living in New Orleans requires: the decision that the city's ample charms outweighed the peril. And anyway, what could we do about it?

Certainly no one at any level of government was doing much. Over the years, millions had been squandered on disaster models and,

most recently, on a simulated Category 5 hurricane named Pam, but at the start of every season, the only truly serious discussion involved the evacuation traffic flow plan that, invariably, had been botched the year before. Politicians could get impassioned about the traffic because voters got extremely impassioned about being stuck in it. It's a whole lot harder to summon outrage about something that hasn't happened yet, so basic stuff, like coming up with the means to evacuate those unable to leave on their own (almost 80,000 households in pre-Katrina New Orleans were without a car) was never addressed. Nor did anyone bother to check the only structures that lay between us and certain inundation—the levees and floodwalls—even though residents whose homes backed up to the 17th Street Canal (and which, therefore, are no longer in existence) had been reporting standing water in their backyards for more than a year. On a national level, three months prior to Katrina, the United States House and Senate, including every single one of Louisiana's representatives, had signed off on an obscene highway bill whose 6,000-plus pork projects cost $24 billion—more than enough to pay for both the wetlands restoration and Category 5 levees needed to protect New Orleans and its port, the country's leading gateway for coffee, rubber, and imported steel.

The port, and much of the rest of the commerce vital to the area—and to the nation—is, of course, directly dependent on the same water that puts us at risk. (Louisiana's wetlands produce 25 percent of the nation's oil and gas, and a billion pounds of seafood annually, hence the seemingly contradictory, and slightly scary, moniker of the Shrimp and Petroleum Festival that takes place in Morgan City every year.) The Mississippi pushes 300,000 cubic feet of water past the city every second, Lake Pontchartrain is so wide it is crossed by the longest overwater bridge in the world, and the Gulf of Mexico lies just 100 miles below us. We're surrounded, which is the reason Bienville's

engineer was so adamant that he move New Orleans, as well as the reason that Bienville refused to budge.

But the Gulf, the river, and the lake are hardly our only source of hydration. Roy Blount says he thinks the reason New Orleanians traditionally have taken "the threat of inundation so lightly" is not merely denial, it is that the city is "so moist as a rule." He has a point—the humidity is so dense it is often hard to differentiate between the air and the water; it rains so much and the drainage is so bad that there are mini-flash floods all the time (during one of them, the car I was driving floated into a canal and I was forced to save myself by swimming out the window).

Not only are we more or less constantly saturated, we have always had a more intimate relationship with death than the residents of any other place in the country, a fact which engenders a certain amount of fatalism. In 1853, six years after our house was built, 8,000 people died in one of the yellow fever epidemics that were a constant throughout the century; as late as 1914 there was an outbreak of bubonic plague. Graves lie above ground in gleaming white "cities of the dead" because the water table is so high that bodies buried below ground would simply pop back up.

The coroner, Frank Minyard, who is also a jazz trumpeter, attributes our abysmal life expectancy rates to our "killer lifestyle," and it's true that we are home to the fattest people in the country, we've had highest cancer rates since the 1930s, and we drink—a lot. Legendary restaurateur Ella Brennan says we drink so much because we start so early: "Drinking a Ramos Fizz or a Sazerac with breakfast is considered normal behavior." Not only is liquor available twenty-four hours a day, seven days a week in barrooms (pre-Katrina there were 1,500), restaurants, grocery stores, and pharmacies, it is also conveniently obtained from drive-through daiquiri shop windows, thanks to an exemption in the state open container law that

makes it okay to drink and drive as long as the alcoholic beverage is frozen. I take Minyard's point—there's no question that sucking down a 32-ounce White Russian daiquiri while barreling down I-10 can be construed as a killer lifestyle choice—but we are also cursed with killers of a more straightforward kind, the ones who carry guns. And, unlike other cities, where violent crime and gang activity goes on out of sight of much of the populace, New Orleans is fluid in more ways than one—"nice" neighborhoods abut "bad" ones throughout the city, so that even the occupants of the grandest of houses are not immune to the sounds of gunshots in the night, or indeed, to the sight of a dead body dumped on the curb.

All this has contributed to something of a survivor's mentality. When the city fathers printed up a batch of bumper stickers bearing the message "New Orleans: Proud to Call It Home," another batch appeared within days: "New Orleans: Proud to Call It Hell." There is a sort of perverse pride the natives take in living in a place that "the big one" may well hit one day, as well as an ingrained rebel defiance. (When the occupying Union troops of General Benjamin "Beast" Butler arrived in New Orleans in 1862, the ladies of the city responded by spitting on them and dousing passing soldiers with buckets of sewage from their balconies.) Seven years before Katrina, when the likelihood of Georges led the mayor to open up the Superdome as a shelter for the first time, the paper carried photographs of patrons in Magazine Street bars wearing hardhats, and the first commodity to run out at my neighborhood grocery store was not water or even batteries, but vermouth. McGee, who had holed up in her French Quarter apartment with a stranded Australian sailor and a case of bourbon, kept calling me in New York to tell me I was missing all the fun. By the time Katrina reared her monstrous head, John was fifty-six years old and had lived in New Orleans for most of his life, but he had never once evacuated for a storm. During Betsy, a

powerful Category 3 hurricane that killed 58 New Orleanians in 1965, his uncle held him by his feet out a third-story window so he could unclog the gutters that were pouring water into their house.

So it was that on the Saturday before Katrina I was busy making a grocery list, not for hurricane supplies or evacuation needs, but for our first dinner party on First Street. Our friends Byron and Cameron Seward, who live in Yazoo City, Mississippi, and have a house in the Faubourg Marigny, just below the French Quarter, were in town with their daughter Egan, a former summer assistant of mine who works as a decorator in New York. Byron farms cotton and soybeans and corn for a living, but he is also a serious wine nut, and all summer long he had been assembling a collection of rosés in hopes that we might actually be able to sample them—in our house—before the summer was over. I love cooking for Byron because he gets so into it and I'd planned several courses, including a lobster spaghetti John and I had eaten in Sicily that I was determined to replicate.

The first sign that something wasn't quite right was the fact that I immediately found a parking space in the always nightmarishly congested Whole Foods parking lot. Then, on my way home, I noticed people waiting in long lines at gas stations—the ones that were still open, that is—while the roads themselves were mostly clear. When I walked back in the house, the phone was ringing. My mother, a steadfast watcher of television (there is one in almost every room of my parents' house, which would prove to come in handy later) and a world-class worrier, was calling to tell me that we needed to start driving to Greenville immediately. "I am not kidding, Sister," she said, using the only name she ever calls me (and which is pronounced "Suhstuh") unless she is really, really angry. "This hurricane is coming straight at you." Elizabeth, with whom I'd endured a tortuous evacuation during the Ivan false alarm (maximum speed of five miles an hour for the first four hours, coupled with a vomiting

Honey), was next. There was no way, she said, she was she was going to get stuck in that traffic again (no one had any faith whatsoever that the new traffic plan would be any better than the last one). "We're leaving now," she announced, adding that McGee would not be far behind them.

Despite all signs to the contrary—chief among them the fact that John himself announced that we were evacuating Sunday no matter what—I was somehow convinced there was still time for the thing to change course before we actually had to leave. Not only did I not want to consider the long-term implications, I did not, in the short term, want to abandon the live lobsters I had just stuck in the refrigerator or cope with tying down the thousands of potential projectiles that littered the construction site that was our yard. I was much relieved when, astonishingly, Eddie called to say he would take care of everything outside, and Byron and Cameron called to say that if the dinner was still on, they were coming. Egan's plane did not leave until the next morning and all the earlier flights out were suddenly booked.

So when Rose called I did not have to pretend to be calm. Rosemary Russ, who had worked for me for years keeping house, and who, along with her whole family, had come to Greenville to cook and serve all the food at our wedding (as they do at almost all my parties), is a phenomenally skittish woman. During the thunderstorms that are daily occurrences during New Orleans summers, she steadfastly refuses to answer the phone, convinced she'll be electrocuted through the receiver if lightning strikes the power lines. I told her that if things stayed like they were, we were leaving the next day. "You better call me if you go a minute earlier," she said, and I promised that I would.

The night turned out to be lovely—prehurricane weather is always clear and breezy, and the impending doom we still did not

take entirely seriously had us all feeling a tiny bit braver and more alive. Byron had gotten us an extravagant housewarming gift, a case of Billecart-Salmon, at about the same time we'd moved into Elizabeth's, and he was as relieved to finally unload it as we were to finally be in the house. We hung out in the kitchen, toasted the new growth on the live oak tree Benton's guys had recently planted, and munched Spanish almonds and tuna *tapenade* on toasted slices of baguette. By the time we sat down to the spaghetti, Byron, whose life's blood is the weather, and John, who had talked to a geologist friend monitoring offshore rigs in the Gulf, both predicted the storm would jog to the east at the last minute; we would be prudent and leave, but we would not worry. Instead, we drank more wine and lingered merrily at the table, and then John and I hiked up to the third floor, where we slept like babies in a new down-covered bed of our very own.

The next morning was not so jolly. Eddie failed to materialize and sent Abel instead, who stayed just long enough to nail some plywood over the big sunroom windows before jumping into his truck and roaring away. I closed and lashed all the shutters, dragged ladders in from the balconies, and cleared the flat roof of the many jagged pieces of marble that surely would have punctured the roofs of half our neighbors, while John got started in the yard. By the time we were done, we had tied down at least a dozen more ladders and filled the shed with random pieces of lumber, wheelbarrows and shovels, piles of brick and pieces of stone. There was not a whole lot we could do about the Bobcat or the cement mixer. We just hoped they wouldn't end up in somebody else's living room.

It was an endeavor that would have gone a lot faster had we been able to avail ourselves of the considerable strength and energy of Antoine Jones. Antoine had worked for me for the past nine years, but for the last four days he had been AWOL, a state of affairs that was not entirely novel. He is an addict and homeless by choice, which

meant that he'd be perfectly fine one day, and the next, with no warn-ing—and no way to call him—he'd simply fall off the face of the earth. Sometimes I'd hear from him, hyped up, talking too fast and too loud into a pay phone receiver from God knows where, full of ex-cuses and promises to see me "tomorrow, Julia, I swear." His mother had died on four different occasions during his time with me, and she may well have been dead to start off with, I will never know. I realize that most sensible people would have long ago dropkicked Antoine to the fates and gone in search of a more reliable helper, but he remains the hardest worker I have ever known—as well as one of the sweet-est and funniest people. The truth is that when he fell off the map I missed him. I'd huff and puff and do my own swearing that "this is it, I mean it this time" but after about three or four days, I'd look at Rose and she'd get out the phone book. If we were feeling optimistic, we'd check first with the Quarter Laundrette, a "washateria" on Bourbon, where he hung out occasionally and kept some of his things; the last call was always to Orleans Parish Central Lockup, where Rose was on a first-name basis with the receptionist. More often that not he was in jail, having been picked up for public drunkenness or possession of crack, only to emerge thirty days later like clockwork, rested, con-trite, and ready to get back to work.

Antoine had come into my life when I hired him to move me from my Royal Street apartment to Bourbon, and I knew we would get along famously when he didn't look at me like I was a lunatic after I showed him the big pots of Confederate jasmine on my balcony and asked him to help me unwind every strand of every plant from the iron railings they had taken over. I couldn't bear the thought of hack-ing them off at their bases for the sake of expedience, and Antoine, who wouldn't hurt a fly, was at least as tender with them as I was. But it was a brief honeymoon—by the end of my first week at Betty's, he had called three times between midnight and two in the morning

asking for ten dollars. The third time he told me he needed the money because he had a "berl" (otherwise known as a boil) on his "butt" that required immediate lancing. In a rare fit of good judgment, I told him never to call me again.

I didn't see him for two years, by which time the house was overdue for a major cleaning and I figured no harm would come from hiring him for a few days at most. I put out some feelers, he turned up, and we worked side by side for a week, after which my long dependency began. Antoine was a year younger than I, and while not as tall, he was wiry and strong, with a sharp, if uneducated mind. (At one point it dawned on me that he could barely read, but he was so careful about hiding it, I never wanted to put him on the spot—the only grocery store I ever sent him to with a list was the neighborhood Matassa's, whose delivery boys kept half the alcoholics and crazy people in the Quarter alive, and where I knew they would artfully fill the order for him.) Over time, his skill set expanded greatly. He had always been able to lift anything (I once saw him carry a sofa down two flights of stairs on his back); and he was an ace cleaner, but he also learned to repair antique furniture and polish silver, and he became an expert gardener. He was my second set of eyes whenever I hung pictures or rearranged rooms, my enforcer when it was time to straighten up my office and dump files, and he invariably knew what I wanted before I did, handing me this tool or that handbag. Once I even pressed him into duty as a bartender.

He'd turned up at my gate on a Saturday morning after a bender, having been gone for two days, looking like a mess and begging for cash. I was about to throw him out when the phone rang—unexpected friends from New York and London were at the airport and on their way over. As was frequently the case, I went from wanting to kill him to viewing him as a godsend in a matter of minutes. He cleaned himself up first, tidied the whole house and the courtyard, and was

done in time for me to teach him how to make Bloody Marys. The guests were rowdy and thirsty and Antoine was doing great, but I had forgotten that he took pretty much everything I said literally. When I told him to "keep the drinks coming," he thought I meant exactly that; at one point I looked around and saw that everyone had four or five full glasses at their elbows, each one perfectly garnished with a leafy celery stick and a wedge of lime.

On the days Rose came, they laughed and smoked together and flirted like mad, keeping a standing weekly lunch date at Hula Mae's, where Rose did the laundry and Antoine brought over shrimp po-boys or fried chicken. Between the two of them, they knew every detail of my personal life, which, in the beginning of their tenure, included A., the man they called the "president," until he was "impeached" by John, whom they had been rooting for. Rose has a very proper common-law husband named Thomas, and Antoine teased her about him relentlessly, but he looked up to her and carried his version of a torch. "That Rose is something," he'd say, shaking his head and grinning, but after he walked her to the bus stop at the end of the day, they went to entirely different worlds; hers included a stable relationship, an apartment, a close family, and an education. Still, what Antoine lacked in knowledge, he made up for in curiosity. At least once a week, he'd fix me with the quizzical look I came to know well: "Say, uh, Julia, what is that?" Invariably it would be a crazy white-person thing that amused him to no end, like the leftover take-out sushi in the fridge or the mad Mardi Gras headdress I'd made by glue-gunning dozens of butterflies and birds' nests onto a homemade tiara of branches. But before long, he'd be practicing with my chopsticks and bringing me the abandoned nests he found in the garden.

We buried dead birds together and shook our heads over the frequently broken eggs of the mourning doves, never very smart about the spots they chose to lay them. In the mornings, he brought me

coffee and the papers from Matassa's, and the only things he ever lied to me about are what all addicts lie about—where he'd been and if he was using—but he never stole a thing from me or anybody else and I trusted him with everything I owned, including my car. There were plenty of crack heads in New Orleans who would do anything, steal anything—kill anybody—for a single fix, but Antoine was the equivalent of a social drinker. The problem was that the great majority of his acquaintances, "Spaceman," say, or "Cowboy," were derelicts and whenever he ran into them, he was incapable of sharing a beer or two and going on about his business. One beer would lead to ten; one hit on a crack pipe would lead to a serious downward spiral. His shelter of choice, the Ozanam Inn, served as the discipline he knew he needed, which is why he chose to spend his nights there, as opposed to a place of his own, which he easily could have afforded. At the Inn, no one is allowed in after seven P.M. and nobody gets past the door high. One missed night in the shelter usually turned into many nights of carousing, which almost always turned into jail time. The police not only recognized him as a small-time drug offender, they also knew he was an easy, nonviolent arrest. Antoine had never even owned a pocketknife. I am convinced they kept their eyes open for him.

It was a heartbreaking routine but one we all, especially Antoine, became inured to. His thirty-day stretches in lockup were like particularly unpleasant versions of the classic twenty-eight-day rehab model; when he was freshly out, clean, and determined not to end up back in jail, the shelter was his halfway house. There were showers, a hot dinner and breakfast, and a TV on which he watched his favorite shows (he loved Andy Griffith and most everything else on Nick at Night) with the other regulars, some of whom he counted as friends of sorts. It was hardly a life that anyone could adhere to forever, but for Antoine it was how he had worked out staying alive. In

the beginning, I used to go over apartment ads with him in the newspaper, offering to set him up, explaining—a bit pompously, I realize now—the kind of life he could have. Embarrassed, or maybe just sick of the spiel, he'd smile and say sure he wanted to get a place, but when it came time to follow through, he always dodged the issue.

His worst enemy, other than himself, was Cassandra, a toothless whore and serious crack head with whom he professed to be deeply in love. She was, thank God, behind bars far more than Antoine, but when she was out they often stayed together with one of her dodgy relatives, a state of affairs that prolonged Antoine's benders because he was mostly hidden from view of the cops. Cassandra weighed maybe eighty-five pounds soaking wet and looked to be seventy if she were a day, but it emerged that she was still of childbearing age when she gave birth to a son she said was Antoine's while doing time in the women's prison for prostitution and crack possession. She was aptly named and a master manipulator, and Antoine, who had the emotional maturity of a fourteen-year-old, was gullible as hell—he never questioned his paternity for a minute. But I was not much smarter. When mother and child got out of jail just before Christmas, I went to Kmart at Antoine's request and spent a hundred and fifty dollars on a stroller complete with all the latest bells and whistles. He had wanted to convince us both—him and me—of his best intentions, yet a full year later Rose spotted it, still in its box, stashed with the rest of his things at the Quarter Laundrette. When I finally saw the child, he had the tragic wide-set eyes of a crack baby.

On that morning before the storm, I had long since gotten over being mad at Antoine for not showing up. I just wanted to find him and put him in the car with us, or, failing that, to ensconce him on the third floor with plenty of food and water and batteries. While I made turkey sandwiches and cleaned out the refrigerator (a project that took about two minutes since we hadn't been in the house long enough to

accumulate anything besides pickled okra, mustard, and Champagne), John made one last pass by all of Antoine's usual haunts. I called Rose, but she was long gone, and when I checked on her mother, Roseanna, she had left too. Byron and Cameron called to report that the airport, with mobs of people panicking and begging to get on planes, was a full-blown madhouse—Egan's 11:30 JetBlue had been the last flight out, and now they were on the road back home to Mississippi.

When John came back, without Antoine, there was nothing left to do but leave. We had a brief back-and-forth about the garbage, which was full of lobster shells: should we put it outside, where it would be another projectile, or inside, where it would surely stink up the place? In the end, we settled on the latter, since we'd already assured ourselves we'd be gone maybe two or three days at the most, the same operating principle that had guided our decidedly casual approach to packing. I had thrown my makeup, a couple of pairs of pants, and some T-shirts into a straw tote bag, left most of my good jewelry in a drawer, and all the things prudent people have at the ready—important household and tax files, treasured letters and photographs—on the floor in the boxes they were still packed in from the move. On the way out the door I grabbed my laptop and a few of bottles of good wine, and John grabbed the cooler with our sandwiches. We left his beloved white Mercedes on the street (after complicated calculations about where branches were most likely to fall), got in my big boat of a Cadillac Deville (a hand-me-down from my father), and pulled out of the drive at one in the afternoon, three hours after the National Weather Service issued a bulletin predicting "catastrophic damage" to the city, and three and a half hours after Mayor Ray Nagin called for the first mandatory evacuation in New Orleans history.

It was in the car that I ceased to be quite so sanguine. Roughly a million people ended up leaving the city before Katrina made landfall

and we were traveling with what seemed like half of them. It took us four hours to go thirty-five miles—the evacuation traffic plans from the year before clearly had not been improved much, since inbound traffic lanes were completely devoid of people trying to enter the city, but still not open to those of us trying to get out. In the first hour we split a sandwich and were vastly entertained by the antics of the dogs and cats and birds crammed into people's cars and trucks along with what looked like a lot more belongings than we had bothered to bring with us. I checked my cell phone messages and found that I'd missed one the day before from the angelic Mr. Dupré. He had gotten hotel rooms in Houston for his family and all his workers—did I want them to come by and help me secure the yard on their way out of town? The call only served to make me twice as mad at Eddie, who was our actual contractor after all—the stuff in the yard didn't even belong to Mr. Dupré.

When I got done with one of my more inspired Eddie harangues, there remained three more hours of sitting in an essentially immobile car, during which time I discovered all manner of other stuff to freak out about, including an enormous English oil portrait of a young cricket player and a Chinese Chippendale sofa that had belonged to my great-grandmother, as well as the aforementioned Regency benches. Suddenly, irrationally, I was convinced the house was going to flood. "We should have dragged those things upstairs," I moaned to John, adding that we'd been irresponsible and lazy and that if anything happened to that painting or that sofa, both of which my mother had wrangled from her sister on my behalf, she would kill me. John patiently explained to me what I already knew: that the days of the unfortunate Mr. Livaudais were over and those levees would hold; that like the Quarter and the other parts of the city's early footprint, the Garden District was on high ground, eight feet above sea level, which is why people had chosen to build there in the first place.

Anyway, he said, there is no right answer. If we'd taken the stuff to the second floor, it would surely be destroyed if the roof blew off or even leaked badly.

Next up was our flood insurance. I remembered seeing the renewal notice in the mail but I didn't remember if I'd given it to John, much less if we'd paid the thing. "You're sure we renewed it?" I asked him at least twenty times, and at least twenty times he responded that we absolutely had, before adding what he'd just finished telling me, that the house was not going to flood. Once convinced, I moved on to Antoine. "What if something happens to him?" Antoine is a survivor, John said, nothing is going to happen to him. "Yes," I said. "But Nagin only announced the Superdome as the 'shelter of last resort' this morning. What if he doesn't know to go there?" He will know, John said, he will hear it on the street. "Okay, but what if he got picked up? The jail is not on high ground. What if he drowns in that place?" He won't drown, John said, because he's not in jail. Didn't Rose just call yesterday? Didn't they tell her he wasn't there?

I had to concede that he was right on all points, and I knew I was driving him at least as crazy as I was driving myself. It was, therefore, a great relief to both of us when we arrived at the "secret" shortcut Elizabeth and I had discovered during our Ivan evacuation: a series of two-lane back roads she knew from Katie's prolific soccer and volleyball playing days, all marked with blue-and-yellow signs saying "alternative hurricane evacuation route," which no one, apparently, had noticed. All of a sudden, we were practically flying, going fifty and sixty miles an hour through leafy little towns whose gas stations still had gas and whose stores sold beer on Sunday. There is nothing like an unexpected ice-cold Budweiser to lessen life's anxieties, and nothing like other peoples' real problems to stem one's own neurotic tide.

We had switched from Louisiana to Mississippi Public Radio and

if John was right about the storm jogging to the east, the people we were listening to would almost certainly be wiped out. When the mayor of Waveland, a Mississippi Gulf Coast town of about 6,700 people, was interviewed, I almost burst into tears. It had already been destroyed once, by Camille in 1969, he said, but unlike his neighbors, who'd been enjoying the considerable economic benefits of thriving casinos, Waveland's economy was just now beginning to rebound. Only last week they'd broken ground on a Lowe's building supply store, a big deal that would bring forty-something new jobs to the community. I prayed that man would be all right and started counting my blessings. We were not, for example, in the Superdome, or looking for an available hotel room as far as five or six hundred miles away. We were heading instead toward safe and extremely comfortable harbor with people who loved us.

I turned into my parents' long gravel driveway in Greenville almost twelve hours after we'd left New Orleans, roughly three times the normal journey. Even though it was well after midnight, my mother and father were waiting for us in the kitchen, where the TV, predictably, was on. We hugged and kissed and carried what little we'd brought with us back to my brother's old room, and John repeated his belief that New Orleans would be spared the brunt of the thing, an assessment with which my father agreed. "You really think it's going to jog to the east?" I asked one more time, just before we dropped off to sleep. "Yes, I really do." Early on in our relationship he had told me a little white lie to make me feel better about something, and when I realized what he'd done I got so mad I threw an orange at the wall behind his head. From that moment on, he'd given up trying to spare me any realities, harsh or otherwise, and it had never been in his nature to shoot from the hip, so I believed him. When the alarm woke us the next morning (we had set it for 6:30, just after the predicted landfall), it turned out he was right.

∾ 6 ∾

I N WHAT WOULD turn out to be a fairly constant tableau for the next several days, the four of us huddled with our coffee in front of the kitchen TV, which was set, at my father's insistence, on Fox News. Shep Smith, a good Mississippi boy, was manning the mike from New Orleans, but there wasn't much to look at beyond still-dark scenes of a soaking-wet Bourbon Street and the blown-out windows of the Hyatt Hotel several blocks away, where the mayor—along with some of our crazier friends—had chosen to ride out the storm. There was relief, of course, but also the inevitable guilt. When you dodge a bullet, it usually means someone else has taken it, and the scenes of destruction from the Mississippi Gulf Coast were increasingly horrific. Before the day was over, we'd learn that not a single structure in Waveland had been left standing.

What we would not learn until the next day is that the levees in New Orleans were already giving way and that the flooding of 80 percent of the city (145 square miles—an area almost seven times the footprint of Manhattan) had begun. At that point, like everybody

else in America (except, as it turns out, the FEMA director's assistant, among others), we were still under the happy impression that the worst thing that might happen was the mayor getting rained on in his otherwise comfortable hotel room. Also, given the fate of our neighbors on the coast, things like the possible ruination of a green silk Chippendale sofa had ceased to be even a remote preoccupation. In any event, there was nothing to do about any of it—our Louisiana cell phones weren't working and all the long distance circuits were busy. After the overwhelming pressures of the house renovation (and the normal but constant pressures of work), the state of being completely incommunicado, as well as utterly powerless, was an unexpected luxury. I'd spent an entire year obsessing over things like whether the front door mail slot should be unpolished brass or dark bronze and going insane over the improper placement of doorknobs; now there was absolutely nothing I could even try to control. So we took a holiday of sorts, settling in at the kitchen table while my mother turned her attention to people who were actually in need.

My mother has been referred to more than once as the patron saint of Greenville, Mississippi, a description that is only slightly hyperbolic. She tutors in the public schools and mentored for years at the Salvation Army, where she was assigned dozens of "Girl Guards" with whom she still maintains close relationships. She has been president of the Boys and Girls Club, the Junior Auxiliary, and the Garden Club, where she turned her considerable energies toward helping to save a bald cypress grove from extinction. She was the second woman to be elected an elder of the First Presbyterian Church, where she also teaches Sunday School and runs the annual fundraiser that benefits, among others, the Palmer Home, from which we took in an orphan every summer. When I was in grade school, the neglected children of one of her Junior Auxiliary families (their mother was an alcoholic named Mrs. Crumley who traded the family's J.A.-provided

milk for whiskey), always seemed to be in my bathtub, where she sponged them down with pHisoderm to soothe their chronic impetigo; a few years later, when the first wave of post–Vietnam War refugees landed in America, a family of seven named Muon lived in our pool house for a year. Now she had taken on the task of feeding the several hundred evacuees who had bedded down on the floor of the local convention center. At one point during that first day, I left the kitchen and returned to hear her on the phone, working up a menu for the multitudes: fried chicken, baked beans, sliced tomatoes, fruit, and two desserts, "so they can save one for later." I knew better, but I had to ask: "You are going to peel and slice fresh tomatoes for almost a thousand people?" (She always insists on peeling her tomatoes, an admittedly refined but slightly obsessive extra step that never ceases to blow my mind.) She looked at me like I was the one who was crazy. "Yes," she said. "You cannot believe how pretty the Arkansas Travelers are right now."

By nightfall, the storm had knocked out power lines as far north as Greenville, so we decided to try our luck at Doe's Eat Place, the legendary, if slightly ramshackle, former grocery store and honky tonk that serves the best steaks and fried shrimp I have ever eaten anywhere. The first photograph of me ever taken, when my mother was still pregnant and sitting on the wooden front steps, was there; I celebrated my fortieth birthday in the "side room" (there's a sign above the entrance designating it as such, just in case anyone is confused), and when John and I got married, friends took over the whole place for a party two days before the wedding. Since Doe's stove and ancient open broiler are both powered by gas rather than electricity, my mother predicted they would come through for us yet again, and sure enough, when we pulled up outside, I could see Little Doe at his post just inside the screen door, flipping succulent sirloins and porterhouses over the leaping flames. Inside, it was as packed as always, but

the party atmosphere was heightened by groups of similarly relieved Greenville émigrés to New Orleans (many more had made the trek since the Percy brothers first decamped), and by the cheap dimestore taper candles, leaning rather frighteningly at an angle inside empty water glasses, where they temporarily replaced the usual fluorescent bulbs as light sources. Though there has never been a printed menu, we ordered pretty much everything that would have been on it: salad and hot tamales (a Delta tradition, and made here with beef suet and steak trimmings), fried shrimp and broiled shrimp, rare porterhouses, homemade French fries, and toasted garlic bread. Between bites we visited with folks at every table, drinking to our good luck with a handful of the red Burgundies I'd thrown in the car when we left. When we got home, we were stuffed and happy and ready for bed, which we found with the help of a flashlight.

The next morning, the electricity—which meant the television—was back on, and well before seven, Mama was banging on our door. "Get up. The whole city is under water." Now I really, really love my mother, but she is prone to serious exaggeration, and the only reason I did not go back to sleep was because the chance to tease her about what was surely an overreaction, a primary pastime of my father and my two brothers and me, was too good to miss. Except that this time there was no making fun. The "whole city" may not have been under water, but we could see enough already to figure out that plenty of it damn sure was. I grabbed a cup of coffee and took my position in the huddle while we watched the biggest man-made disaster in the history of the country unfold. At eleven o'clock, wine replaced coffee as the beverage of choice. When Mama asked if we thought it was too early to open a bottle of wine, no one bothered to answer—by the time I pulled the glasses down from the cabinet, she had already retrieved the wine from the fridge. The tortuous slow boil had begun.

By Wednesday, the water was no longer rising (stopping, finally, just nine blocks across St. Charles from our corner), while scenes of rampant looting gave us something different to worry about. Reports of attacks on rescue helicopters sounded like scenes from *Black Hawk Down*, and fires raged out of control less than three blocks away from our house. Almost every hour brought a new fear, but our worst ones were assuaged when my friend Bob Rue, an Oriental rug dealer who had stayed in the city, left a message at my father's office via his ancient BellSouth landline: "House looks okay. Tell them I'll be watching it." I'd met Bob long before I even moved to New Orleans—he'd sold his rugs at the garden club antiques show my mother had helped put on for years, and they'd become big buddies. Every trip, he declined the hotel room the club offered to provide for him, choosing instead to sleep on the floor in the convention center, much as the evacuees were doing now, on top of his rolled-up rugs. It turned out to be good training—in the days following Katrina, he alternately camped out in his shop on St. Charles and on the porch of his girlfriend's house in the Garden District—all the while acting, as I would later discover, as a one-man neighborhood posse.

Our house might have been okay, but there was no shortage of bad news. Conditions at the still crowded Superdome and convention center were beyond hellish, and so many people had been stranded on one particular stretch of the I-10 overpass for so long that a clearly sleep-deprived Shep Smith resorted to repeating the name and number of the closest intersection over and over again, in case anybody in any position to help was watching. Charmaine Neville, the singer and daughter of Neville Brother Charles Neville, told of being raped at knifepoint before driving a commandeered bus filled with other terrified citizens upriver to Baton Rouge. Charmaine's estranged husband, a musician who sometimes painted with McGee, had put up the third version of blue in our dining room, and I started

obsessing about the sorry condition of his truck, which I knew could never have made it out of town.

I started obsessing about a lot of things—Antoine, of course—but also why in the hell the levees had broken when the storm had turned out to be a weak Category 3. (My father, who had been a surveyor for the Corps of Engineers when he was a kid, and, later, the owner of a barge and towboat company on the river, stood in front of the screen as helicopters dropped countless—and fruitless—sandbags into the breach at the 17th Street canal, shaking his head and bitching about the politicization of the Corps. "They should not have broken," he said more than once, confirming with some authority what I already thought.) Then there was the question of what on earth had made the majority of Louisiana's electorate vote for Kathleen Blanco, who had not yet managed to call out the National Guard, and who appeared on the screen far too often, patting her hair and asking everyone to pray. At one point, the governor angrily told a reporter she had no idea what day it was, so I did pray—that she would cease to go near a television camera for the duration of the crisis. The mayor had already lost it on the radio, and when Bush finally turned up after his initial flyover, he told "Brownie" he was doing a "heckuva job." In the face of all that, plenty of people besides us were forced to resort to wine—and whiskey too, as it turned out. On Wednesday, when John and I went to our favorite local liquor store, the Cask and Flask, to restock our dwindling bar, there wasn't a bottle of Scotch left in the place.

Meanwhile, those of us more firmly rooted in reality than our elected officials had already gotten back to work. I had assignments from *Newsweek*, *Vogue*, and *The Spectator* in London—there is nothing like being a resident of a disaster zone to make one popular with one's editors. And then there were the standing assignments I somehow had to find the focus to finish, like a profile of Reese Wither-

spoon, who had been thoughtful enough to email *Vogue* to ask if I were okay. John, who is managing partner of his law firm, was charged with temporarily relocating the entire practice to Baton Rouge. So I started typing while he stayed on the phone, tracking down the lawyers and secretaries and paralegals, finding office space and lining up furniture. Both tasks were made easier by the efforts of my father, who, as soon as it became evident that our evacuation wasn't temporary, arranged for two new cell phones on a network that was working, as well as wireless Internet, a printer, and a second landline in my youngest brother's room, which became my office.

If Mama is Mother Teresa, Daddy should have been FEMA director. He thrives in a crisis and his political instincts are infallible. (In the aftermath of Camille, Richard Nixon became the first sitting president since Teddy Roosevelt to set foot in the state of Mississippi thanks to his advice, which Bush would have done well to heed. "If you're not going to stop, don't bother to fly over," my father told White House aide Bryce Harlow. So Nixon stopped—and in the next election he carried Mississippi with the widest margin of any other state.) Every day at noon he'd call from his office and ask, "What you need, kid?" before arriving home with the day's *Wall Street Journal* and a helpful new surprise: a stack of legal pads, a stapler and some Post-its, and, best of all, a checkbook from the local bank with my name on it. "There's five thousand dollars in there," he said as he slapped it down on my brother's old bed. I almost fell over. He may be efficient, but he is notoriously unextravagant. It was the strongest evidence yet that these were desperate times and a fine alternative to the real FEMA. McGee, who had already decamped for Tennessee, reported that she had actually stood for hours in a FEMA line before being told that since she had insurance she was ineligible for any immediate relief.

Not that she needed any. McGee was ensconced in the empty

Nashville house generously offered by her friends the rocker Steve Winwood and his wife, Genia (she and McGee had gone to boarding school together), and she'd found work with a local decorator. But she was not the only one with places to go. By Thursday, John and his office manager had miraculously gotten the firm's move squared away, and after a quick shopping trip that enabled him to look like a lawyer (all he'd brought with him were jeans, Nikes, and a couple of shirts), he drove to Baton Rouge, where he moved in with my cousin Linda Jane and her husband, Scott. Also, since no one had any idea when the New Orleans schools would reopen, Lizzy had enrolled in boarding school—Elizabeth had allowed her to go online and choose one on her own, and she found one she liked, St. Margaret's in Virginia.

So on Friday, five days into it, things were pretty quiet when the phone rang in our house. It was early evening, Mama and Daddy were both out (he at a meeting, and she, naturally, at the convention center feeding giant casseroles of eggplant Parmesan to the folks still there), and I was about to pour a drink (by that time we had procured more Scotch) to celebrate having finished two of my assignments. When I picked up the receiver, a vaguely familiar male voice on the other end asked if he had reached the Reed residence. I said yes, so he identified himself as Leon Pearce and explained that he was looking for John and me. It took a second to register, as Leon is the rarely used formal name of John's older half-brother Skeet, a retired San Diego motorcycle cop who lives part of the year in a tent in a state park in Southern California, part of the year in a cabin fifty miles below the Canadian border in St. Marie, Montana, and the rest of the time on the road or in San Diego with his saintly girlfriend Cindy, who accepts all his mail and takes his phone messages, since he is adamant about not owning a cell phone or a computer. I had met him only twice, once in New Orleans and once at our wedding. "Skeet,"

I said, after finally making the connection. "It's me, Julia. Where are you?" I had in mind either California or Montana, but his answer was a tad more dramatic: "the Greenville Inn and Suites."

Since Monday, he told me, he'd been trying unsuccessfully to reach John on his cell, and the overloaded long-distance lines had kept him from reaching our house as well. Skeet's a driver, so he looked at his atlas and discovered that Highway 82 runs from Greenville to Fort Rucker, where his son, just back from a tour in Afghanistan, was stationed. He figured that even if we weren't in town, my parents would know how we'd fared, and once he found out, he'd continue on to Alabama and make a trip of it. When he called, he'd just driven 1,800 miles in two days; I hated having to give him the news that he'd missed John by less than twenty-four hours. "That doesn't matter," he told me. "I just needed to know that he was all right."

As signals go, the fact that Skeet had just driven halfway across the country to check on his little brother brought home the import of the events of the week in a way that even the gift of the well-endowed bank account could not. And the quiet urgency that had propelled Skeet all the way to Greenville made me weak in the knees. Skeet and John and John's two sisters had the same mother, a nurse who was also an alcoholic and a drug addict from whom they'd been removed by their paternal grandparents when John was almost five. A year or so earlier, John's father, a doctor who had gone to medical school and completed his residency in New Orleans, had moved the family back to West Texas, his birthplace, where he planned to open a clinic in San Angelo. But almost as soon as he'd arrived, he was essentially lobotomized in an accident—he ran into the back of a pipe truck that had stalled in an underpass, and when the pipes crashed through his windshield, one landed square in the middle of his forehead. It was an awful, complicated story—when John and I first started seeing each other, it took him five hours and at least as many milk punches at

the Rib Room to get it all out. The one constant in the narrative was Skeet, who had early on acted as a sort of ur–big brother, protecting him as best he could from their mother and her abusive boyfriend. When the situation became unbearable, it was Skeet who led his half-sisters and John, whom he carried most of the way on his back, on a trek of several miles from their house to the bus station, where he convinced the manager to put them on a Greyhound, C.O.D., to Ballinger, the town where their grandparents, along with their newly impaired father, lived.

In the aftermath, it was decided that John should go to Manhattan to live with his Uncle Charles, who was finishing up his own residency at New York Hospital, and his wife, Dorothy, a chemist who worked with Dr. George Papanicolaou, inventor of the Pap smear. They eventually had two sons and a daughter of their own, and when John was in his early teens the family moved to New Orleans, where Charles taught at Tulane and started his practice as a heart surgeon. Despite the physical separation, John and Skeet stayed close, and the first time I met him I was pretty sure I had never encountered anyone so gentle or calm or at peace with himself. John has a lot of the same stillness and self-containment, but Skeet's is seriously profound, and I was not sure how well my decidedly unquiet mind of the moment would handle the dinner at Doe's I'd immediately invited him to. I enlisted Elizabeth to accompany me, but it had been ridiculous to worry—we had a big steak and a really lovely time and Skeet painstakingly recorded our latest two phone numbers in his notebook before pushing off to Alabama the next morning. "Don't you want me to at least try to get John on the phone?" I kept asking him. "No, he's busy. I don't need to bother him." Like everybody else in America, I had spent five days watching gruesome images of death and destruction and desperation, and each new morning brought glaring new evidence of just how inept, callous, irresponsible, and just plain base

a too-big segment of humankind can be. Skeet was a timely reminder of our better angels.

That next afternoon, my father, determined to remain in his jaunty crisis mode, suggested that he drive my mother and me to Lusco's for supper. Lusco's, a restaurant in Greenwood, about forty-five minutes east of Greenville on the edge of the Delta, began life in the 1920s much like Doe's, as a grocery store run by Italian immigrants. (The Delta is heavily populated with citizens of Italian descent since, during one of the many unpleasant chapters in our history, landowners suffering through the acute labor shortages of the late nineteenth and early twentieth centuries lured thousands across the Atlantic with the promise of parcels of land, whereupon they became nothing more than indentured servants or worse.) In the Delta's heyday, no one thought anything of driving forty or fifty miles just to eat and have fun—hell, we went all the way to Memphis for the justifiably famous lump crabmeat in hollandaise at Justine's. It was equally worth it for the broiled pompano at Lusco's and the festive curtained booths, originally designed to facilitate a discreet and relaxed enjoyment of wine and whiskey—unbelievably, Mississippi was legally dry until 1967.

Still, on this particular day, I don't think any of us had bothered to make the trip in more than ten years, but it was a sweet suggestion and we did it. Food, after all, is a much-vaunted comfort, and by day six, I was well on my way toward gaining what became universally referred to among New Orleanians as the Katrina Fifteen. And no wonder. On that first bad night, after we realized that the levees had broken, my mother overcompensated with two-inch-thick pork chops, squash casserole, fried okra, sliced tomatoes (some of those "pretty" Arkansas Travelers, which were, it must be said, delicious), both corn on the cob and cornbread, and homemade blackberry cobbler. Every day for lunch, Frank Lijer, who has worked for my mother

in all manner of capacities for almost twenty-five years, brought in bags of chili cheeseburgers and fried catfish sandwiches from the excellent Abide's drive-in; in six days I'd been to Doe's three times. Then there is the typical largesse of the Southerner when the chips are down—before we even arrived my eighty-nine-year-old next-door neighbor had brought over a basket of muffins and a container of her signature homemade mayonnaise; someone else dropped off a caramel cake.

On Sunday, John came back for an overnight visit and we went to Lillo's, the third of the Delta's venerable Italian restaurants and the site of one of my father's better lines. In the early 1960s, a friend of his and my mother's had recently divorced and he was dating a younger woman, a former beauty queen who did not have a lot to say when they met at my parents' house for cocktails before going out to Lillo's (in those days known as Lillo's Dine and Dance) for dinner. When they pulled up, the music from the jukebox was spilling out into the parking lot, and as soon as the beauty queen got out of the car she started gyrating and carrying on like crazy. The transformation was, apparently, remarkable, and prompted my father to look at my mother and say, "She ain't much in a parlor but she's hell in a tonk."

Lillo's is no longer much of a "tonk," but the jukebox is still there and a live combo plays on Thursday nights. On one wall there are numerous pictures of Marie Lillo, a stage actress who left the Delta to make her fame and fortune in New York, where, judging from the photographs, she also formed a tight connection with Milton Berle. I went to school with Jimmy Lillo, who runs the place these days, and he still serves the best Italian salad I've ever tasted (the secret is the mashed green olives in the otherwise classic dressing), excellent thin-crusted pizzas, and a delicious Delta hybrid, catfish Parmesan. Located in the next-door town of Leland, just about eight miles east on Highway 82, Lillo's is a lot closer than Lusco's, and maybe even

better, so we met Elizabeth and some of her cousins there for an anniversary of sorts—it had been exactly a week since we'd first arrived. Despite the rather grim marker, there was cause at least for slight celebration: my old buddy Ken Wells was in New Orleans running Katrina coverage for the *Wall Street Journal* and he had been thoughtful enough to go by our house and snap a picture, which he'd emailed that afternoon. While there were a handful of big oak limbs and what looked like the whole top half of the ancient magnolia down in front, the house itself seemed to be in remarkably pristine condition. When I saw it there, glistening in the bright New Orleans sunlight, I literally jumped up and down.

I was happy to see John, we were both ecstatic to see the house, and we were, as had become the recent norm, completely stuffed with food and wine when we arrived back at my parents' house. At the door, though, contentment gave way to hilarity. Since I was a teenager my mother has been a big proponent of the late night note, filled with all manner of instruction or, depending on my behavior, warnings. They invariably contained way too much information, and my brothers and I often kept them for our mutual enjoyment, but this one was in a class by itself, veering as it did from the usual mundane stuff about setting the alarm and turning off the outside lights, to the more pressing matter of the new family pet. Our beloved yellow Labrador, Bo, had died almost fifteen years earlier, and in his absence—and unbeknownst to me until that moment—both my parents had become unnaturally (in my opinion) attached to a tiny green tree frog, though he had not yet been given a name, which I chose to take as a good sign. For the last three years, the note informed us, the frog had come back after his warm weather sojourn at the end of every summer to take up residence in his fall-and-winter habitat, the pottery planter attached to the wall by the back door. My mother had made the discovery of his return on that very day, and urged us to be especially

careful opening the door, since he was fond of taking evening outings across it and she was afraid we might alarm him, or worse, knock him off (no matter that, as I learned in my subsequent research, tree frogs have adhesive toe pads, and, though they are reluctant jumpers, they are capable of taking great leaps).

The note was illustrated with happy faces signifying her joy, and arrows designating his whereabouts, and when we got inside, neither of us could stop laughing. Not at my mother, necessarily, but in a tickled but awed appreciation of this woman who peels tomatoes for the displaced and is so overprotective of a two-inch-long tree frog she leaves notes insuring his well being taped to her door. It reminded me of a night earlier in the week when I'd come home to find her at the kitchen table putting supplies in one of the children's relief boxes the church was sending to shelters across the state. Each volunteer packer had been instructed to include useful stuff like a toothbrush and toothpaste, sharpened pencils and paper, but also a stuffed bear. "Feel this," she said, triumphantly handing over the softest fake fur animal I'd ever felt. I had laughed then too, at the image of my mother, prowling the aisles of Wal-Mart at ten o'clock at night, pressing shelf after shelf of plush toys against her cheek. But when she asked me, "Wouldn't you feel better if you could hold that against your skin before you went to sleep on a hard floor?" I had to agree that I would.

All week long, my dreams had been filled with images of floodwaters and mayhem, but it was in the kitchen with John, holding the tree frog note in my hand, that I determined the source of a deeper anxiety. So many people had lost so much. On that very same night, for example, my friend Irvin Mayfield, the extraordinarily talented trumpeter and leader of the New Orleans Jazz Orchestra, was in Baton Rouge, worrying about the fate of his father, who, as he would find out later, had drowned in the storm. I remembered that Antoine

told me he'd lost his father to Betsy (and now, suddenly, I was in-clined to believe that it was true), and my own husband had not seen his mother—or cared to—since he was four years old. And here I was with parents who were not only very much alive, but busy—aiding, working, doing, sheltering their middle-aged daughter and son-in-law, and keeping us well entertained to boot. After having been with them under such close and extraordinary circumstances, I was reminded again of their effortless generosity and humor, of the sheer charm of my own parents. I realized that my biggest fear was of an inevitability far greater than any hurricane: the fact that one day they too would be gone.

7

IT WAS NOT a fear I could dwell on for long. Monday morning
the phones started working. I was at my usual post in the kitchen
when my Louisiana cell rang for the first time, but the reception
was so bad I was halfway down the driveway before I could tell who
it was. "Julia, Julia, it's me, Antoine," he said, his voice high-pitched
and breathless, desperate to make himself heard. I gushed on and on
about how I had been worried to death about him, and he gushed
right back, calling me "Boss Lady," over and over, a moniker almost
always reserved for when he was high and trying to ingratiate himself
to me, but this time he was laughing—it was our mutual joke, some-
thing familiar, and I was so glad to hear from him I couldn't stand it.
He told me he had indeed made it to the Superdome and that when
he was finally rescued, he was put on a bus bound for a place called
Camp Copas, a Baptist Bible Camp in the town of Denton, in north
Texas. I later found out that Denton had been founded by a Method-
ist lawyer and preacher named James Denton, who was famous for
leading attacks on the Indians, and that though it is one of the fastest-

growing towns in the country, less than 10 percent of the current pop-
ulation of about 110,000 is black. Antoine had been placed in Dorm
Happiness, and though he was clearly happy to be alive and seemed
to be handling his recent experiences with typical aplomb, I could tell
he was a tad unsettled. I'm sure it had a lot to do with the fact that he
had never been in a place with so many Baptists and white people in
his life, and, come to think of it, neither had I, so I promised to come
get him out of there as soon as I possibly could. When I talked to the
officious-sounding woman in charge, she assured me that they would
be housing Antoine for at least two more weeks, time I would use
to figure out what to do with him once I got him. Greenville's crack
problem was as bad or worse as that in New Orleans, and it didn't
seem like we'd be heading home for good any time soon.

The next call, not surprisingly, was from the well-organized Mr.
Dupré, who had already opened a bank account in Houston and gotten
his family an apartment. His house, with its just-completed swimming
pool, his wife's artwork (she was a different kind of painter), and his
beloved coin collection, was in New Orleans East, and based on what
he could see from the televised flood maps, he feared it was under
water. Since I owed him the usual whopping amount for a week's
work, he was eager to give me the address, and I was, under the cir-
cumstances, more than happy to send him a check. Then it turned
out that I owed John Benton money too—I just hadn't known it until
he called to report that he'd righted the live oak in the back garden,
the one with the new growth we had toasted the night before we left.
Its roots were still so shallow it had blown sideways, and then there
was the matter of the top half of the enormous magnolia and a big pile
of limbs from the old oak he still needed to come cart away. Benton
told me that he and a small crew had found their way back into the
city just two days after the storm and were camping out in his house

near the airport with a couple of ice chests full of food and water, a generator, and lots of firearms. They used the generator so sparingly the nights were passed in complete darkness, which meant that every time one of the group got spooked by a noise or saw a headlight in the drive, another almost got his head blown off. I was touched that given their rather edgy existence, not to mention the fact that they were faced with major thoroughfares to clear and huge clients, like the Port of New Orleans, to satisfy, they still found time to check on my comparatively inconsequential tree. To me, of course, it was of major consequence—as an "anchor" to the plan, it had represented a strikingly healthy percentage of Ben's "Opinion of Probable Cost" and was so big the whole street had to be blocked off when it arrived on a truck from Florida.

Every call brought a different narrative, and one of the most dramatic came from Quincy, Rose's son. Quincy is a butcher by trade, but he is also a gentle giant, a soft-spoken, really big guy who owns a really big Suburban, and he had been extremely helpful during our incremental moves from Bourbon to First Street. He told me that Rose and Thomas had left early, right after Rose had called that Saturday, in fact, to stay with Thomas's cousin in Natchez, and that Roseanna had gone to "the country," up the River Road to Assumption Parish, where she grew up and where some of her siblings still lived. But Quincy had decided to ride it out, as had Joe, Rose's brother, along with his daughter and granddaughter and his wife, Robin, and Frankie, the younger sister of Joe and Rose, who is a single mother of six children, aged two to seventeen. Roseanna had worked as a cook and housekeeper for a handful of families in New Orleans since she first came to town, when, as she says in the city's vernacular, she "made" eighteen. Neither of us can remember now how we even met, but she helped me throw parties in one of my earliest apartments the

one on Royal Street (we still laugh about the time I hung Spanish moss from the candelabra and the whole table caught on fire), and all four of them—Roseanna, Rose, Frankie, and Joe, who is an excellent bartender—had helped with every big party I ever threw on Bourbon. Sometimes Robin came too, as she had in Greenville for our wedding, and when Joe needed extra help, he called his first cousins Lorel and Lamont—they were a one-stop entertaining shop and they'd all had been working parties in New Orleans for years.

I loved them mostly because I had such a good time with them in the kitchen and, since my gatherings were slightly different in tone from the Uptown affairs they were used to, they had a good time with me too. We had a "coming out" party for a friend who had, wrongly, done some time in jail; one of McGee's birthday bashes had been Mexican-themed and featured a piñata "stand-in" for her newly minted ex-husband, while another was a surprise with all her favorite foods, including mini-BLTs, pigs in a blanket, and fried chicken. We did countless dinners and brunches, a seated New Year's dinner for 40, a "small dance" for 150, each without a hitch (on our part at least—the guests got up to all manner of no good, including, at the New Year's Eve party alone, a fistfight, a fainting spell, an extremely unwelcome advance, and two different powder room trysts). Roseanna is a typical matriarch, bossy and opinionated and entirely imperturbable, while Rose, who once worked for a professional caterer, is emotional and hypersensitive, but also more talented. In the kitchen, she'd roll her eyes at me while undercutting Roseanna's orders at every turn, leaving Frankie, who may well have the sweetest disposition of anyone I have ever known, to keep the peace. They were incredibly close (despite one fairly long and problematic stretch when Rose refused to speak to Roseanna, even when they worked together) and mightily protective of Joe, which meant that they weren't always the most ardent fans of Robin. It was a complicated dynamic, especially in a

kitchen as crowded as the one on Bourbon—Rose is the only one in her immediate family who could correctly be referred to as thin—but we never failed to end the evening laughing. One night, at a particularly festive birthday dinner for Patrick Dunne, which featured Alice B. Toklas's "Cream Perfect Love," Frankie announced it to the table as she'd heard it, "Cream Purple Love," a slightly more lurid but certainly more interesting-sounding dish that I immediately vowed to create in her honor.

On the Sunday night before Katrina, they all stayed in the gymnasium of Booker T. Washington High School, where the janitor, a friend of Robin's, was letting friends in with his key. On Monday, when they, like everyone else, thought the worst had passed, they went home, emptied out the contents of their collective freezers and refrigerators, and started barbecuing in front of Joe's house, offering food to everyone who passed. "We had chicken, ribs, smoked sausage, hot sausage, and pork chops," Frankie told me later, describing a mind-set and a celebration much like ours at Doe's. "We were just cooking it up. Some people said water was coming but we had no idea what they meant because we didn't have TV or radio or anything. We were like, 'Coming from where? The hurricane is over.'" That night, sleeping all together in the duplex that Joe and Roseanna share, they heard the water "bubbling first," coming out of the sewers, and when they woke up the next morning, it had risen up the porch steps. A Louisiana National Guardsman passed by and told them there was a single gas station open, at Washington and Magazine, just five blocks from our house and not all that much farther across St. Charles from theirs, so Frankie piled her kids into Quincy's Suburban and off they went, only to be turned away by rifle-wielding cops. The police chief and mayor were AWOL, the officers told them; they'd been left with no command and no supplies and felt they had no choice but to claim the only gas left in the city for police use only. One of them pulled out

his cell phone and showed Frankie photos of the Ninth Ward, where the water was already up to the rooftops. "When I saw that, I said, 'Oh Lord, we got to get out of here, gas or no gas.'"

The problem was that they had no idea how much they had— Quincy's fuel gauge had long been broken, along with his rear door (a fact which had made our moving experience a bit tricky)—but the vehicle itself was sturdy and high off the ground, so they went back to get the others, hoping Joe's much lower car could follow in Quincy's wake. When they got there, the water in the street was up to Quincy's tailpipe and Joe's car just floated when he tried to drive, so all twelve of them crammed into the Suburban and made it across the river where, sixty miles out, they finally found some gas—in the nick of time, apparently, since it took $70 to fill the tank. They also found a shelter—with air conditioning and showers and toiletries in little boxes like the ones Mama had packed—near Roseanna's increasingly crowded family homestead. The next morning, the decision was made to head north, to Dyersburg, Tennessee, where Robin had family. Her daughter, who had been watching what they had not been able to see on TV, kept calling, frantic, saying, "Come, I don't care how many there are, just come." They did, and by the end of the week, a local minister had arranged for a house for Frankie through FEMA, as well an apartment each for Quincy and Joe and his family.

When I hung up, I got some clothes together for Frankie's children, who were all starting school, and sent some money to Quincy for whatever else they needed. By the time Eddie called me, from his mother's house in Jackson, Mississippi, I was primed to be sympathetic. I was even, sort of, happy to hear from him. Though we had been at loggerheads for most of it, the renovation was still a shared ordeal, and now a hurricane had all but wiped out our adopted city. I swear I think Eddie was more into New Orleans than I was—his house in the Quarter was always on the "patio tour," he organized

the annual Christmas caroling in Jackson Square, and never missed a single Wednesday concert in the Central Business District. And now his ticket back into the "entertainment business," the virtual reality tour of the Quarter, was pretty much worthless. He'd put all his hopes—and, I had a hunch, at least some of our money—into it, but tourists were his primary market and it seemed unlikely that they'd be around any time soon. Just two weeks before the storm, the "first run" of thousands of copies had been produced, and while he talked vaguely of "screening" one at a fundraiser somewhere in Texas, he sounded forlorn and deflated and told me he'd been almost paralyzingly depressed. We agreed to meet back in New Orleans as soon as we could, and I wished him well and meant it.

A much more entertaining call came from my friend Brobson Lutz, a doctor and specialist in internal medicine and infectious diseases, who was for years the city health director. (He told me once that he'd resigned after watching our former mayor untying and retying his shoes eighteen times during a one-hour meeting and realizing that "there was some chemical driving the mayor that the rest of us weren't taking.") Brobson lives on Dumaine Street around the corner from my old place on Bourbon in a sprawling and extraordinarily beautiful complex of dwellings and gardens that had once included the apartment of Tennessee Williams, whom Brobson and his partner, Ken, who is also a doctor, had known well. When he called, he was somewhere in his home state of Alabama, and he had caught me on MSNBC, where I'd been on a panel with the then-New-Orleans-based historian Douglas Brinkley. Brinkley had said he could not in good conscience bring his family back into the city because of the likelihood of major outbreaks of cholera and typhoid fever, and Brobson was about to blow a gasket because of what he considered the impossibility of same. I had instinctively discounted Brinkley's dire warnings on camera, but I had no idea how over-

blown they actually were until I talked to Brobson, who explained that the "causative pathogens" did not exist here in sufficient quantities to be a remote threat and that the worst thing that might happen to people (in addition to cutting an arm off with a chainsaw) was a "staphylococcal abscess," otherwise known as the kind of boil Antoine claimed he had on his butt all those years ago and which is easily treated with the common antibiotic minocycline. In addition to the typhoid talk, there had been a lot of noise about snakes and tetanus that also got him going: "There has never been a recorded snakebite after a hurricane in the history of the United States," he hollered into the phone. "There has never been a recorded case of tetanus." In the near term, he said, folks would be hard pressed to get a mosquito bite—the mosquitoes themselves had all been blown away.

Brobson and Ken had ridden out the storm in his house with their friends Dr. Kenneth Holditch, whose areas of academic expertise are the lives and work of Faulkner and Tennessee Williams, and Edwin Curry, whom Brobson described as a "vegetarian cat lover" who writes obituaries for the *Times-Picayune*. The house, on the highest ground in town, got no damage, so they all stuck around until Wednesday, when the city turned off the water. Now he was about to have a stroke to get back in. Clearly he had no fear of diseases, and he was an old hand at hurricanes.

At eighteen, he'd made his first trip to New Orleans just in time to meet Betsy. He and two high-school classmates had saved their summer wages and bought tickets on the *Hummingbird*, the old Nashville and Louisville Railroad train that picked them up in Decatur, Alabama, and deposited them in New Orleans, where they asked the cab driver to take them to the finest hotel in town. Instead, he dropped them off at a fleabag, the Lafayette ("which is what I'm sure we looked like we deserved"), where they took a corner suite and slowly became aware that a hurricane was on her way. On the night

Betsy hit, Brobson distracted the clientele and hustled free cocktails in the hotel bar by drinking whiskey sours standing on his head. After the storm had passed, he and his buddies got to stay another week because the train tracks had blown away, and it was then that he knew he would one day return to stay. He'd grown up in a dry county, and in New Orleans he was not only able to get a drink legally, even at eighteen, but "there was an aisle of liquor that seemed to be a mile long" in the grocery store. "I thought the devil himself had something to do with creating New Orleans when I saw that."

During medical school at Tulane, he'd had a place on Dumaine just three blocks from his current abode. The Quarter was his beloved home and longtime stomping ground, and he was furious that the city was denying him (and every other resident) the right of return, based, at least partially, on more flimsy medical grounds. The current city medical director had cited the danger of E. coli in the floodwaters, adding that when the waters receded people would get septic E. coli and pneumonia from breathing the dust. "That is malarkey because when E. coli dries, it dies," Brobson said. "It doesn't even form spores. He's got his bacteria mixed up." He told me he'd spent every waking hour going slightly crazy wondering what was really going on; also, he was a doctor with a house that was perfectly intact. "If there's anything I can do, I want to be doing it." I realized he was right. More than a week had passed and we needed to see things for ourselves. I honestly did not think I could stand in front of the TV for another second. I told Brobson I thought his expired medical badge could get him past the National Guard checkpoints, and failing that, he could caravan behind me with my press pass. Either way, it was time to go back to New Orleans.

8

A S SOON AS I hung up with Brobson, I called Jon Meacham, my editor at *Newsweek*, who promised to FedEx me something on the magazine's letterhead to produce at the National Guard checkpoints. The only story I had left to do was for *Vogue*, but I had the sexist idea that *Newsweek* would carry more clout with uniformed gatekeepers I knew would be entirely male. Either way, relief workers, journalists, and contractors were the only people allowed into the city, and now the mayor was ordering everybody who had stayed through the storm to get out. John's name was included in the letter too, but amorphously, as a sort of driver/photographer/general escort, along with that of Byron Seward, who was past desperate to get in and check on his house—unlike us, he'd received no reports from the field. The plan was that Byron and I would drive down together from the Delta and meet John in Hammond, forty miles past the Mississippi/Louisiana line. From there, we'd take a circuitous route into the city, crossing the river above New Orleans and entering from the west bank via the Greater New Orleans Bridge. The

direct route required taking Interstate 10 East all the way in, but Ken Wells had already warned me that parts of it were still under water.

Before dawn on Friday, September 9, eleven days after Katrina had made landfall, I got up and armed myself rather feebly with empty tote bags, flashlights, pens, and a notebook. Frank drove me the hour and a half or so that it takes to get from Greenville to Yazoo City, and on the way he told me about his close friends and serious partying buddies from Gulfport, one of the hardest hit towns on the Mississippi Coast. They had—crazily—ridden out the storm (Gulfport is smack on the water), and Frank had been worried to death about them all week. When he finally made contact, he discovered that not only were they fine, they were also having a fine old time, keeping cool with fans powered by their lawnmower engine, and dining, in a makeshift pavilion lit by automobile headlights strung overhead, on the grilled contents of the ice chests they'd thought to fill up ahead of time. They told him they had plenty of whiskey and water and no intention of going anywhere.

When we pulled up at Byron and Cameron's we were still marveling over the often festive ingenuity of our fellow man, but when we saw Byron's truck we were forced to marvel instead at his own personal preparedness level. Once again, I was reminded that the wrong person had been in charge of FEMA. The truck bed was filled with enormous wrenches and crowbars and all sorts of other serious-looking tools I'd never seen before, along with three or four big cans of gasoline and several gallons of water. There were surgical masks, heavy work gloves, plastic gloves, flashlights of a far higher caliber than my own, heavy-duty garbage bags, and insect repellant of a grade strong enough to ward off predators of the sort that inhabit Mississippi Delta cotton fields at the height of summer. Inside, there were a couple of hunting rifles, Handi Wipes, industrial-strength bleach, and bottles of disinfectant. In a small ice chest, the same one

Cameron packed for him to take to the farm every day, there were carefully wrapped sliced apples with peanut butter and other healthy nibbles that were the only reminder of Byron's illness.

Almost two years earlier Byron had been diagnosed with stomach cancer, a particularly cruel fate for someone with as refined and enthusiastic a palate as he possessed. But, alone among his group, he had come through a rigorous clinical trial at M. D. Anderson, the renowned cancer hospital in Houston, with flying colors. (One man had simply gotten up and left, saying he'd rather dice with death than endure another minute of whatever it was they were putting them all through.) Byron is not a big guy—he looks a bit like Paul Newman and has much the same physique. (At twelve, I was shocked to find out, after buying a life-sized poster, which I promptly lay down on top of, that Newman is only about five foot five.) Byron makes constant teasing jokes and can drive you half-crazy—the first time I met him he was terrorizing the diners in Galatoire's with a pocket full of plastic roaches. But he is also intuitive and really smart and generous to a fault. More important for this particular outing, at least, he is extremely handy, and I could tell he couldn't wait to get going and find a use for those tools. Before he and Cameron had bought their own house in the Marigny, they too had been Betty's tenants, at her place on Esplanade, and he spent the majority of his years there serving as plumber-in-residence and chief excavator of out-of-control banana trees.

While Byron drove, I checked my various lists—when folks heard we were heading back in, our services (or, I should say, Byron's) were much in demand. The TV footage of the fires had panicked everyone, so we had lots of gas lines to turn off, and then there were the less pleasant tasks. My friend, the journalist Curtis Wilkie, had overnighted his keys from Oxford, Mississippi, where he also lived, along with a page from a Galatoire's notepad. "May we live to

dine here again," he'd scribbled, along with a plea to clean out his festering refrigerator.

In Hammond, we filled up at the last working gas station we would see for a while, bought some Nabs for me (who had not thought to pack snacks, healthy or otherwise), and John pulled up behind us in my car. It was a beautiful day, clear and sunny, but the closer we got, the usually lush hardwood trees growing out of the swamps on either side of us were increasingly flattened, and the hunting and fishing camps that once dotted the route were now just so many piles of kindling. As we neared the bridge, which crosses the Mississippi in downtown New Orleans, there was a short line at a checkpoint, where a disinterested guardsman took a look at our letter, glanced at John behind us, and then waved both vehicles through. Midway across, I looked up to see that the walls of a high-rise hotel looming alongside us had blown off, revealing room after room of seemingly tiny tableaus—beds, nightstands, bureaus—all still in place but completely exposed, just like a developer's model on a lobby table.

We got off at the Tchoupitoulas exit and made our way toward Magazine Street, a main artery that runs parallel to St. Charles Avenue and forms the riverside boundary of the Garden District. Dozens of cars parked along the way had been relieved of their tires and their gas tanks had been forced open, some with the siphoning hoses still hanging out; a police cruiser's smashed passenger window had been taped over with a garbage bag. Ornate iron fences surrounded the charred remains of once-lovely Lower Garden District houses; here and there a brick chimney or a metal fire stair rose up from the ashes. On the corner of Magazine and Jackson Avenue, where a wall of a nineteenth-century brick building that housed the flower-and-antiques shop of a friend had caved in, there was a handwritten sign saying "Please Do Not Demolish," while on the opposite corner, some of the bricks had already been put to sad use. An

elderly lady from the neighborhood, who died, as we would find out later, when she ventured out from her apartment just after the storm, was respectfully covered with a white sheet held down by bricks in a neat oval. Flowers and a salvaged white cross had been left on the sidewalk amid the rubble, and across the sheet, in red, a message had been painted: "HERE LIES VERA . . . GOD HELP US."

At the end of our block, the scene was not nearly as tragic but no less dramatic. A couple of years ahead of us, our neighbors had completed a renovation of their own James Gallier–designed corner house; the crowning touch, not long before Katrina, had been a handsome new copper roof. Now it was sitting in the middle of the intersection of First and Camp Streets, in a single enormous piece, as though a giant hand had peeled the lid off an even more gigantic sardine can. John's car was still on the street, in its carefully chosen spot, as was the black pickup truck belonging to our outdoor painter Freddy—both miraculously unscathed by the nearby roof or any number of ancient tree limbs, or even the gas siphoners and tire thieves. It was almost 100 degrees outside and completely still. I stood atop the sideways trunk of our snapped-off magnolia and looked around. The gallery in front of the house was sagging a bit where it had gotten waterlogged, and the wind had blown a third floor shutter open and broken a lone pane. There was some visible roof damage and a big gash in the siding, and I had to laugh because our yard, which for a year had been the messiest in the neighborhood, now looked roughly the same as everyone else's. We were very much alive, our house was more or less okay, our cars hadn't even been damaged. Meanwhile, less than four blocks away, there lay Vera. I looked at John and knew he was feeling the same thing: utter unworthiness coupled with intense, joyous relief.

———

IT MAY HAVE been damn hot outside, but inside, I was convinced
that the upper floors were hotter than hell itself. I raced through them
and filled up my totes with extra power cords, the jewelry I'd idioti-
cally left behind, more clothes, a box of checkbooks, the pile of bills
and mail and tax stuff I'd left on my desk in the office I had yet to
unpack. I taped a piece of cardboard over the window on the third
floor, grabbed my small kitchen laptop as a backup, and, on Byron's
advice, took the rest of our housewarming Champagne and a few
more good bottles before the heat destroyed them all. Who knew
how long it would be before the power returned? The pantry was
by far the coolest space in the house—even the lobster shells weren't
completely unbearable. We re-bagged them in one of Byron's triple-
ply bags and put it outside next to a pile of limbs, and then we headed
downtown.

The Faubourg Marigny, whose plan dates back to 1806, was the
original Creole city's first suburb, the subdivided estate of Pierre
Philippe de Marigny de Mandeville, father of Celeste de Marigny,
the woman who had married the unlucky Livaudais, divorced him,
and ended up with the land that became the Garden District. Byron
and Cameron had bought their house there, on a street just a block
below the Quarter, three years before the hurricane. It remains one
of my favorite New Orleans houses—an airy two-story Caribbean-
style shotgun with a rare side gallery and a long front parlor—and,
unless it was a particularly busy time during planting or picking
season, they were there almost every weekend. The commute was
more than three hours, but other than a pretty good barbecue joint
and a KFC, there is not an actual restaurant in Yazoo. The Marigny,
on the other hand, is blessed with an abundance of them, including a
Thai place, a sushi place, and an excellent French bakery, as well as
a bar on Byron and Cameron's corner that stocks more than a dozen

hard-to-find foreign beers, hosts crawfish boils, and gives free hair-cuts on Thursday nights.

Usually there is lots of foot traffic, too, but on this day there was no one—until Brett Anderson, the relatively recent and currently wild-eyed food critic for the *Times-Picayune*, came flying out the front door of his house across the street. Brett was slightly breathless and extremely sunburned, with a T-shirt tied loosely around his head in a futile attempt to provide shade. He'd been in town since the day after the storm, he told us, one of the noble and sleep-deprived foot soldiers who rallied each day to get the paper out, and whose beats had expanded to include pretty much everything they saw. He'd been staying with a group of colleagues in a crowded Uptown abode they'd dubbed the "frat house," but which nonetheless had a genera-tor, and he'd made the trip back home to get more clothes and clean out his refrigerator. From the looks of him we did not have a pleasant task before us.

We wished him well and while Byron went inside to check things out, I noticed, for the first time, the light. The Marigny is closer to the river and lacks the canopy of trees that defines the Garden Dis-trict and Uptown, so that the sky seems somehow closer. It also, at that moment, seemed hard and pale yellow and generally strange, an impression intensified by the menacing drone of the low-flying heli-copters overhead. There was definitely an apocalyptic feel to things, like in the movies after a nuclear holocaust has taken place or a deadly volcano has erupted. I'd just never seen one where the event in ques-tion had been a devastating hurricane followed by a flood. I'd also never been in occupied territory before. We were in it now—we'd already spotted guard units from Oregon, Oklahoma, and Califor-nia—though I also realized that of all the big trucks I'd seen stocked with supplies and water, none of them said FEMA or even Red Cross.

Rather, they were emblazoned with the logos of either Wal-Mart or Sam's Club, and, as I would learn later, they'd arrived first and in fuller force.

The tall wooden fence that separated Byron's property from his neighbor had blown over, supported only by the listing sweet olive trees now beneath it, but everything else was intact, so after he procured his big wrench from the truck and turned off his gas, we headed across Esplanade to the Quarter and Curtis's Creole cottage. Curtis had recently become a tenured journalism professor at Ole Miss so he often rented out his place in New Orleans (he would make a killing off the *Washington Post* in the months to come), and the last tenants had failed to clean out the refrigerator before they fled. They also hadn't stayed long enough to amass the kinds of New Orleans freezer fodder that would have made our jobs as disgusting as Brett's clearly had been, so when we left for Elizabeth's we were stupidly emboldened.

Elizabeth lives in what is loosely referred to as Uptown, on Carondelet Street, parallel to St. Charles and one block over and several blocks beyond the Garden District. She and Mike had bought their late-nineteenth-century house just after Katie was born and it is beautifully proportioned, with high ceilings, a pretty walled garden, and the two-room guesthouse where we had squatted for almost six months. The kitchen had been recently renovated and boasted roomy new side-by-side freezer and refrigerator units, both of which had been packed to capacity with the kinds of things Curtis's tenants probably didn't even know existed: vacuum-sealed bags of crawfish tail meat, links of andouille sausage and *boudin*, pints of lump crab, pounds of pork tenderloin. I knew there had been containers of seafood gumbo and red beans and rice from the beloved Uptown grocery store Langenstein's in the freezer because there always were,

along with the justly renowned "Le Popeye" spinach dip and an addictive cheese-and-walnut spread called "Betta Chedda" from the same place.

Let me just say now that there is absolutely no way to adequately describe on the page the greenish white slime that all those ingredients turn into when they have been unrefrigerated for a full ten days. John had survived a year in Vietnam and Byron a potentially fatal disease along with treatment that he alone had the fortitude to finish, but neither of them could stay inside for stretches of more than thirty seconds once we opened the appliance doors. And I couldn't manage that much. The sight was so nauseating and the stench so overpowering that Byron's surgical masks proved so useless as to be laughable (though we were profoundly grateful for his gloves and bleach and disinfectant). Later, my good friend Donald Link, the owner and chef at Herbsaint, told me that even the full-fledged rubber gas mask he had donned had been of little assistance during his own ordeal, which, admittedly, had been way worse than ours, involving as it did an industrial-size walk-in that included a full complement of fish and game and house-cured pork products among the many items on its shelves.

To this day, after a typically delicious meal at his restaurant, Donald will sit down with John and me for a jovial glass, and if the talk turns to the dread refrigerator cleanup, his eyes become slightly glazed and we all, invariably, drink more heavily. I have heard Donald talk about what most people would consider critical blows— a hurricane landing a month before he was due to open his second restaurant, say, or losing his house in the flood. But he always stops himself—nothing, not even those things can compare. For one thing, there's not a whole lot to be done about them. The refrigerator, on the other hand, required confronting.

For all of us, that confrontation became a badge and a touchstone

and proof of membership in a relatively exclusive and still vaguely shell-shocked club. When I made brief mention of its more horrific aspects in the first Katrina story I wrote for *Vogue*, my editor insisted that I cut it from the piece, referring to it, with not just a touch of self-righteousness, as my "Marie-Antoinette moment." I got—and get—her point. But the problem is that unless you or the people you loved just flat-out drowned, almost everything is a Marie-Antoinette moment. More than 700 people in my adopted city died; many, many more lost everything they owned. Our house had a broken window. By default, and in reality, I am eating cake. So when, late at night, Donald and John and I sit around like soldiers from the front, talking about some seemingly silly and really gross thing like dragging leaky garbage bags full of goo to already reeking curbs, what we are really doing is celebrating our very existence. We are bragging on our luck, boasting of our stamina, commiserating, laughing, drinking, talking. We are still alive, we are saying to one another, and more than that, we are still here, in New Orleans, because we choose to be.

~~ 9 ~~

AFTER WE TENDED to the rest of the gas meters on our list, I insisted that we check in with Bob Rue, who was still commuting between his shop on St. Charles and the Garden District house of his girlfriend Jean, a French professor at the University of New Orleans who had evacuated to Jackson with her mother. When we pulled up in front of Jean's gate on Eighth Street, Bob was waiting on the front porch with a two-year-old white German Shepherd by his side and a magnum of red wine in his hand—both, as we were soon to find out, gifts of the storm. I didn't know Bob well, but I'd always had great affection for him, coupled with an odd faith that dated back to my thirtieth birthday, when I happened to be in Greenville and he was there too. My mother invited him to the impromptu party at our house and within about ten minutes he had marched up to Jessica and told her he could tell she needed what he was about to give her. I held my breath while he did something to her neck and back that looked very dangerous and vaguely acrobatic and afterward she told me she had never felt better in her life. Jessica has always car-

ried more than her share of the world's woes on her shoulders and I loved that he'd immediately gotten that—and that he had been bold enough to release her from them, at least temporarily.

This afternoon was sort of like that. We'd had a long day, were in need of refreshment in a city that eleven days earlier had been visited by the biggest natural disaster in the history of the country, closely followed by an even more devastating man-made one, and now Bob was seating us in wicker chairs on a lovely side gallery, offering us two different kinds of almonds, and pouring what turned out to be a very nice Bordeaux into Jean's stemmed crystal glasses. Furthermore, there were other guests, a *New Yorker* writer who'd arrived on a bike, and Ellis Joubert, a brilliant local artisan and restorer of antique metalwork who had evacuated to North Carolina but had come immediately back when his Yankees fanatic brother-in-law had insisted on watching a game rather than footage of the flooding on Ellis's own street. When they hadn't let him past the checkpoint, he went back to his mother's house in the burbs, made a red cross on a white T-shirt with a Magic Marker, and tied it to his antenna. Next go round they waved him right through, because, as Bob put it, "It was the first fucking Red Cross presence they'd seen."

Bob, as I knew, had not left the city even once since the storm. On the second night, he'd been sleeping naked in a second-floor bedroom with all the windows open when, around three in the morning, he heard a noise. With Jean's .38 in hand, he rolled from the bed, crawled out onto the porch, and saw that a guy with a flatbed truck and a forklift was about to make off with a vintage Porsche belonging to the neighbor across the street. So Bob says, "Hey partner, which way you want your hair parted? I'm getting ready to blow the back of your head off." Bob is six-foot-six, bald-headed with what's left of his hair in a longish ponytail, and not entirely svelte; at this point, he's also naked and in possession of a pistol. As it happens, the culprit was

spared such a singular vision—the city was still pitch black—but the I-mean-business voice out of nowhere had an equally forceful effect, and the thief skedaddled, taking the BMW and the Jeep Wrangler that were already on the truck with him.

The next morning Bob covered the Porsche with old carpet pads and some downed fencing and topped off his handiwork with a hand-painted plywood sign that said "Looters Shot." On the gate to the car owner's house, he affixed another, reading "Go in and Die," and then he called him on the same trusty landline he'd used to call me. (Such was the vital nature of the cheap Princess phone in Bob's shop, the only one he'd been able to find that did not require electricity in order to function, that he unplugged it from its jack every night and carefully hid it away from possible looters.) The Porsche owner, a doctor with a serious wine collection, was so grateful for the salvation of his car that he told Bob how to get into his cellar and to avail himself of everything he had, which turned out to include quite a few bottles of Château Latour. "I don't know one from the other," Bob told us. "It's all just red wine with a French label to me." But from the taste of things so far, there were few bad choices.

The dog had turned up the next day, wearing a red bandana and clearly in need of food. Bob gave him some kibble and had him tied up on the sidewalk outside the shop when a woman in a big black van pulled up and demanded that he hand over the dog. Bob had already put himself in charge of the care and feeding of at least a dozen neighborhood strays, including a bitch in her first heat who'd exhausted all the others, so he was offended by the implied accusation. "Hell, I ain't had him but an hour and a half," he told her. By this time other identical vans had materialized, along with a soundman and someone toting a tape recorder to immortalize the would-be heroics, and it was finally explained to Bob that he was their first "client," that they had come all this way to rescue dogs and they were determined to

rescue his. Bob explained again that Snowflake, whom he named in that moment, did not need their help, that both dog and master were perfectly fine, so they settled for a shot of him with his arm around his new best friend, and a few weeks later he heard from his cousin in Manhattan that she had seen him on the local PBS station on a show about the doings of the dog savers.

While Bob told us the story, it dawned on me that the only other "unofficial" vehicles I'd seen so far, other than the Wal-Mart trucks, were in fact cars and vans with homemade signs that read Oregon SPCA or Humane Society of Missouri. Now I really love animals. When I was growing up we had everything from bunnies and ducks and a noble gray cat named West Virginia to a horse and at least eight dogs, two of whom had simply wandered up our driveway; when John and I bought the house, part of the whole real-life plan had been to eventually adopt a beagle, the dog I had always wanted and never been allowed to have. But I had to ask myself: if I had been watching the saga of Katrina unfold on TV from somewhere almost 3,000 miles away, like, say, Oregon, would my first thought have been to jump in the car and drive like a bat out of hell to rescue someone's hungry housecat? In the end, for the most part, the well-meaning dog and cat lovers performed an invaluable service, rescuing close to 8,000 animals that were then housed in temporary shelters all over the state, and I went so far as to send one group a bunch of money. But at that moment, with half the city still under water and dead bodies unclaimed on sidewalks, the zealousness seemed a tad misplaced, an impression hilariously confirmed by officers of the Oklahoma National Guard, whom we visited after we tore ourselves away from Bob's hospitality.

The Oklahoma Guard, which included 600 men in their battalion, along with a cavalry unit and another small company of military police from Puerto Rico, was assigned an area of town that included

the Garden District, and I wanted to be sure and introduce myself and, more importantly, show them where our house was. Their TOC, or tactical operations center, was located in a replica of the top of the Eiffel Tower, an unlikely space toward the bottom of St. Charles Avenue usually reserved for fairly tacky party rentals, and where, when we pulled up, the soldiers were sitting on gold ballroom chairs absently cleaning their semiautomatic weapons. Because the governor had been a tad slow in calling them out (she'd been overheard by a CNN producer as late as Wednesday telling an aide she'd forgotten it was her job to do so), it had taken them six days to get there, until which time, according to Bob, the city more closely resembled Dodge City, an assessment with which the men from Oklahoma agreed. We were told by Captain McGowan, a Tulsa police officer and a veteran of Afghanistan, that by the time he and his men arrived, on the Sunday after the storm, the looters were so well established and so organized that when one band discovered an especially lucrative stash, they notified the others via two-way radio, communications traffic that the Guard, thankfully, began to intercept.

By the time we turned up, they were operating on foot, by air, in Humvees, and boats. Order had been more or less restored, streets had been cleared of power lines and the largest pieces of debris, and the looters were being rooted out with the same antennae, which can detect the presence of body heat, that was currently being used in Iraq. The animal rescuers, though, posed a more complicated problem. McGowan told us about the "culprits" who'd been spotted the day before by a helicopter patrol and quickly located and tackled by the men on the ground. It turned out they were workers from the Georgia Humane Society who'd been given permission online by a frantic pet owner to break into his house. The problem arose after they'd kicked in three or four doors before finding the right place, and all that running in and out had garnered the airmen's attention.

When the tacklers realized the "looters'" cargo was a pair of house-cats in a crate, they let them go, but the destroyed locks and now completely unsecured houses of the petless were left unaddressed. It got so bad that on a return trip I noticed a house on Magazine whose owner had spray-painted a message by the front door: "NO CATS! If you come in I WILL shoot you."

We left the Guard to make one more stop in the Quarter before it got dark, and on our way down St. Charles, we took a moment to check out more of Bob's handiwork in front of the Sarouk Shop. The plate-glass windows, which ordinarily display gorgeous Serapis and Bidjars and Herizes, were boarded up with sheets of plywood painted white with two messages in black lettering. The first, done the morning after the storm, read: "Don't Even Try. I am Sleeping Inside with a Big Dog, an Ugly Woman, Two Shotguns, and a Claw Hammer." Two days later, he had added an update: "Still Here. Woman Left Friday, Cooking a Pot of Dog Gumbo, Still Got Claw Hammer." As entertaining as they were, they also seemed to have worked. All the places of business in Bob's general area, including Emeril Lagasse's Delmonico, where he had painted a helpful "Looters Shot" by the front door, remained untouched. By contrast, a bit further afield almost nothing had been spared, from the Smoothie King to the Please U Restaurant, where the cash register had been busted open and the tables and chairs and ceiling fans all smashed for the sport of it. At the nearby Walgreens drugstore, someone had simply removed the locked-down steel front door with a forklift.

At Lee Circle, some rather more good-natured looters, a trio of winos whom I recognized from before the storm, were drinking from magnums of Moët & Chandon procured from the Le Cirque Hotel behind them. But heading into the Central Business District, we were back to the more destructive stuff. There was the Athlete's Foot, whose looting I'd watched live on CNN the week before, and

Canal Place, the shopping center near the edge of the river where Saks Fifth Avenue had been set on fire after being ransacked. The only display windows in the entire complex that survived without a scratch belonged to Brooks Brothers, where the Ken-doll mannequins in white flannel pants and blue blazers accompanied by neat stacks of candy-striped shirts and matching stadium blankets apparently held no allure for the criminal minded.

It was almost dusk when we made it to our final destination. On the news, Johnny White's, a dive on the corner of Bourbon and Orleans, had been repeatedly hailed as the bar that had never closed, and there it was, a beacon of sorts—albeit one dimly lit by a handful of voodoo candles in glass jars. It was as reassuringly disgusting as always, and filled with the same combo of die-hard "Quarter Rats"— heavily pierced latter-day punks; two guys making out on barstools; assorted neighborhood drunks, including one with a freshly busted forehead—except that now there were also a couple of wide-eyed Yankee cameramen and a large bottle of Germ-X on the bar. The beer, Budweiser long necks floating in barrels of melting ice, was delicious; the street empty and astonishingly clean. We were reluctant to leave this unlikely oasis, but Byron was heading all the way back to Yazoo, and we were all suddenly very hungry. We left the city the same way we came and caravanned north until Byron took his turn to Mississippi. An hour later, John and I were in the newly teeming metropolis of Baton Rouge (its population had almost doubled in the week after the storm). When we walked into Linda Jane's brightly lit kitchen, I don't think I'd ever been so happy to see my cousin—or the bottle of Scotch she was holding in her hand.

The next morning John and I got up early to head back into New Orleans, but first we had some shopping to do. The day before, when I'd asked Bob if there was anything he needed, he'd answered, "ice and garlic powder." This was classic Bob, and it turned out that Ellis

is an excellent cook specializing in Indian curries and Szechuan stir-fries, but I wanted to stock up on some slightly more substantial items for the National Guard. Their only means of nourishment were military issued "meals ready to eat," envelopes full of powder that became beef stew or even Cajun rice with beans and sausage when mixed with water, but that were so heavily laced with chemicals that a sergeant told me he wondered if when he died there would be any need to embalm him. It was a funny line, but in New Orleans of all places, the idea of people not eating well, especially people from a place already as culinarily deprived as Oklahoma, seemed deeply wrong to me. Later, I'd find out that my friend Chris Rose, the gifted *Times-Picayune* columnist, had acted on the same thought—and, in the process, confirmed one of my darkest suspicions, that most of what had been served lately at Antoine's, the once-great Creole institution, was not fresh, but frozen. Leery of the fish and crabmeat, Rose had commandeered the rapidly defrosting lamb chops and beef filets from the restaurant's walk-in freezers, merrily "looted" some grills from his neighbors' porches and backyards, and, with the help of his colleagues, staged a cookout amidst the fallen oaks in Audubon Park for the California National Guard, who were looking after most of Uptown.

Likewise, John and I filled the car with hams and turkeys, pound cakes and cookies, fruit and chips, and ice chests full of drinks. As we drove toward New Orleans, it dawned on me that it was the first time in my life I had brought food into the city; people were forever asking me to bring things, things you couldn't get anywhere else, out: Zatarain's Fish Fri, olive salad from the Central Grocery, Turduckens and boneless chickens stuffed with dirty rice from the Gourmet Butcher Block. That had been the tradition from those very first forays with McGee, when we were invariably charged with bringing fresh shrimp back to my mother, and it must be said that the imports

did not match up to the exports. Still, the guys in the Guard, who had likely never heard of a Turducken (a partially deboned turkey stuffed with a deboned duck stuffed with a deboned chicken, and layered with cornbread stuffing or sausage dressing or both) were glad to see us. When they found out I was a journalist, they immediately offered to take John and me and the photographer who'd been roaming around shooting for *Vogue* on their mission the next day, and we gladly accepted. It was the only way we could get into the still-flooded parts of town without our own Humvee or boat.

For the rest of the day, we took a more extensive tour of the parts of town where we could easily move around, and since food was on our minds, our first stops were all our favorite restaurants. At Herbsaint, Donald had written "Back ASAP" on his boarded-up doors; at Lilette, the unboarded and miraculously unbroken windows revealed wineglasses appropriately turned upside down on top of crisp white butcher paper, and napkins neatly folded at each place. It was hard to believe we couldn't just push open the door and take a seat in our usual booth. Further uptown, the brightly painted façade of my friend JoAnn Clevenger's Upperline, where I dined for the first time during that fateful Jazz Fest, was as cheerful as ever. But on St. Charles, at the entrance to Audubon Place, a gated street full of lavishly appointed, mostly 1920s mansions (including one once owned by Bob Dylan), there was a slightly more sinister sight. At the first reports of looting, some of the residents there, most of whom were safely ensconced in their Aspen summer houses, pooled their considerable resources and flew in a team of Israeli commandos. Now, I had shared the same panicky fear as these particular house owners, and the person most responsible for bringing in the security team happened to be one of my favorite people in the city. But these guys, in their head-to-toe black outfits and wraparound sunglasses and Ninja headscarves, wielding their Uzis in what was now, for all practical

purposes, a ghost town, looked utterly ridiculous. It was easy for me to say it, since our house had survived the looters and the fires and the storm itself, but I was glad our own security team had instead consisted of Bob and his dogs and his armload of painted signs.

Bob was in front of his shop when we dropped off his provisions, and he was happy to get them, but happier still over his first commission. As soon as the Guard had cleared the roads, he'd started parking his paneled truck at various highly visible intersections throughout the Garden District and Uptown, in hopes that any homeowners who had managed to slip in to check on their property—and who might also have some waterlogged rugs—would see his sign: "Bring All Wet Oriental Rugs to Sarouk." In a scene that would grow familiar over the next several months, he had an enormous Serapi spread out on the sidewalk, drying it before he got to work on the stains. Unless they'd stayed in salt water too long—"It eats up the foundations"—he could salvage them, he told me, and in the end, he cleaned more than 600 carpets at $2 per square foot.

The next morning we arrived early to meet the Guard, this time bearing more ice, coffee cake, and Krispy Kremes, which prompted the same heroes' welcome we'd received the day before. I had never met our photographer, but he'd taken the famous *National Geographic* cover shot of the blue-eyed Afghani girl that had so penetrated the public's consciousness during the Soviet invasion in 1985, and then he'd found her again, at a refugee camp on the Pakistani border, after our post–9/11 invasion. He was with his girlfriend, also a photographer, and the two of them had already spent one night with Linda Jane, who'd been nice enough to put him up because he'd made no other arrangements. He might have been a war photographer but he was not exactly clued in as to the conditions on this particular ground. After introductions were made, the four of us piled into a couple of the Humvees in the Guard caravan. The order of the day was "urban

recon," covering the dry parts first, block by block, following the crumpled Xeroxed grid of the city that each driver had stuck in his pocket.

We drove past the Robért Grocery, with its bittersweet banner "You Are too Late; Already Looted" strung across the front and stopped to chat with a young Haitian family that were by now trading inside jokes with the soldiers. Although the mayor had issued an order for everyone who had stayed through the storm to vacate the city, McGowan had already told me, "We're here to serve and protect, not to drag people out of their houses." (The mayor, on the other hand, seemed to be obeying his own order.) We stopped to check out radio reports of some activity at a long-abandoned building where plentiful caches of loot had already been discovered—mostly electronics and cases of alcohol and cigarettes—but the perpetrators turned out to be a couple of cats who had so far managed to elude the vigilant rescuers. The day before, a call had yielded less amusing results. Our "guide," Staff Sergeant Chris Havens, told me they'd chased a suspected looter into an apartment where they'd also discovered "an unfortunate woman." I had visions of the toothless, coked-up Cassandra—"What do you mean, 'unfortunate'?" I asked. "She was dead."

At first, Havens told me, the body was so large and so decomposed that they couldn't figure out the source of the overwhelming stench—they thought she was part of the bedding. Also, it had been difficult to tell, he said, whether she'd been a victim of foul play or had just suffered a heart attack in the heat, but they'd been forced to leave her there because there was not yet anywhere to take bodies, and even if there had been, there was no proper means of transporting them—hence Vera's sidewalk "burial." When the photographer's girlfriend heard that the body was where they left it, she all but de-

manded to be taken there so she could get a picture. While I get the need to illustrate the more gruesome aspects of a tragedy, I thought asking those guys to revisit such a scene was a bit much, not to mention the fact that there were plenty of gruesome sights that did not involve disrupting a mission or disturbing what was left of the dignity of an "unfortunate" woman lying dead in her own home. Havens, who had been all but ordered to do whatever we asked, was about to radio that he was turning around, but his discomfort—and that of the rest of the men—was palpable. I told him to forget it and we were best of chums for the rest of the day.

As we drove up Jackson Avenue and crossed St. Charles, I began watching for Danneel Street, home to Rose and Roseanna, Frankie and Joe. The water line there was not much past the porches it had risen to when the gang had made their getaway, but just one or two blocks farther on, the lines were considerably higher. In front of a side yard, a chain-link fence bore a sign saying "Beware of Dogs," while the animals in question sat vigilantly atop the flooded cars parked on the other side. "You can start to smell it now," Havens said, and he was right. You could also see the evidence of the mayhem that had ensued as the water began rising. Brown's Dairy trucks, packed with flooded loot, now stood at all angles with the doors wide open on the higher neutral grounds (known in less parade-going parts of America as grassy medians), along with dozens of white stretch limos and black hearses (the Brown's parking lot, as well as that of a limousine service and a funeral home, was in the neighborhood). By this time we were driving through a housing project that had been in terrible physical shape pre-Katrina, and so notorious that even the out-of-state troops referred to it as "bad man's land," but it had not dawned on our savvy war photographer that the abandoned vehicles might have been stolen. "Man," he said, "this doesn't look like a very good

neighborhood, but these people sure had a lot of limos." At this point the two of us were atop the Humvee accompanied by Sergeant Morales and another young man who pulled a Tom Clancy novel out of his jacket every time there was a long wait. When I looked at both of them their shoulders were shaking so hard in silent laughter I thought they were going to fall off.

As we moved—slowly, since the water was now churning beneath us and coming in through the doors —I talked to the men, many of whom had joined the Guard long before it meant an almost certain stint in Afghanistan or Iraq. Havens, a litigation specialist who had signed up in 1987, told me he had talked with his wife early on. "I said, 'If anything ever happens to me and you cry on TV, I'll come back and haunt you. Because we're doing what we want to do, what we're proud to do, and you shouldn't ever be sad.'" We both knew it was unlikely that something so drastic would befall him in New Orleans, but the mission was not entirely devoid of danger—or pathos. Toward the end of the crawl through the project, we came across a dead man, alone and facedown in the grass, his hands, the back of his head, and much of his torso chewed off above the twin waistbands of his white Jockeys and dark jeans, his ribs sticking out but his feet still protected by black leather sneakers. Earlier I had commented on the general good health of many of the dogs we'd come across, and now Havens looked at me: "That's why the dogs aren't hungry."

We stopped but, except for the photographers who were immediately on the ground snapping pictures, there was not a whole lot for anyone to do. Just ahead us, there was an agitated pit bull on the roof of one of the units, and from the radio a voice in front said, "If he's not a threat, leave him alone." Who could tell? I thought, but a subsequent communication was clearer: "Rules of engagement on the shooting of animals, over: If you see any eating human remains,

shoot them." They rogered that, at which point another voice was heard: "The water's coming in here, Gonzo, I mean really coming in"—and we were forced to turn around. Part of the reason for the exercise had been to measure how much the water had receded in the previous twenty-four hours and I was told that it had gone down a full six inches. Only the day before, Morales said, he'd seen a catfish swimming down Claiborne Avenue, another of the city's major thoroughfares that runs parallel to Magazine and St. Charles. Now Claiborne was more or less dry, but the ground was covered in a disgusting sludgy slime that would later dry into a thick dusty hull marked by a web of deep cracks.

On the way back to the TOC, our convoy passed a fire station packed with hundreds of volunteers from all over the country, including the New York Fire Department, who were all veterans of 9/11 and who wore airbrushed T-shirts reading NEVER FORGET. As it happened, it was 9/11/2005, and there was no way, shaking the hands of those men and women, not to cry. They told us they'd all signed on for two-week stints and as we thanked them and began to pull away, they rushed inside and came back out with armloads of extra boxed lunches and cold Cokes and big bags of M&Ms for the Guard, who were so elated by yet another chance to eat real food they let out war whoops.

September 11 is also my birthday, so after another run by Elizabeth's to grab some school clothes to send to Lizzy and a black suit for Elizabeth ("in case anybody dies"), we headed back to Baton Rouge to do what little celebrating we could. I had been in Manhattan on 9/11 and watched the second tower fall; the following year, on September 13, as I was dashing out for a belated birthday lunch, McGee had called to say come quick, Mike was dead. With the arrival of Katrina three years later, Patrick Dunne had emailed to say

enough was enough, that perhaps I should make like the Queen and arbitrarily pick another date on which to celebrate my birth, preferably one not so loaded with bad karma.

Despite recent dramatic events, I had to say that karma-wise at least, this particular birthday was actually not so bad. I was forty-five years old, not exactly the age I thought I'd be when I moved into my first real house—and certainly a lot older than I'd pictured myself being back in the day's when I was rearranging Barbie's furniture—but I'd moved in nonetheless. And yes, a catastrophic hurricane had hit the city I'd finally chosen to live in almost immediately afterward, but it had all but spared our little patch on First Street—Eddie and crew, as we would continually find out, caused us a lot more damage than Katrina. Then there was our drive-through with the Guard, which had reinforced the notion that figuratively speaking, we were definitely eating cake. So it was in that spirit that we headed off to eat the real thing with my cousins, whom I dearly loved and never saw enough of and who really believed (Linda Jane is a devout Catholic) that our being together was an unexpected blessing of the storm.

I believed it too and when we arrived at Linda Jane's, she and her mother and her daughter were waiting with the wedding presents they had never gotten around to sending, a lovely crystal and silver bud vase that had belonged to Linda Jane's grandmother, my great aunt Trudy, along with an art nouveau tea strainer (I am a tea fanatic) that had been hers as well. After we uncorked a bottle of the rescued Billecart-Salmon, John presented me with his present, a glass oil lamp and a big bottle of oil, which was really funny but also typically sweet and potentially useful—it is sitting on the bookshelf behind me as I type just in case. Afterward the two of us went to an oddly romantic and surprisingly delicious restaurant where a really good pianist played at just the right remove and journalists and volunteers and evacuees filled the tables around us, along with

a few locals intrepid enough to venture out among the newly arrived populace. It was another one of those out-of-time experiences in the post-Katrina vortex. We didn't know a soul in the place, our phones still didn't really work very well. Just a few hours earlier we'd been in no-man's-land and now we were in some pleasant anonymous place sharing a decent bottle of wine. I would have been happy to stay there forever.

∽ 10 ∾

URING THE NEXT several weeks, I made a regular loop from
Baton Rouge to Greenville to New Orleans and back, with
the odd trip to New York thrown in between. Natchez is on
Highway 61, between Baton Rouge and Greenville, so on the morn-
ing after my birthday, I stopped to see Rose for the first time. It had
been two weeks and two days since we'd had the conversation about
evacuating, but since then I'd talked to her on the phone enough to
know that she had no privacy in the house with Thomas's cousin,
whom she did not know, and she'd spent whole days standing in line
applying for FEMA money.

She couldn't tell me exactly how to get to the cousin's house and I
don't know Natchez well, so we agreed to meet in the parking lot of
the Wal-Mart. I had barely made it out of the car when she ran over
and picked me up off the ground. Thomas is a proper, reserved sort,
so he stood by the car smiling slightly with his arms folded while we
whooped and hollered and carried on. I was brimming with promises
and enthusiasm—I'd blithely assumed that as soon as it was possible,

she'd want to return to New Orleans just like me. But when I mentioned finding them an apartment in the event that theirs had been damaged, I could tell she was terrified at the thought of coming back. And then I stopped for a minute: Of course she was. All she had seen for the last two weeks was television footage of people—the great majority of whom were members of her race—wading through the floodwaters, waiting on rooftops, perishing in front of the convention centers; members of her own family had come terrifyingly close to being among them. Then there were the warnings of typhoid and cholera, and, after that, of toxic mold spores from the dried sludge (which Brobson had already characterized as more of the same alarmist hooey). In the best of times, as Roseanna reminded us whenever they got into it, "Rose's nerves are bad." The first thing she had asked me was if I had seen any snakes.

Unlike me she had a lifelong history in the city, but no financial investment. Even if I'd dreaded the thought of returning, I would need to get pretty chipper pretty quick, on the assumption that there was not much market for a half-finished house in a hurricane-walloped city. But Rose and Thomas rented their apartment; their neighborhood was in far worse shape than mine. Thomas had worked as a mechanic in the same garage for years, but his boss had never given him benefits of any kind, not even health insurance. The only reason for either of them to return would be the tug of roots and family (I knew without asking that Roseanna, who owned her house, would not stay gone for long), but I could tell it might be a long hard pull and I couldn't blame them. I hugged her again and gave her a month's salary and promised to see her during the coming weekend.

It was on my way back through that I noticed the billboards advertising Podnuh's barbecue. All I had brought my Oklahoma boys so far had been cakes and snacks and sandwich stuff—it was time for some hot food. I figured that if Podnuh's was advertising as far away

as Natchez, which was an hour north, it must be good, so I called the Baton Rouge location nearest Linda Jane's and ordered brisket and ribs and pulled pork for seven hundred, along with baked beans, potato salad, and cole slaw. There was a slight pause on the other end of the phone but then a very determined young voice assured me that he could do it, that I could pick it up the next morning. When we got there, I was amazed. This particular Podnuh's was a tiny place attached to a gas station just off the interstate; the staff had stayed up all night filling the order. I felt awful for laying such a job on them, but the young manager—yet another person who could have done a better job running FEMA—assured me that I shouldn't, and flashed me an enormous grin: "We've just met our quota for the next two weeks."

When I looked at the bill, I knew he wasn't exaggerating—one of the many things about me that has always driven my father, and now my husband, totally crazy is my ability to order up barbecue for a literal battalion without even thinking of asking the price. Still, I was flush for the first time in a year—with the exception of the ones to Benton and Mr. Dupré, neither John nor I had written a check to anyone in almost three weeks. It was exhilarating—like being on temporary parole from debtor's prison. Besides, when we started hauling great heaping containers of the stuff up the steps of the TOC, the men were ecstatic. Captain McGowan on the other hand was almost embarrassed: "You know, you really don't have to keep doing this." I told him I did indeed know that, it was part of the joy of it. These guys had come all the way from Oklahoma, they were spending weeks and maybe months away from their families, sleeping on either the concrete floor of the most ridiculous building in town or in tents in a nearby vacant lot in heat that constantly hovered around 100 degrees. They had cleaned up the place and restored order to "Dodge City," and so far they had not seen the mayor or the police chief or the

governor—somebody had to welcome them, and I realized for the millionth time how easy it is to make people happy by feeding them.

Our next stop was the Sarouk Shop, where we delivered more ice and a couple of chickens to Bob so that Ellis could knock himself out on Jean's gas stove. By this time, Bob's signs had appeared on CNN and the front page of *Le Figaro*, and, given the publicity, he figured he'd add a plea of sorts to potential tourists as well as to the locals and their carnival krewes: "You Know What It Means to Miss New Orleans. Y'all Come Back for Carnival. I Have my Parade Spot. Come Back Rex, Iris, Zulu, Bacchus, Toth. Proteus, Hermes, Muses, D'Etat, Elks, Babylon. Hey Throw Me Something Mister." Next door, at Emeril Lagasse's Delmonico restaurant, there was a white patch where Bob's "Looters Shot" message had once been emblazoned in big black letters. When I asked him what had happened he told me that the young Emeril's employee who turned up to check on the property was so aghast by his graffiti that she'd gotten back in her car and made the hundred-mile roundtrip to Houma and back to purchase the nearest can of white paint. His warning, she told him, was not "the kind of message the Emeril's organization wants to send." Maybe not, but I'm pretty sure that neither was the message Bob's neighbor promptly scrawled over the white space: "Emeril Is a Wuss."

When we finally made it to First Street, I had to laugh: Three Guardsmen from Pennsylvania were parked in front, taking pictures of each other posing in front of Anne Rice's great violet-gray manse directly across from us. Pre-Katrina, this was a familiar sight— dozens of tourists a day came by on foot, by tour bus, in limousines or in cabs, and now we had a handful in a Humvee. Rice's career-making *Interview with the Vampire* had been published in 1976; since then, more than a hundred million copies of her books had been sold. For years, she'd arrived at book signings at the nearby Garden District Book Store lying in a coffin, and at the annual Halloween par-

ties for her devoted fan club she did the same. She'd been great for the neighborhood because she was a devout preservationist—at one point she had owned at least four other huge properties, which she'd restored and kept up beautifully. She'd moved into this particular house in 1989, and it had not only been her primary residence but also the setting for *The Witching Hour*, which had come out in 1990.

Some of our neighbors complained about the constant traffic—and the more goth-like elements of many of the sightseers—but I completely understood the allure behind their pilgrimages. I'd read *The Witching Hour* just before I'd arrived in New Orleans that first summer, and had been completely hooked by its descriptions of the "townhouse on the corner" with its "white fluted columns" and "tapering keyhole doorway." Lying in bed in my apartment in Manhattan, I wanted to will myself into the "engulfing stillness and greenness" of the setting, but I never imagined that almost every description, from the "plaster medallions fixed to the high ceilings" and the floor's "heart pine boards" to the "long silk draperies" and "carved marble fireplaces," could someday be used to describe a house I would actually live in, or that it would be across the street from the one I was reading about. I'd been in the Rice house once, years earlier, when I'd interviewed her for *Vogue*, and it hadn't occurred to me then either, but I had loved the house and liked her, a lot. I'm sure I would have liked being her neighbor too, but she no longer lived there, having sold all her properties and moved to San Diego after her husband, Stan, an artist and poet, died of cancer. The fact that she now lived on the other side of the country had done nothing to diminish interest in the house, and it was heartening to see the first Anne Rice "tourists," even if they were under orders to be here.

It was still way too hot—and too dark—to think about spending the night on First Street, even though Byron had given me tips: "What you do is sweat and get the bed soaking wet and then you cool

down and go back to sleep." We decided, instead, to head back to
Baton Rouge, but first we stopped to meet Brobson at Molly's at the
Market. Molly's is an Irish bar in the Quarter that had been open
almost as regularly as Johnny White's, though, as Brobson pointed
out, it was decidedly more "white collar" than the "blue collar"
Johnny's, where the good doctor had become something of a hero
by successfully treating the numerous boils afflicting the clientele to
whom the FEMA medics had given the wrong antibiotics.

Brobson had been living well at his house on Dumaine because
he had wisely allowed the *Wall Street Journal* to set up camp there
and they came complete with two generators and the resources to fill
them up with eighteen gallons of gasoline every day. Not only was
his place a news bureau, it was also, as the banner draped across the
front balcony announced, the "French Quarter Health Department
in Exile." His friends in the police department let him into one of the
pharmacies they'd commandeered, so he was able to dispense drugs,
and, with the help of some "renegade" paramedics from California, to
run a far more helpful sidewalk operation than FEMA, whose emer-
gency clinic was hidden in the bowels of the Royal Orleans Hotel and
required getting past two sets of cops at two sets of doors. At one
point, his Uptown office even became a morgue of sorts. The owner
of the New Orleans Cookery had ridden out the storm in his Conti
Street restaurant with a crowd Brobson described as "his girlfriend,
his girlfriend's son, eight or ten dogs, twice that many cats, and a
bunch of birds." When the poor man died of a heart attack a week or
so later, the girlfriend had found some policemen who had come and
pronounced the obvious, but that was all they knew to do. "Nobody
was removing bodies yet," Brobson said. "But she had him there in
that restaurant with all those dogs and cats, and with the heat, he was
starting to swell up, so I went on over."

Brobson and his paramedic buddies wrapped him in "a bunch of

plastic bags," and headed toward a funeral home the coroner had told them might be open. But it turned out to be still under water. Brobson's office is on the same block of Napoleon Avenue as the flooded former Memorial Hospital just off Claiborne Avenue, but it's a classic New Orleans raised cottage, high off the ground, and no water had gotten inside. They put the body in a back room, where it stayed until FEMA retrieved it several days later.

Brobson was full of all sorts of slightly less macabre information, including a useful tidbit he had gleaned from a fellow Molly's regular on "the best possible use for an MRE": the heating elements from eight of them are enough to heat an entire bathtub full of water. While he talked I checked out the action at Molly's, where reporters and insurance adjustors and contractors from across the country joined the assortment of Quarterites too stubborn to leave, packing the bar and spilling out onto the sidewalk and into the backs of the pickup trucks parked out front. The bartender, a stunningly beautiful young woman wearing white rubber shrimpers' boots, a bathing suit top, and a denim miniskirt into whose waistband she had stuck a bottle opener at the small of her back, was taking cash tips from the out-of-town adjustors and contractors that were three and four times the cost of the drinks themselves, while several harried employees kept toting in huge bags of ice from God knows where.

In my early Quarter days I had clocked many an hour at Molly's, which makes the best Bloody Mary in town and is a favorite of politicians, journalists, and the Romanian writer Andrei Codrescu, who once cited as his reason for moving to New Orleans the fact that its residents had "complete disdain for the whole yuppie, Puritan ethos of exercise and denial." If people run here, he added, it is usually "from someone." Like Codrescu, Molly's founder Jim Monaghan was a transplant who visited the city in the 1970s and decided to stay after catching a glimpse of Ruthie the Duck Lady, wearing her ubiquitous

rain hat and pulling one of her pet ducks behind her on a string as she skateboarded through Jackson Square. Ruthie, a sickly child whose only education had been kindergarten, spent more than sixty years in the Quarter, cadging beers and leading her ducks around, just as she'd done in her youth, when, as the Duck Girl, she and her brother sold picture postcards of her likeness at three for a dollar. The *Times-Picayune* theater critic David Cuthbert once wrote that the striking thing about most of the Quarter characters like Ruthie was that they took themselves entirely seriously, that while they may have evolved into tourist attractions, their "act" was not, in fact, a pose.

Either way, as soon as Ruthie had passed by, Monaghan looked at his wife and said, "This is the kind of place I'd like to live." He went on to own thirty different bars in New Orleans, and though he died four years prior to the storm, he was still very much with us—the new owner, his son Jim Jr., had placed the urn containing his ashes on a shelf above the booze. Now, looking around at the jovial crowd of locals in particular, I realized why I loved living here too—there was the brilliant, ponytailed criminal lawyer who had succeeded in having the wrongful conviction of one of my closest friends overturned; there was the owner of the eponymous art gallery Arthur Roger, holding court from a pickup while his basset hound Ariel sat faithfully beside him. The lights weren't on yet, but signs announcing an impending neighborhood meeting were already posted on the bar's walls.

After a few exquisitely cold beers, Brobson escorted us the four blocks to the Royal Street Grocery, which he had taken to calling "the new Galatoire's"—no matter that other than the occasional Red Cross truck, it was also pretty much the only hot food in town. The store, around the corner from my old place on Bourbon, has been in the same family since 1938 when 20,000 people lived in the Quarter and more than a dozen places just like it served the neighborhood

with po-boys and groceries and chicory coffee and conversation. Skyrocketing rents and a much smaller population (the Quarter is now home to less than 2,000 full-time residents) had driven out most of its former competitors, but the original owner's grandson, a lawyer who still practices in order to pay the bills, took the place over primarily to keep the family tradition alive but also because he likes it. Even before the gas was turned back on, he was out on the sidewalk, flipping steaks and simmering pots of gumbo on a propane-fired grill, while his three-year-old daughter, Ava, served as hostess to the handful of tables inside.

Brobson told us that during the last week he had dined there daily, enjoying red beans and rice and burgers on French, as well as such delicious occasional specials as sausage po-boys and crawfish *étouffée*. The state health inspectors had been put off by the initial lack of running water, and, after that, by Ava's cat, but since, as Brobson pointed out, "Those folks don't work after three o'clock," the cat was not forced to stay in hiding all day and was snoozing peacefully beneath the counter when we arrived. A day or two after our "dinner" there, a pink paper, the permit posted on the door saying restaurants were legal to serve, was finally granted, which came as a great relief to the neighbors, especially Brobson, who told me, "I think hunger is a far greater health hazard than eating around a cat."

We agreed, and happily dug into a couple of chili dogs, which were all that were left at the end of the busy day. After saying our goodbyes and vowing to return to sample more from the Royal's extensive list of delicacies, we headed back up I-10 to Linda Jane's.

The following week I was in New York when I realized the deadline to fetch Antoine in Denton was looming. It had been three weeks since the hurricane, and the electricity in our neighborhood was due to come back on any time. I decided the best thing to do was just bring him back to town and see what happened—at the

very least I could pick up an air mattress on the way (so far, John and I owned only the lone mattress and box spring) and move him in with us.

I was actually looking forward to the journey. Denton was a day's drive from New Orleans, and Dallas was on the way. John's first cousin Andrew, with whom he'd been raised, and whom he always referred to as his brother, had for many years suffered from schizoaffective disorder. Not long before we had started seeing each other, John had been forced to commit him to "a group home," a collection of townhouse apartments in New Orleans East, populated by people with needs much like Andrew's. In the days before Katrina hit, John had made sure that Andrew was evacuated with his roommate to a similar facility in Dallas, so I figured I would take Andrew whatever he might need and spend the night there before going on to Denton, collecting Antoine, and enjoying a festive trek back.

And then I called Camp Copas. The same officious woman I had talked to the first time gave me the "wonderful news" that Antoine had been tracked down via Red Cross computer by his "wife," a woman named Cassandra, and that he had been put on a bus to Houston so that the two of them could be reunited in wedded bliss in a FEMA-funded room at a Motel 6 on the Katy Freeway. For a long moment, I honestly thought I might have a stroke and I started to tell this woman what she had done, but then she told me she had a phone number so I took it wordlessly and hung up. The motel operator connected me to his room and when somebody who was not Cassandra answered, I asked for Antoine. I could hear people and television and all manner of commotion in the background, and when a groggy Antoine finally came on, I announced brightly that I was on my way to pick him up. This time, there was no laughter, no joyous relief, and definitely no breathless "Boss Lady" greeting. The only words out of his mouth were, "I'm sleep." It was two o'clock in the afternoon and I

didn't know who I wanted to kill more: the wily Cassandra, the idiot Baptists, or Antoine himself.

During the course of four or five more calls over the next two days, I managed to piece together that they were ensconced in a block of motel rooms with some folks Antoine referred to as his "brothers," as in the siblings to whom he had never been close (I had met only one of them, years earlier, when he'd come to pay a call on Antoine and stole a bottle of bourbon from my bar) and Cassandra's "children," who had never, until this moment, lived with their mother. Whoever they really were, they were all pretty well set, since in those early weeks, FEMA was still paying out $2,000 per person in emergency assistance in the form of checks or debit cards, in addition to picking up the tab for lodging. Later I would find out that Cassandra had managed to supply "proof" of two hurricane damaged houses at two addresses, one each for her and Antoine, and she had received additional payments for each of the children she claimed, along with hefty—and seemingly indefinite—disaster vouchers not just for their rooms at the motel but for the apartment complex they subsequently moved into. Antoine, who was high as a kite every time I got him on the phone, no longer had the remotest desire to be "rescued."

Most people, of course, desperately needed the help, but at a congressional hearing several months later, it was revealed that FEMA had paid out $1.4 billion in fraudulent aid during those first few weeks alone, and that the money had gone to such varied pursuits as a week's vacation at a resort in the Dominican Republic, season tickets to the New Orleans Saints games, and the services of a divorce lawyer in Houston. Since drug dealers don't ordinarily hand out receipts, there was no mention of crack cocaine, but, in an effort to figure out how long it would be before I had any hope of hearing from Antoine again, I had already tried to calculate how much of the stuff I thought he and Cassandra could now afford to buy, and how long it might take them

to smoke it. The results did not bode well. A single emergency debit card could pay for up to 200 rocks or 50 grams, which, at roughly three inhalations per rock, translated to 600 hits. Given that a mere two or three rocks led to behavior that inevitably landed him in jail, I would likely never see Antoine again. As Rose said when I gave her the news, "They don't play in Texas." So much for our triumphant return to the city.

Instead, I arrived solo, on Friday, September 30, a month and a day after Katrina made landfall, in order to lead CNN on a tour. A second hurricane, Rita, had devastated the areas to the west of us and forced the mayor to delay the reopening of parts of the city. Now folks were finally being allowed in, and the producers wanted to show them a slightly quirky and less grim version of what they might find. My first stop, naturally, was Bob's shop, where they filmed me dropping off yet another cooler full of chicken and ice, and where at least ten more damaged rugs had been spread out in front, along with a new sign: "Welcome Back Y'all. Grin and Bear It." I showed them the goofy Eiffel Tower TOC, and a house on St. Charles where a 200-year-old oak had landed, hatchet-like, in the center of an otherwise undamaged Greek Revival house. We walked down Canal Street, past the still pristine Brooks Brothers window, and into the Quarter, where the Big Daddy's Big Ass Beers banner, accompanied by an enormous helium frosted mug, dominated Bourbon Street. On nearby St. Louis, in front of Alex Patout's restaurant, the open-shirted owner, Finis Shelnutt, sat at a bistro table sipping Champagne from a flute and stirring a huge propane-fired pot of spaghetti. Shelnutt, the ex-husband of Gennifer Flowers (who, until just a few months earlier, had performed most nights at the piano bar on the ground floor), had stayed through the storm and turned out to be the source of the never corroborated rumors that looters had shot a policeman in the head. Sitting there in his diamond-encrusted Rolex and

gold-rimmed glasses, he was clearly enjoying his celebrity, so we skipped him, heading instead to Molly's, where I met Brobson and Byron and John, who were happy to join me in a cold beer for the benefit of the camera.

We spent that night in the Royal Sonesta, the Bourbon Street hotel that had become the CNN bunkhouse, and Byron slept in his usual sweat-soaked bed, but we were all in equally excited moods the next day when we met for lunch at Stanley, whose recent opening on Decatur Street had been major news. Stanley is the casual off-shoot of the critically acclaimed Stella, whose chef had been planning Stanley's opening long before Katrina hit, so when she did, he postponed the planned menu of sophisticated sandwiches and po-boys (think fried catfish with *rémoulade* sauce and house-made cole slaw), fired up his grill, and started selling hamburgers with hand-formed patties and ripe Creole tomato slices for five bucks apiece. The line stretched for blocks, and while we were standing in it, a girl on a bike came by with fliers touting the immediate reopening of ZydeQue, an upper Quarter restaurant co-owned by my buddy Tenney Flynn, who is also the co-owner and chef at G.W. Finn's, an excellent upscale fish restaurant around the corner. It had never occurred to me to seek out barbecue in New Orleans, even if it was Tenney's, but now that it was on offer, we could not wait to go, and began planning dinner before we even sat down to lunch. This was the New Orleans we all knew and loved—the place where you talk about food in the rare moments when you don't happen to be eating any.

There was a limit of one burger per customer, so we ate slowly and exchanged the latest animal rescue stories. Byron had seen a van advertising itself as an Avian Rescue Unit in his neighborhood that morning, and once again, we had to laugh at the innocence of the do-gooder newcomers. While I'm sure plenty of abandoned parakeets and parrots might well have needed care, rescuing them in New Or-

leans is not exactly a clear-cut proposition, since thousands of wild Argentine "monk parakeets," also known as "Quaker parrots," have for decades happily—and noisily—dwelled in our trees. Twelve inches long and lime green with lovely pale gray faces and chests, the birds do not migrate, which means at least two of them either escaped from captivity or were intentionally released sometime around 1972, when the first pair was spotted in the suburb of Metairie. They make communal nests out of sticks, complete with compartments, and can be found all over town in anything (including telephone poles) re-motely resembling a palm tree. I told Byron they'd likely be as miser-able over being captured as our neighbor Allison's feral cat who had been "rescued" two days earlier.

When John and I checked on the house that morning—and dis-covered to our great amazement that we had electricity—we also found a note from the LASPCA stuck in our mail slot, informing us that they had removed "our" silver tabby to a shelter in Gonzales. At first I couldn't believe that after four weeks the rescuers were still so hard at it, but then I realized it had probably taken even the most zealous volunteer the full month just to catch that one cat—he was incredibly beautiful with exotic markings, but so relentlessly wild I was honestly afraid that being put in a crate might have already killed him.

Byron went back to mend his fence and we went back to revel in the fact that we had power. Though the same doomsayers who predicted the typhoid epidemic were also warning us not to bathe or drink the water, I continued to take my cues from the unflappable Dr. Lutz, who was doing both. Since returning to the city, Brobson had been emailing his friends occasional "reports from the bowl," in which the results of his long, therapeutic soaks in the bathtub and his "in vivo" testing of the water supply were always the same: He was still alive and well. My own bathtub was still unfinished but John's

lavish shower was done, so we availed ourselves of all its many nozzles for the first time in more than a month, and celebrated a tiny milestone in the city's recovery along with the rehabitation of our house.

That night, as we made our way downtown, I realized that the National Guard's Humvees were now outnumbered by the even more bulbous vehicles of the contractors and electricians and engineers we'd seen at Molly's. Apparently even insurance adjustors don't drive cars anymore because there wasn't one in sight—the entire unflooded part of the city looked like the parking lot of the world's largest monster truck rally. Hundreds upon hundreds of them were parked on the neutral grounds, on the sidewalks, on both sides of every street, which meant that the narrow thoroughfares of the French Quarter were especially harrowing to navigate. Undeterred, we met Byron and set off for our first post-Katrina meal in the city that would not be a hamburger or a hot dog, tasty though they'd been. Chef Tenney, who ordinarily would have been in the kitchen of his "proper" restaurant, serving up impossibly light lobster dumplings, sizzling smoked oysters, and by far the finest pompano in New Orleans (if not the country), was in the corner at the wood-fired oven, happily tending half chickens and slabs of ribs—he had even figured out a way to make individual pecan and apple tarts on the grill. Recently divorced, he'd been living in a house trailer across the lake in Folsom, which was still deprived of power and more than fifty miles from the restaurant where he was putting in fifteen-hour days. When I asked him how he was holding up, he just grinned—a cook likes to cook and he was, pardon the metaphor, on fire.

We had a stellar gumbo, of stock that had been made from the remnants of all those chickens and which was served Cajun style, with a scoop of creamy potato salad in the center rather than rice, followed by the chickens themselves, plump and tender and succulent

with just the right hint of smoke. We could hardly speak we were so happy, a condition prolonged by the two bottles of Oregon Pinot Noir I'd brought along: a knockout 2002 Beaux Frères that had been a wedding gift, and a Domaine Serene that had long been a favorite of McGee and me. I figured that if there was ever a good time, in her words, "to drink some serenity," it was now, but really, we'd already achieved it. The various truck owners were piled in at the bar munching on ribs and watching college football on TV, Tenney was making magic at a rare working oven, and I was sitting across a table from my dear friend and my husband, with whom I was about to go home—to our house—for the first full night since the storm. Brett Anderson, his sunburn faded and his wild-eyed look mostly gone, came over to share a glass and we each raised one, not for the last time, to friendship and endurance and our amazing good fortune.

When we got home, the first thing we noticed was the utter stillness and quiet. From the time we had owned it, the house on First Street had been full of noise. For more than a year, all day long, people had been hammering and sawing and drilling, yelling at each other, knocking down walls. Once we'd moved in, we heard the same nighttime sounds of gunshots and sirens as everybody else across the city, but on this night there was nothing. The city had only been "open" for a day or two—all of our neighbors and well over 80 percent of the population were still gone; the guys in trucks were concentrated in a few downtown hotels. I'd never been in such a large urban space so sparsely populated; I had also never seen such an astonishing sky. When I left the Delta I rarely bothered to look up at night—the lights in all the cities I'd lived in, including New Orleans, made the stars barely visible. But now, not only had Katrina knocked out the electricity in New Orleans, there were no lights to speak of all the way to Mobile. I felt as though I were looking through a telescope.

Bob had told me that on the first night after the storm, the night

before he'd been disturbed by the car thief, he'd been awakened by the far more pleasant sound of hundreds of owls who had blown in off the lakefront and taken refuge in the great oaks on St. Charles. When he'd walked over to get a closer listen, he'd looked up and seen the Milky Way. "There it was," he said. "Clear as I've ever seen it from the middle of the Atlantic Ocean."

Telling it, he had still been a little awestruck, and now I knew something of how he'd felt: completely alone, a little brave (even though by the time I looked up there was nothing much to be afraid of except the city's unknown future and I had a bizarre blind faith in that), and suddenly proprietary. We were pioneers of a sort and even the sky was ours, however briefly.

When I looked up that night, I didn't see the Milky Way, but I did think of Robert Penn Warren's lovely lines from "Audubon": "Tell me a story. In this century, and moment, of mania, Tell me a story. Make it a story of great distances, and starlight." In the emptiness where I was standing, the poem, subtitled "A Vision," seemed startlingly appropriate, topical even; also, part of Audubon's own story had played out under the same intensely starry sky. It was here, mostly in a studio on Dauphine Street, that he had painted his brown pelican and great white heron, his snowy egret and sandhill crane, my favorite fish crow dining on a crab. (Broke, he'd also painted the nude mistress of his friend Bernard de Marigny, Celeste's brother who introduced the game of craps to Louisiana and who kept his many mistresses on a street in his new "subdivision" called rue Amour, which, like his original Craps Street now known as Burgundy, sadly goes by a different name.)

When Audubon came to New Orleans in 1821, he was impoverished but determined to follow his passion, and he set for himself the task, which he came impressively close to meeting, of painting a bird a day in order to finish his mammoth *Birds of America*. I envied him

his extraordinary ambition and discipline but also his freedom and his intimacy with the natural world—watching the passage of "millions of Golden Plovers" in the woods outside the city, jumping in his rowboat whenever he needed to procure a new species for his drawings. I even envied Bob his owls. New Orleans had always been lush and green and even a little wild, but since my early childhood, when the "country" just outside of Greenville where we lived began to get increasingly populated, I had missed the rawer aspects of nature. And then, as if on cue, the crows appeared. On our first morning home, I was visited by a whole flock of them: they landed two and three at a time on the railing of the second-story balcony just outside my office windows, and spread out into what was left of the ancient magnolia and the enormous live oak that flanked the house.

Unlike the Creoles, who, according to Audubon's letters, made gumbos out of the "barred" owls they bought for 25 cents at the French Market, John is firmly an owl man. As a wedding present, I'd given him a tiny owl stickpin made of diamonds with emerald eyes, but I have always been partial to the majestic raven, even though in this instance I certainly knew what they were doing in town. Crows and ravens are scavengers after all—not only do they have an uncanny ability to detect the dead, they have a literally "ravenous" appetite. They are also generalists in their eating habits and I pictured them munching on the piles of newly beached crabs like the one Audubon had painted in the mouth of his fish crow. They're lordly, yet lithe and elegant in their flying patterns and I had always wanted to go dressed as one to a costume party, with great wings and a headdress made of their glossy black feathers.

For years, one of my favorite restaurants in London was an elegant, now-defunct place called Odin's. Until I found out otherwise, I thought it had been cleverly named for the Norse god who gave up one of his eyes in exchange for dipping his cup in the well of wisdom.

Thereafter, he relied on the ravens Hugin (thought) and Munin (memory) who flew through the nine worlds and returned to him at night, perching on his throne and whispering news of all that had transpired. The fact that Odin had made the correct choice of bird for such a mission was confirmed not long after my own visitation on one of my many drives through Louisiana and Mississippi when I heard Constance Savage, a writer who has chronicled the doings of crows for years, on NPR. According to Savage, "For their size, crows are among the brainiest organisms on earth, outclassing not only other birds, with the possible exception of parrots, but also most mammals." Further, she said, their ability to make and use tools is a distinctive characteristic of humans, and when they sing together, they actually harmonize as "a mark of friendship or social affiliation." Though my crows filled the air with random-sounding caws and "quorks" rather than harmony or whispered news, they seemed somehow to possess plenty of the latter. I found myself wanting so badly to talk to them, and I looked forward to their morning visits.

11

THE FIRST WEEKEND in October, the Viking Range Corporation, which makes stoves and refrigerators and all sorts of other appliances, and which happens to be headquartered in Greenwood, Mississippi, six blocks from Lusco's, held a retreat for the displaced chefs of New Orleans and I was enlisted as a cheerleader.

The purpose was to hold informal discussions to find out what everyone needed most, but also to provide some much needed R&R in the form of rooms and meals at the surprisingly luxurious and really cool company-owned hotel, The Alluvian, and treatments at the well-appointed spa across the street. Among the guests were John Besh, a Gulf War vet and the aforementioned supremely talented chef/owner of Restaurant August and Besh's Steakhouse, who, in the days immediately after the storm, had fired up his butane boiler, put it on a flat boat, and served hundreds of pounds of red beans and rice to folks stranded by the flood. Susan Spicer was there from Bayona, along with Greg and Mary Sonnier from Gabrielle, whose restaurant near City Park had suffered extensive damage, and Leah Chase,

who, at eighty-two, was the undisputed *grande dame* of Creole cooking and whose restaurant Dooky Chase had taken on several feet of water.

I was happiest to see my friend JoAnn Clevenger, owner of Upperline. I had interviewed JoAnn for one of the pieces I'd written just after the storm, and by the time we'd hung up, she'd given me an assignment: convince Ken Smith, the restaurant's chef, to return to the stove. I was happy to oblige—Ken is a gifted cook, a dear friend, and he shares JoAnn's and my passion for collecting old cookbooks—owner and chef had been brought together through a rare bookseller. Ken and JoAnn are both from north Louisiana, Natchitoches and Alexandria respectively, but Ken is a lot more fond of it up there, and I knew uprooting him from his evacuation roost in what he calls "God's Country," was not going to be easy. Much of my driving time during the last month had been spent on the phone with either Ken or JoAnn, but it had paid off. Ken was returning to New Orleans (mainly, I think, because his beloved books were here) and to the restaurant; JoAnn had come to the retreat for encouragement and advice on how to get it up and running.

Those with families brought them, and it was all very gay, but some folks were clearly better off than others. Besh, for example, was simply recharging before returning in the next week or so to reopen August and to nail down a contract to feed FEMA workers—he had bought the three-story brick building that houses August literally days before the storm and the contract would enable him to pay the mortgage. No matter what their situation, everyone was worried about staffing; JoAnn was worried about whether or not any of her wine, which was worth many uninsured thousands, had survived the heat; and Greg and Mary were worried about where—and if—they would reopen.

One person missing was my good buddy Donald Link, and when

we got back to town, we found out why—Herbsaint had reopened that weekend, becoming the first "white tablecloth restaurant," using real china and silver and offering both lunch and dinner, to have done so. Pre-Katrina, the restaurant had forty employees; the first night we dined there, six people were doing it all. The manager was also a busboy, the sous chef was also the dishwasher, and everybody was dashing around madly, dressed in the Herbsaint T-shirts usually reserved for games in the restaurant soft-ball league. The customers, on the other hand, were not harried at all, but profoundly grateful. In the midst of a city that was still, essentially, a wasteland, Donald had pulled it together and given us a glimpse of Life As We Had Known It. The crowds that waited on the sidewalk outside—drinking, talking, laughing, greeting—reminded me of the glory days of the Galatoire's line; in the ladies' room I heard a woman exult that it was "just so great to see other people." Not all of his vendors were even close to up and running but Donald improvised brilliantly, offering up comfort foods like his usual fine gumbo, chicken and dumplings, meatloaf enhanced with tiny bits of andouille sausage, and an excellent iceberg lettuce salad with fennel and applewood-smoked bacon that was so good everyone demanded that it stay on the menu long after the usual arugula and *frisée* and romaine were easily procured.

The night Herbsaint reopened happened to fall on the same date as the planned grand opening of Cochon, a restaurant with a sophisticated Cajun emphasis that Donald and his sous chef Stephen Stryjewski had been working on for more than a year. Donald and his wife had lost their house in Lakeview in the storm and were staying at his brother-in-law's place in Metairie with their six-year-old daughter. At the end of the night he was so wired he went through at least one bottle of tequila before he could even think about tucking into his mattress on the floor—a practice he discontinued when the dairy delivery guy found him throwing up in the kitchen's garbage can early

one morning. He is German on one side and Cajun on the other, with a subtle sense of humor and extraordinary focus. He is also a truly great chef and it hadn't surprised me a bit that he had been the first to open and that he was pressing on with plans for Cochon.

"What else are you going to do?" he asked me that night. "We didn't bring this on ourselves, it was just something that happened." In the middle of his second week, during a particularly brutal lunch service, he noticed two Mexicans having a drink at the bar. They told him their FEMA gig had just run out, they'd lost their lodgings, they were headed back to Texas that afternoon. Donald didn't miss a beat—he ripped off his apron, grabbed the newspaper, and came back an hour later with keys to one of the last habitable apartments in the city. In little more than an instant, the Mexicans had become Herbsaint dishwashers on a fast track to becoming kitchen assistants.

Donald also told me that as tough as it had been to get it open, the restaurant had immediately become a sanity-saving "sanctuary" for him and his staff. "When we leave, there are reminders everywhere that it's not the same," he said. "In here, it's just the normal day to day." I knew exactly what he meant—it was the chefs who saved us. Every week there were more and more places to go for sustenance, a few hours of normalcy and camaraderie, and, most important, hope. People like Donald were just doing it: cleaning things up and repairing what was broken, taking out loans and cheering on their employees, all of whom were doing the work of at least five people. Nobody had seen the mayor, no one had heard a plan, but if these guys could do it, so could the rest of us. When Besh reopened August, I ate the same lunch special, a Moroccan-inspired chicken stew with pistachios instead of the pine nuts he couldn't get, three days in a row—not because nothing else was on offer (the menu was in fact surprisingly extensive), but because it was so totally delicious. They were all winging it, and cooking better than ever.

A few days after our first dinner at Herbsaint, I walked the twenty-something blocks up Magazine to Upperline Street to visit JoAnn. It was the second week of October and still hot as hell. For weeks now it had been too late to salvage a refrigerator by cleaning it out, so when people got back to their houses, they simply duct-taped them closed and set them on the sidewalks. Their stench was overpowering but they made such great venues for graffiti that a small book of refrigerator photos was printed up in time for Christmas. The most popular messages were "Here lies the heart of Tom Benson" (Benson is the owner of the New Orleans Saints who had threatened to move the team to San Antonio), and "Please forward to 1600 Pennsylvania Avenue" (the address of the White House). There were those that could only have been found in New Orleans—"Voodoo Today Here Now 5 PM" along with the slightly grosser "Free Gumbo Inside" and "Got Gravy"—and at least one that lampooned the cat saviors, "No Pets Inside." Some were just weird—"My Lover Is You!"—while another performed a public service: "Slow the Fuck Down."

During my trek, there was little traffic, fast or otherwise, which was a good thing because enormous piles of tree limbs and trash made the sidewalks all but unnavigable. By the time I got to Upperline Street and the restaurant, which was five more blocks off Magazine on the corner of Prytania, I was about to pass out, but when I got there I quickly rallied. All I'd done was walk, and here was JoAnn down on her hands and knees scraping up carpet glue. Since the restaurant is on high ground and hadn't flooded, I assumed her roof had leaked but that did not turn out to be the problem. The stench from her own refrigerators had gotten into the wall-to-wall carpet of the front room and there was nothing to do but pull it up.

JoAnn is a trouper—in every sense of the word. Her first home in New Orleans had been an otherwise empty infectious disease ward in the back of Charity Hospital that she shared with the nuns who

terrified her ("I had grown up Baptist"), and her mother, who was slowly dying from a rare fungal disease called coccidio mycosis she'd contracted through a small cut over her eye. Her father was, as JoAnn put it, a smart man with little education and a "Zane Grey sense of adventure" who moved the family constantly, so it was left to JoAnn, at seventeen, to come to the city with her mother while also taking the bus from the hospital to high school every day. Though she'd transferred to town in her senior year she was bright enough to become a National Merit Finalist, which earned her a picture on the front page of the *Times-Picayune*, a key to the city, and a scholarship to Tulane. When her mother died during her first year there, she "fell apart," she said. "I thought, you know, since I was with the one who was with her, I should have been able to save her."

Her grades failed and she lost her scholarship, so, completely on her own, she took an apartment in the Quarter. For the next several years JoAnn would work as a waitress and meet pretty much everybody, including Tennessee Williams and Dizzy Gillespie, for whom she mixed a drink when the white bartender refused to do it (they became fast friends). She bought her own bar, the Abbey, for $1,500, built a back bar out of two old mantels, and became the only tavern owner in the entire Southeast to offer Guinness on tap. She also served up such exotica as free cheese and pumpernickel on Sunday mornings as well as the Sunday *New York Times*, which she had to go all the way to the airport to pick up. ("We had this lazy, eclectic group of people coming in to get their paper and bread and cheese.") A few years earlier she'd started a business selling bouquets from a cart, which she now expanded into the Abbey, and which led to a successful lobbying effort to change the state law keeping everyone but licensed florists from selling cut flowers. Part of her strategy was placing a flower on the desk of each legislator, along with a greeting card in the shape of a cart. "I think that brought more happiness to more people than any-

thing I've ever done," she told me. "Because think about it—now, all over Louisiana, little grocery stores can sell flowers."

Along the way, she married, had a son and a daughter (her husband worked in the day; she worked at night), and met her second husband, a British engineer who approached her in a bar called the Seven Seas and told her she looked like Ruthie the Duck Lady—a line so "unpredictable" she forgave him, she says, and "anyway, he was the cutest dancer you can possibly imagine and I can't dance." After she got a divorce and married Alan, she opened a secondhand clothing and costume shop that led to a job as costumer for the musical *One Mo' Time*, which ended up playing in Manhattan for three years. In 1982, just back from a *One Mo' Time* tour through Australia and New Zealand, she found the building that would become Upperline and opened in January 1983 with "forty chairs, no money for the first week's paychecks," and her son Jason, who had been chef at Café Sbisa's in the Quarter, at the stove. Now, almost twenty-four years later, she was on all fours with a razor blade scraping up the glue she had poured herself just before that first opening.

Two days later, riding my bike on Magazine, I couldn't believe what I was looking at. In the short time since my walk, the merchants had banded together and staged a massive cleanup aided by the remaining National Guard troops, who were by now getting bored, and the firemen from the Magazine Street station. At one point even the mayor, shamed into turning up, briefly managed to lift a shovel. Now, with the debris gone I could see things, important things like the banner hanging across the Belladonna day spa exhorting me to "Be a NEW New Orleanian," and the open takeout window at the pie and praline stand of Tee Eva, a former dancer for Ernie K-Doe, the late New Orleans soul singer whose biggest hit had been "Mother-in-Law" (hence his widow's Mother-in-Law Lounge, which boasts a painted life-sized statue of Ernie dressed in one of his embroidered

suits). Aidan Gill, John's Irish barber was back up and running, which meant he was also dispensing shots of my favorite Red Breast Irish whiskey, and, at Casamento's, the narrow, tile-walled oyster bar that opened in 1919, a hand-lettered sign announced a reopening date of November 15. Joseph Casamento, the son of the founder, had been born in the second-floor apartment above the restaurant where he lived his entire life until, at eighty, he evacuated for Katrina and died of a heart attack on the same day she hit. A bachelor, he had never worked anywhere but Casamento's or lived in another spot— his nephew's wife told Brett Anderson she thought the upheaval had been too much.

On October 19 at six in the morning, Café Du Monde began dispensing its famous chicory coffee again, along with its addictive beignets. A month earlier, the mayor had predicted that "once the beignets are in the oven, [New Orleanians] will come back." Despite that fact that beignets are fried in a deep fryer and not baked in an oven, people did flock to the reopening, though at least half of them appeared to be FEMA workers and the media, including the folks from CNN who featured it on the morning show, complete with an anchor biting into a golden brown, powdered-sugar-dusted, fried beignet.

That night Upperline opened its doors with Alan behind the bar, Ken in the kitchen, and Jason, now a philosophy professor in St. Louis, backing him up as sous chef. The slightly shortened menu featured the restaurant's signature fried green tomatoes with shrimp *rémoulade*, the idea for which JoAnn thinks came to her in a dream and which by now has been copied across the country, and Ken's Cane River Country Shrimp, a delectable combination of shrimp, bacon, and mushrooms over crispy grits cakes which my mother and I helped name. John and I went with McGee and Elizabeth and ordered pretty much everything we'd been missing: the duck *étouffée*

on corn cakes with pepper jelly, the crispy oysters with celery root *rémoulade*, the Cane River shrimp, the baby drum *meunière*, the slow-roasted duck with sweet potato fries.

JoAnn's funky mix of art and her gorgeous cut roses (of course) still enlivened the dining rooms, as did, on this night, the grateful diners. It was another raucous cocktail party, with people hollering and hugging and asking the ubiquitous questions: "How'd you do?" and "Are you back for good?" More than one person who answered yes to the latter told me that in those early, still half-dark days (by now everyone on unflooded ground had electricity but the streetlights wouldn't be back on for months), that the constant trickle of reopening restaurants—and, therefore, civilization—was what had convinced them to stay. We closed the place, as usual, joined at our table by Alan and Ken and JoAnn, who kept plying us with the wine she wanted to make sure was okay. We happily obliged, but by this time it was frankly hard to tell, and when we finally left, we had to wake up McGee, who'd been napping on the banquette.

If food led the way, culture wasn't far behind. I was proud that the Ogden became the first museum to reopen—despite the fact that all but one staff member, including the director, had lost their houses. By the second "Ogden After Hours," a weekly event at which drinks are served and local musicians perform, word had gotten out, and more than a thousand people gathered to hear Walter "Wolfman" Washington play his mix of soul, funk, and blues. The pre-Katrina crowd rarely topped 300 to 400, and now there weren't even a hundred thousand people in the city, but folks were desperate for normalcy, and more than anywhere else, "normal" in New Orleans means music. To that end, Irvin Mayfield, who by now had found out that his father wasn't just missing but drowned, had written an epic jazz piece, "For All the Saints," which he performed with his New Orleans Jazz Orchestra at Christ's Church Cathedral on St. Charles. The church had

originally planned to commission a piece by Mayfield to commemorate the Episcopal bicentennial in Louisiana, but given the circumstances the mission, and the music, changed. Before the concert, the lieutenant governor urged the crowd to "get a sense of where you are in time and place." Right, I thought, summoning Warren again, "Tell me a story in this century and moment of mania"—and then Irvin did tell it, a story of a life lived beyond his twenty-seven years, a story of grieving and loss and hope and celebration. When he was done, the standing-room only crowd was silent for a full minute before applauding for much, much longer.

By this time, Eddie had sufficiently recovered from his depression to show up with some guy I'd never seen before to reinstall all the bolts and pulls and doorknobs on the two walls of French doors and windows in the sunroom that Abel had installed incorrectly. He also told me that the company that was supposed to have delivered the remaining stone, including the five sets of limestone steps, had gone out of business. (I found out later that for a whole year before the storm they hadn't paid any of the money they owed to the Pennsylvania quarry that had been their—and our—chief supplier, money which included the hefty check I'd written to them for the stuff we'd received so far.) But since we had no one to install the stuff, it didn't much matter—Eddie had the heard from the subcontractor whose equipment still littered our yard only once, when he'd called from St. Louis asking for money, a sad fact that meant that our gate would likely be inoperable for some time.

He also assured me that he had repaired the leaks in the flat roof "for good" this time, and since I very stupidly believed him, I got Mr. Dupré's men, now managed by his son Blair while Billy tried to put his flooded house back together, to come and paint the sunroom ceiling for the third go-round. By the time it had rained—and leaked—again, Eddie had taken off for Oaxaca, one of the very few

people at the time who was leaving New Orleans for Mexico rather than the other way around. When I told Joe Wallis, who was back on the job painting the outside of the house, that Eddie had gone down for a long-scheduled trip to get married and to celebrate the Day of the Dead, for which he made an annual visit, I thought he was going to explode. "Day of the Dead? Day of the Dead? Goddamn, hasn't he had enough of that around here?" Joe is a little guy but he has a deep Irish voice whose primary register is outraged disbelief. When he got through yelling and shaking his wet paintbrush, we both started laughing so hard we were crying. (Later on, when I found out that an early-twentieth-century print of a woman known as "La Catrina" was a symbol of the festivities I couldn't wait to call him on the phone.)

Freddy, on the other hand, was not laughing. I'd seen him on that day, a couple of weeks after the storm, when he'd come to check on his truck. He'd been thrilled to find it exactly where he'd left it, un-damaged and still full of about a thousand dollars of equipment. But when he came back to retrieve it not long afterward, it was gone. A woman down the block, who was involved in a renovation far more extensive than ours, told Joe she had called a service to tow it away. We all agreed that there was something a tad bizarre about this—it had been parked on a public street in front of a house not her own and she could not remember the name of the towing company she had called. When she told Joe she thought it had been "abandoned" it gave him an opportunity to vent some more outrage. "ABANDONED? We had a HURRICANE," he told her. Later he said to me, "You know what you call that? Two words: GRAND THEFT."

Other than the truck lady and Allison, a young widow with two children (and owner of the feral cat who had miraculously survived his captivity), we had very few neighbors and most of the ones we did have were men. Only a couple of private schools and no public

schools were open, so anybody who wanted to educate their kids had to put them in boarding school like Elizabeth had or stay gone, at least until Christmas. This was disappointing because I had been looking forward to Halloween ever since we'd bought the house—donning a witch's hat and dispensing goodies to the neighborhood children were a big part of the commitment-to-real-life package of my imagination. In Manhattan I never had a single trick-or-treater and on my block on Bourbon, the only people in costume were grown men dressed in drag. I hadn't had the need to carve a pumpkin since I was maybe twelve, and now this year, alas, it was going to be no different, but I carved two anyway and bought multiple bags of candy. In the end we had two sets of visitors, a grateful father who'd been desperately driving around the darkened city with a two-year-old "Cinderella," and Allison's son and daughter who came dressed as looters, with wads of "loot" stuffed beneath their stretchy T-shirts and Saks Fifth Avenue bags for their candy. Their lone friend wore a T-shirt that said POLICE, which was stuffed with similar wads.

It was heartening to find out in the paper the next day that the Bourbon Street Halloween had been typically lively. I had been thinking a lot about Bourbon because Prince Charles and Camilla, on their first official visit together to America, were coming to New Orleans, and one of the stops on their brief itinerary was the Cathedral School, behind Betty's, which had been the first school to open in the city. I was reminded of the singing nun on the loudspeaker who had woken me up every morning, but more than that, I remembered watching Diana's funeral in my big iron bed. It was four o'clock in the morning, and I was on the phone during the whole event with Andre Leon Talley, *Vogue*'s editor-at-large and my very dear friend, who kept up a running—shrieking—commentary that lightened up the proceedings considerably: "What IS THAT on Fergie's head? Would you LOOK at how many earrings Elton is wearing." Toward

the end, a very frantic Vicki Woods cut in. She was our friend in London who had a coveted seat in St. Paul's, where her view had been entirely obliterated by one of Sir Christopher Wren's vast pillars. She had a half hour to write exactly the sort of stuff we'd been saying to each other for a special edition of *The Telegraph*, so we basically dictated the whole story, and I recalled the episode often as an oddly happy morning.

Now unlike, say, my mother, I was happy that Charles had finally been united with his one true love, and I was even more delighted that the two of them had deigned to come to see us, receiving gifts of Mardi Gras beads from the uniformed schoolchildren and generally being more helpful and pleasant than Ted Stevens, the senator from Alaska who dropped in the same week and wondered aloud, in front of the devastated homeowners of Lakeview, why on earth anyone would want to rebuild there. In Alaska, he explained, they would simply relocate the whole town.

In Alaska, they also build bridges to nowhere, thanks to the obscene amount of pork Stevens regularly shovels into the place, so when, several months later, it was revealed that he was under investigation for all manner of dubious financial transactions and that the FBI had raided his house, I could not have been more thrilled. I had long since lost patience with irresponsible, inept, and just plain crooked politicians from both without and within Louisiana (our own congressman Bill Jefferson had also been paid a recent visit by the FBI who found, among other things, $90,000 in cash in his freezer). Every day our local elected officials made it maddeningly clearer that people do indeed get the government they deserve. It would take a little time to create a real leadership pool to replace the cesspool every one of us, voters included, had been swimming in way too long. But it was time to do something, anything, to get involved, to help speed our recovery along.

So it was that over dinner at Upperline with my friend Walter Isaacson, the writer and Aspen Institute chief who also served on the governor's Louisiana Recovery Authority, a small plan was hatched. Walter, who had grown up in New Orleans, had brought along an old buddy who ran the Preservation Resource Center's "Operation Comeback," which for years had been buying up the many thousands of blighted houses owned by the city at rock bottom prices, renovating them and making it possible for mostly low-income, first-time homeowners to move in. We all agreed that housing was the biggest single problem facing the city—we had also been imbibing a great deal of whiskey and wine. The next thing I knew Walter and I had agreed to co-host a fundraiser for Operation Comeback, and, since Wynton Marsalis and Walter were both due in New Orleans for a meeting in January, we decided to have it then and to share the proceeds with Wynton's Higher Ground musician's fund as well as the Ogden. (I was also already figuring out how to snag one of the houses for Rose and Thomas, who had left Natchez and gone even farther away, to Dyersburg with the others.) Once we'd shaken on it, Walter cautioned, "I'll help you sell tickets but I won't do anything else." I told him I already knew that and immediately started planning the event in my head. In addition to raising some much-needed money, we needed to show people from out of town that we could still throw a good party.

Everybody, including my father, told me I was crazy, that under the circumstances—with few hotels fully staffed, beleaguered locals low on money, and out-of-towners wary of coming to visit so soon—it would be virtually impossible to raise the money and showcase the town. "I've done them with huge staffs and it's still hard as hell," Daddy said. But I was not afraid, and anyway, I had an assistant coming, Vasser Howorth, the niece of good friends from Oxford, Mississippi, whom I'd met when she was working in one of my fa-

vorite New Orleans bookstores. The store had still not reopened, she was back in Oxford, and her boyfriend was in New Orleans, so I implored her to work for me and she agreed. She was arriving just after Thanksgiving and I knew the two of us could pull it off. We would call it Rebirth New Orleans.

$$\sim 9 \; 12 \; 9 \sim$$

THOUGH MY LATEST endeavor was exactly the sort of thing I'd hoped to do once I'd committed to John and the house and a life in New Orleans, when I first arrived in the city in 1991, civic activities could not have been farther from my mind. Unfortunately, at the time the same could be said of the state's leaders, a great many of whom placed embezzling, evading, and general enjoyment of their various offices much higher on the list.

I had arrived that year, two months after Jazz Fest, to see A. again and with Edwin Edwards serving as my larger-than-life excuse. He was making an unexpected comeback after conceding four years earlier to the reform-minded Buddy Roemer, who, while seemingly honest, was also abysmally lacking in leadership skills. Into the void stepped figures far more familiar to Louisiana voters, Edwin and David Duke, the ex-Klansman who had already served two terms in the state legislature. Their ultimate match-up gave rise to the most popular bumper sticker of the campaign, "Vote for the Crook, It's Important," which was not only a grim reflection of the state's leader-

ship pool, it was true on all fronts—though Edwin ultimately went to jail for the criminal activities he engaged in while in office, it had indeed been important that he be elected given the far more devastating alternative.

In the not-so-noble pantheon of Louisiana politicians, Edwin was the last of the great entertainers. Though he was a scoundrel of the first order, he was not a megalomaniacal dictator like Huey Long, and certainly not an obsessive racist like the backwater tyrant Leander Perez, the man A. J. Liebling called the "Pasha of Placquemines Parish"—and who, according to Robert Sherrill, author of the brilliant *Gothic Politics in the Deep South*, was so flat-out "evil" that "one is constantly expecting him to resume the shape of a toad." (On the contrary, Edwin was thoroughly progressive on matters of race, hiring, for example, the first black state troopers and assiduously courting the black vote, which he always got—though, like Perez, he did turn out to be a thief.) While Edwin was as funny as "Uncle Earl" Long, and certainly as crazy about women, he was not nearly as violent or profane. (Earl once bit a colleague on the cheek and, in front of the entire legislature, he referred to one of its members as a "cocksucker.") He was also slightly more dedicated to his job than the singer and yodeler Jimmie Davis, who wrote "You Are My Sunshine," and who compiled the most days spent out of state than any governor before or since (much of them spent trying to sell Hollywood on a movie of his life). The fact that it was unlikely that Edwin would do the citizens of Louisiana a lot of good did not much matter to me—he was great material.

Besides, in the New Orleans I lived in then, I couldn't think of a single thing that needed improving. From the moment of my arrival, I was firmly ensconced in the city of Tennessee Williams, where, on rainy afternoons (which is pretty much all of them, in the summers at least), "an hour isn't just an hour but a piece of eternity dropped into

your hands." Faulkner, who wrote *Soldiers' Pay* while living in New Orleans on Pirate's Alley, called it "a place created by and for voluptuousness." I knew what he meant—my existence might have been a tad narrow to some folks, but pleasure almost completely defined my days.

When I wasn't on the road with Edwin, the great majority of my movements were happily confined to Galatoire's, Elizabeth's comfortable kitchen, and a handful of French Quarter bars, including the Napoleon House, a place known for its superior Pimm's Cups, its operatic soundtrack, and the fact that its original owner offered it as a safe haven for the exiled emperor. (One of the many ironies of Katrina is that until the storm, New Orleans had always been better known for taking in refugees—escapees from boredom, sexual oppression, you name it—rather than shipping them out.) On my first night in town I met A. there at midnight and realized it would be impossible to separate romance from the city's endless romantic settings.

The exotic nature of Edwin's campaign was equally seductive. The last race I'd covered was the 1988 presidential campaign of George H. W. Bush, whose fans were not nearly so ardent. At a roadside honky-tonk in Delcambre, for example, I asked the owner about the enormous framed portrait of Edwin above the bar, and she told me, in a Cajun accent so thick I could barely understand it, that after Edwin had kissed her cheek during his first campaign, she refused to wash her face for so long her husband finally left her.

Edwin had served his first two terms as governor from 1972 to 1980, and a third (state law says you can serve only two consecutive terms) from 1984 to 1988. When Roemer came out far ahead of him in the 1987 primary, Edwin, always good at counting, knew he wouldn't win the run-off so he conceded the race. His first two terms had been buoyed by an oil boom that enabled him to make like Huey Long and build road after road and bridge after bridge, while spending big

on education and health care and abolishing state property taxes. He was the reform-minded one that first go-round, forcing a constitutional convention to rewrite the state's convoluted constitution and make government more transparent. He seemed invincible. He was quoted as saying he didn't believe Christ had been resurrected ("it goes against natural law") and after the inevitable outcry, he lampooned himself at a press club lunch with a mock stigmata, comprised of ketchup on his shirt and lipstick on his hands—and the Pentecostals stayed with him anyway. (Their support became clearer to me at a church service in Alexandria, where the pastor lavishly thanked Edwin for his earlier help, which somehow allowed the congregation to skirt the law and avoid installing a $40,000 sprinkler system.)

At the beginning of his first corruption trial, he told a reporter, "It will be long, but I guarantee you one thing, it won't be boring." When asked what he thought of the jury, which included a shoplifter, an admitted wife beater, and a man who had pleaded no contest to negligent homicide charges, he replied with a grin that they were "a jury of my peers." But in the end, it wasn't the trials that got him, it was the dramatic downturn in oil and gas prices that left the state with a $170 million budget deficit and forced him to raise taxes. The great benefactor had been forced to make the public foot part of the bill, and then Buddy came along and promised "fiscal responsibility" and hammered away at Edwin's "dishonesty," so that by the time Edwin stepped aside, his career was pronounced dead as a hammer. Reporters across the country wrote obituaries, not just for "the rogue," but for the roguish nature of Louisiana politics itself.

But Edwin had no intention of walking off into the sunset. When he announced his comeback bid in 1991, one Louisiana political analyst told me it was all about "redemption," but I came to realize that it was really about revenge. Buddy was a whiny-voiced Harvard graduate who used words like "neat" and "awesome," and was famous for

saying in an interview with *Esquire* that whenever he had a negative thought, he banished it by popping a rubber band he kept around his wrist (which prompted my father to comment at the time, "Hell, if I never had a negative thought I wouldn't get anything done"). Buddy's father, Charlie, who had been commissioner of administration in Edwin's first term, had gone to jail for bribery in 1981, and it offended Edwin's sense of loyalty that Buddy had given the reporter who had exposed Charlie's crimes a job in the statehouse. Edwin wanted a showdown with the man who had cost him what he viewed as his rightful position.

My first meeting with Edwin was in July, just after I arrived, at the Monteleone Hotel in what I came to call the "sleaze suite," a set of rooms on the hotel's roof where Edwin typically stayed whenever he was in New Orleans, and where he had celebrated each of his election night victories. ("Twenty years, same three rooms," one of his closest advisors, Robert D'Hemmecourt proudly told me.) When I'd called to request the interview, I was told to turn up at the same time as the reporter from the *New York Times*. I'm sure they had no idea what to make of me—a writer for *Vogue* who was doing a long piece on the election for *The New York Review of Books*—so they lumped me with another Yankee outfit and figured they'd be done with both of us.

When it became clear that I wasn't going anywhere, they invited me to travel with them. It wasn't because Edwin was making the sexual overtures for which he was so famous (his former bodyguard, Clyde Vidrine, had written a book called *Just Taking Orders* in which he described his role as chief procurer of Edwin's women); to everyone's astonishment he had become monogamous and was genuinely devoted to Candy Picou, a twenty-six-year-old nursing student from Gonzales whom he married after the election. "At my age," he said prior to the happy event, "a man should have a nurse and a mistress

and with Candy I have both." I think the guys that comprised "the campaign" put up with me because they liked having some outside company—someone for whom they could put on their act. "You wouldn't go away," D'Hemmecourt told me when I saw him in New Orleans a few months after Katrina. "And we liked you." I liked them too, and every day I'd check my messages to find out where to meet and when.

Usually we traveled via small plane, a six-seater that carried: Edwin; his son David, who served as pilot and chief bodyguard; Andrew Martin, who had been in the shrimp business in LaFourche Parish and Edwin's confidante since the first race in 1971; and D'Hemmecourt, otherwise known as Bobby or Bobby D., who has deep roots in New Orleans (where there is a D'Hemmecourt Street) and who met Edwin during the gas rationing crisis of 1974 when Bobby was president of the service station operators association.

By definition, David's job was fairly specific, though he sometimes went so overboard on the bodyguard part that Bobby would just look at me and shrug: "Nothing I can do," he'd say. "It's the legacy of Huey Long." But the exact nature of the others' roles was unclear. Once, when I asked Bobby if a guy who had joined us on a trip worked for Edwin too, he looked at me like I was crazy—"None of us work for him."

They did, however, perform many vital services, including the placement of the football bets. I'd listen in amazement as they phoned their various bookies (Bobby called his "my author"), dropping $15,000 here and $35,000 there, before tuning into the Sony Watchman to monitor games from the road. During the Saturday afternoon parade that is the highlight of the Shrimp and Petroleum Festival in Morgan City, I watched as Edwin waved to the crowds from the bed of a pickup truck. Andrew clutched his waistband to support him and Bobby crouched out of sight, passing on the scores as he got them—

information which prompted intermittent bursts of profanity amid the more jovial "Hey chere" and "How's your mama?" Once, when someone jokingly referred to Bobby as the "numbers man," he dryly corrected him: "No, I'm the communications coordinator, I supply information on the numbers." Meanwhile, Andrew busied himself with the numbers that really mattered, collecting the checks, stuffing them into his inside pocket as we went from event to event and ripping open the envelopes later with his pocketknife so he could give Edwin the tally. On one trip, he told me without a trace of irony that he had been carrying Edwin's breath mints since 1971, but that, too, turned out to be an important job. Edwin, who had picked cotton as a child, had an obsession with hygiene that bordered on the pathological. At every stop, he excused himself to wash his hands and scrub his face so hard that it shone.

After the second or third trip with them, I finally got up enough nerve to inquire as to what was in the briefcases. They kept them so close, I naively assumed there must be valuable donor lists or super-secret strategy papers lurking within. But when they popped them open in unison the only things inside were more phones, football spreadsheets, the breath mints (along with multiple dispensers of dental floss), and a whole lot of guns, including a semiautomatic and a .350 Magnum.

Edwin went everywhere—bingo halls in Kenner, dance halls in Westwego—but Buddy turned up in so few places that Edwin supporters had milk cartons printed up with Buddy's likeness. During a rare Saints winning streak, Buddy showed up alone in his box at the Superdome, fell asleep, and left early. He was also a no-show at nearly every debate between the candidates, who included Duke as well as Kathleen Blanco, the public service commissioner who finally became governor two years before Katrina hit, and who persisted in deriding Edwin as a "jokester" and a "character," stopping just short of calling

him a crook. "I can't stand the corruption and the lies anymore," she said again and again. "I'm tired of the looks of pity."

During this performance Edwin invariably did an excellent imitation of a man sleeping. He had no intention of acknowledging the presence of the former high-school teacher, much less of responding to her—preferring instead to marshal his vitriol for Buddy, the "hypocrite" who had switched parties, turning Republican midway into his term after heavy courting by the first Bush administration.

At a gathering of black leaders in a church in Evangeline Parish, Edwin said, "Buddy Roemer betrayed you who helped him get elected. He switched parties and got in with the rich folks." Referring to Roemer's plan to privatize one of the state's Charity Hospitals that Edwin had built, he warned: "They'll try to make money and not help the poor folks who cannot pay." Then he returned to one of his favorite subjects, the overgrown weeds along state roads, which apparently had become a big issue among the voters. "You wanna know the difference between a man and a boy? I built the highway between here and Shreveport. Buddy Roemer can't keep the grass cut."

Edwin's disdain was catching. All over Baton Rouge, bumper stickers appeared saying "Harvard Owes Charlie His Money Back." The Harvard attack was even more effective than the party-switching one. Before a Sunday afternoon rally at a bait shop in Simmesport, a tiny town in Avoyelles Parish where he was born, Edwin greeted the folks inside, picking his way through the cages of crickets and tanks of minnows, the shelves of camouflage jackets and enormous gumbo pots. Outside, he took the mike and said, "I know what a shoupfish is, I know what a catfish is. I know what it is to make a living—I picked cotton . . . I don't think Buddy Roemer likes us. He went to Hahvahd and got a Hahvahd education." He mentioned that Buddy's commissioner of education had been brought in from Massachusetts, "and I bet he doesn't know where Simmesport is." By the time he

closed with, "The only people in Louisiana who are better off than they were four years ago are the people who got out of jail," he had managed to push every button. During the raucous applause, an elderly black woman turned to me and said, "That man could run a hundred times and I'd vote for him every one."

My own headquarters throughout these shenanigans was the apartment on St. Philip Street. A. had dubbed it the gas chamber, due to its lack of windows, Spartan furnishings (the bed was technically a cot), and the bolt on the door that was almost an inch in diameter. The bolt was more comic prop than effective lock since the door was so cheap and hollow almost anyone could have kicked it in, but it made me feel a tad better about the guy across the hall, who heard voices and went from wanting to be my chatty hall buddy one minute to thinking I was saying terrible things to his face, depending on his extremely volatile moods. At night I'd hear him yelling terrible things at his benefactor, a sweet old white-haired street artist, casting aspersions on the ability of his private parts and refusing to give him sex.

On the rainy afternoons Williams described, A. and I would picnic in the gas chamber with a bottle of red wine and a muffaletta sandwich from the Central Grocery. If a bomb had gone off outside, not only would we have missed it, I'm pretty sure we wouldn't have cared. "There is just us," he said one night over and over again. In any relationship, there is never, of course, "just us," but I was reminded of lines from Robert Penn Warren then too: the passage in *A Place to Come To* in which he describes the "second stage" of a love affair, when time ceases to move laterally and context is all but gone, and, above all, there is total contempt for the rest of the world.

In New Orleans it seems possible to sustain that second stage forever—and it's not just the people with no windows who lose track of the world outside. Indeed, much of the populace appeared to me to

have adopted one or two of Warren's characteristics permanently. I once interviewed a state legislator from New Orleans who told me: "I don't know any Yankees, I don't give a shit about them"; and "There is no reason to ever leave here." Even before Katrina there were lots of reasons to leave, most of them stemming from that exact attitude. By the time I arrived the school system was in shambles, businesses had fled, and the economy was truly colonial in that it was based almost entirely on tourism, with the owners of the hotels, et al., living elsewhere and supplying only low-paying jobs (taxi drivers, hotel maids, bellmen) for the locals. Edwin's panacea for the city's every ill was to push for the passage of a law allowing the largest land-based casino in the world to be built at the foot of Poydras Street, an addition that would only reinforce the economy's fragile dependency.

But that, in those days, was not my problem. I was a refugee from an earnest and ambitious urban environment, thrilled to be a long, long way from the Manhattan dinner parties I had grown to loathe, punctuated as they were by lengthy and very important monologues from guests who had just returned from somewhere like the Gaza Strip. Once, in the middle of just such a monologue at a dinner party devoid of any fun or even good food, the nurse of the then still with-it Brooke Astor arrived to fetch her at ten o'clock, her established departure hour, and I have never been so jealous of anyone in my life. I longed for the spontaneity and joie de vivre and glamour I felt had worn off New York during the over-the-top eighties, perhaps permanently. I read in a magazine once that true glamour requires at least the possibility of decadence, some hint of "enjoyable sin." I was enjoying all the sin I could handle without the least thought of its consequences. And when I wasn't with A., I was with a notably sinful and ultimately felonious politician. I was also having more fun than I had ever had in my life.

At the first organizational meeting of the campaign, Edwin had

predicted he would be in a run-off with Roemer, unless the numerous second-tier candidates split the vote and then it would be Duke, whom he would certainly rout. "I've been lucky in politics all my life," he said that day. "But I've never been that lucky." On election night, though, Edwin's luck did, in fact, hold—Roemer had lost big and he was in a run-off with Duke, whom he crushed a few weeks later in the second biggest landslide in Louisiana history (he had already won the first). At a news conference before the swearing in, Edwin said, "I hope I'm smart enough and mature enough to profit from the mistakes I made in the past," and everyone was hopeful. "I want my grandchildren to sit on my lap and I can tell them I knew him," Bobby told me. "I can tell them I helped give him the opportunity to turn this state around, to be the greatest governor who ever lived."

It was not to be. In addition to the passage of the law allowing the New Orleans casino, his only notable achievement was the lining of his own pockets by extorting hundreds of thousands of dollars (some of which was stuffed into garbage bags and passed into a car waiting under a Baton Rouge overpass) from riverboat casino applicants. (One of those who "bought" a license and later profited handsomely from the sale of his Treasure Chest Casino—profits the Feds let him keep—was Bobby Guidry, a slimebag of a barge company magnate who testified that he routinely kept up to a million in cash on hand in his house for emergency purposes, hidden in either a secret compartment in his hot tub or beneath the wild ducks stored in his freezer, a secret stash location that was turning out to be increasingly popular among the white collar crooks of Louisiana.)

In 2001, Edwin was convicted of racketeering and fraud, along with son Stephen and Andrew Martin, and sentenced to ten years in the pen. Of the old gang, only Bobby had never been remotely implicated in the wrongdoings. "I told Edwin, 'You know I'll do any-

thing for you, chief—anything but time.'" For his part, Edwin main-
tained his innocence to the last, telling reporters, "I have always been
a model citizen and I will be a model prisoner."

Though Edwin may have disappointed his supporters and con-
firmed the worst suspicions of his enemies, the storm provided a
strange sort of redemption for the former governor—even his most
devoted critics could be heard wishing aloud that he was still in the
mansion, or, at the very least, that he could be released long enough
to manage the crisis. He might have been larcenous but he'd also
been governor four times and a congressman before that. He knew
New Orleans and, above all, he knew what to do, unlike his old critic
Kathleen Blanco—who was now the one inspiring "the looks of pity"
she'd once derided Edwin for provoking. In the storm's immediate
aftermath, she appeared so disoriented that one press account of her
public appearances went so far as to suggest that she seemed "over-
medicated." When *Times-Picayune* columnist James Gill reported
that "Me-Maw's tranked is the word on the street," I was reminded
of Frank's comment as we stood in front of the TV in the Greenville
kitchen: "All that woman does is stand there and pat her hair."

Bobby, who remains in constant contact with Edwin, reported to
me that her two-day indecision over whether or not to allow the Guard
troops to be federalized (keeping troops, including my boys from
Oklahoma, literally sitting on runways) had floored the old "silver
fox." Edwin also told Bobby that he would have been on the phone
urging the president to respond much sooner (and threatening to cut
off every refinery and oil and gas pipeline in the state if he didn't give
him everything he asked for), much the way Senator Russell Long
had prodded LBJ after Betsy. As for the Guard, "You always hand
command of the military over to the president," Bobby says Edwin
told him. "Then it becomes his problem. It's a no-brainer."

There were countless no-brainers that no one in any position of

power seemed equipped to handle and I was reminded of the final debate back in 1991 between Edwin and Duke on *Meet the Press*, when Tim Russert asked Duke to name the biggest employers in the state and Duke responded that he didn't know, that he did not carry around an almanac. Edwin hadn't been able to get over it for the whole rest of the day. "An ALMANAC? An ALMANAC? You look at the almanac if you want to know the stages of the MOON," he said over and over. Now I wondered if, like me, he was thinking of that day, since Blanco apparently had been without both an almanac and a governor's manual.

~◦ *13* ◦~

BLANCO MAY HAVE been the governor, and the mayor was, alas, still the mayor, but as the holidays approached there were plenty of other things to be thankful for. For one thing, at the start of November, FEMA began disposing of all the refrigerators, which was no small task. After being toted to one of a half dozen appliance mortuaries overseen by the EPA (at the cost of $2 million a day), they were emptied of their contents and power-washed with bleach before being drained of Freon for recycling. What was left was then piled onto a big heap and crushed into metal bales that were bought by scrap metal dealers who hauled them away. Before it was all over, more than 200,000 refrigerators had been picked up and destroyed, and a million pounds of Freon, a fleurocarbon capable of doing some heavy damage to the ozone, had been recovered (which explained the graffiti I'd seen on a French Quarter fridge admonishing that "Chemtrails Are Real"). Trash, it turns out, is a complicated thing—the average TV set left out on the curb, for example, is a lethal little bomb containing four pounds of lead.

I was also tremendously grateful for the delivery of two brand-new appliances, the washing machine and dryer that was a belated birthday present from my very generous mother. She'd already given me many more extravagant things for the house, but this was especially important to her because she knew how important it was to me. I was forty-five years old and had enjoyed the use of a washing machine only one time in my entire adult life, during the year I'd lived in a rented cottage in Orlando, Florida, and worked for the newspaper there. That had been exactly two decades earlier and since then I had done a whole lot of weeping during those General Electric commercials, the ones where irresistible golden retrievers and pretty children bounded around, and happy people pulled warm towels from the dryer and pressed them against their cheeks. Such was the ads' schmaltz level that I'd heard plenty of people admit they cried too when they saw them, but I think my tears went deeper. I so craved the domestic scene I watched on the screen, but I didn't, apparently, have the slightest idea of how to go about achieving it—I'm not even sure I was conscious of how badly I wanted it. There had been no room in any of the places where I'd subsequently lived for a washer and dryer, and, I had thought, no room in my life for all the less concrete stuff that usually went with them. In addition to adding a great deal of convenience to my life and being, well, normal, the gift of these two items was extraordinarily symbolic to me. So much so that I did not mind taking a number and waiting in line for almost two hours to pick them out at Sears, which was doing a bang-up business from all the thousands of people who were back and forced to replace their destroyed appliances.

Then there was the happy fact that Rose and Quincy and Roseanna were coming to town for a Thanksgiving visit. Rose and Quincy were driving down from Dyersburg in Quincy's Suburban; Roseanna, who was waiting for her New Orleans roof to be repaired,

was coming in from the country. They were homesick and wanted to make some money. Since I had invited pretty much everyone I'd run into on the street—literally—for Thanksgiving lunch, our needs were in sync.

I knew I'd asked at least twenty-four people, which was how many our table seated with all its leaves, but John warned me that there were likely a few folks I'd forgotten about, since my magnanimity generally expands with each drink and we were still attending the festive reopenings of every bar and restaurant in town. JoAnn and Alan and Ken were coming, and Elizabeth and her girls, of course. My parents were driving down from Greenville and staying at the Windsor Court hotel, where there was no room service or even an operational restaurant yet, and nothing in the minibars, but it was far better outfitted than our house, which still possessed only one bed. My father's business partner of fifty-two years and his wife were visiting their daughter, M.T., and her husband, so they were on the list. (Like Elizabeth, I'd grown up with M.T. and she was one of my closest friends as well as my neighbor in Manhattan. John and I had fixed her up on a blind date with a friend of his, a judge from across the lake in Covington, and they had married four months after we had.) Our former "landlady," my cousin Linda Jane, was driving over from Baton Rouge with her husband and their two children. Then there was one of my solo male neighbors whose wife and kids were still away, John's son Roger, and, as John continued to point out, God knows who else.

No matter who came, we'd have enough to eat. I'd ordered two turkeys from D'Artagnan (not all our grocery stores were close to being open yet and I did not want to take a chance). I was also making oyster dressing (despite the immediate dire warnings that it would be years before we could avail ourselves of the bounty of Louisiana's oyster beds, the state department of health and hospitals allowed half

of them to reopen in late October, after what they assured us had been extensive testing); green beans with caramelized shallots; corn macques choux with crawfish, in a nod to the Indians and my borrowed Louisiana roots; and cranberry relish with the kumquats that were ripening all around us, including on the tree that was just outside the big kitchen window. Elizabeth was bringing the marshmallow-topped mashed sweet potatoes in orange shells that her children (and some of the adults) could not get through the day without, and M.T., one of my all-time favorite cooking partners, was supplying miniature crab cakes for hors d'oeuvres, along with slow-cooked Brussels sprouts with pine nuts and her grandmother's cornbread dressing.

Quincy turned out to be an ace turkey cooker and hyper-efficient baster who never failed to set the timer at thirty-minute intervals, while Lorel and Lamont, two of Roseanna's triplet nephews, did an excellent job of keeping everyone well lubricated with Bloody Marys and brandy milk punches and lots of Champagne. Only three people I had forgotten about turned up, but we somehow made room for them, and when we sat down to give thanks, we all realized, for the millionth time, how blessed we were to be here. The only mishap came during the washing of the dishes when the sink backed up and almost a foot of water came flooding into the kitchen. Eddie's idiot father-and-son plumbing team had returned to fix the same problem—I swear—seven times, and each time they had billed me for it. Fortunately, Lamont had a neighbor who was a plumber, the dashingly named Wellington Grant, and we implored him to come over the next day.

Like our governor, our original plumbers must have been without a manual. Within about three minutes of his arrival, Wellington had removed the pipe that drained the water from the sink to the street, and it was so caked and corroded on the inside that the passageway was now maybe an eighth of an inch wide—a cigarette could not have

fit through it, much less a double sink full of water within any rea-
sonable amount of time. I saved it with the thought of beating Eddie
over the head with it if I ever saw him again, but that was looking
increasingly unlikely since he had not been in touch since his Mexican
respite.

Just after Thanksgiving, John enlisted Lamont and Lorel to help
him salvage what was left at his brother Andrew's old apartment. We
had been there once before and found that the door was blocked by
an enormous bookshelf that had washed in front of it, the sofa was
upside down on top of a table, and a treadmill was on top of that. John
had climbed in through the window and discovered that Andrew's
books and his treasured pipe collection on the second floor had sur-
vived intact. There was his Standard French-English Dictionary, his
Modern History and Anatomy textbooks, his John Lennon albums.
Andrew had gone to Columbia and was exceedingly bright, so when
I looked at his things it was doubly heartbreaking. A lot of people
had been forced to undergo the painful process of sorting out the
remnants of what was now another life pre-Katrina. But Andrew's
things had already been remnants of his life before his illness kicked
in—now there was another remove. Still, he was happy to get his
stuff, and he told John they provided a great amount of comfort in his
new life so far away.

At the same time John was packing up Andrew's things, Eliza-
beth was dealing with a different family issue. Since Katrina, she had
not heard from Mike's mother or any of his siblings and none of the
phone numbers that she'd starting dialing as soon as the storm passed
had ever worked. Finally, just before Katie's birthday in November,
her mother-in-law, DeeDee, had gotten in touch, and after Thanks-
giving Elizabeth took the girls to see her. It turned out that she had
an extraordinary story. She'd been in her house in Lakeview with
one of her sons when the water began rising. The two of them sat

atop ladders until they were no longer high enough, at which point they swam underwater, which was the only way to get out the front door. DeeDee, who does not actually know how to swim very well, grabbed onto a passing Little Tykes truck and managed to stay afloat before being pulled atop a tall nearby shed by her son and a neighbor who had jumped in to help. This was made all the more remarkable by the fact that she is eighty-something years old, and not only vastly overweight but also afflicted with Parkinson's disease. Once she was on top of the shed, with a back that had been skinned raw, another whole day went by before they were rescued and flown to a hospital in Baton Rouge.

Maybe it was survivor's guilt in the wake of such stories; maybe it was just the excitement of having a house. Whatever it was that had gotten into me, I launched into such a frenzy of holiday entertaining that Elizabeth gave me a guest towel embroidered with the message "A Fool and Her Money Can Throw a Hell of a Party." Our neighborhood of temporary bachelors was finally filling up with mothers and children again (and Jean had returned to Bob), so I had all my new neighbors over one night, and then the hundred-plus folks from John's office, who had worked so hard and pulled together under so much stress, the next. Rose was bored out of her mind in Dyersburg, so I got her a train ticket and almost every day we were in the kitchen together, making roasted pecans and cheese straws for gifts, or preparing sausage balls, watermelon rind pickles wrapped in bacon, and ham biscuits to pass at the parties. Standing in line at the Langenstein's meat counter to pick up the tenderloin and crabmeat I always served on the dining room table, I was reminded once again of how much patience was required to live in the new New Orleans—and to wait on spoiled rich people. I'd been in the store a long time, but it wasn't me that I felt sorry for. Buddy, the eighty-two-year-old butcher who had been politely serving the denizens of Uptown New Orleans for

many decades, was having what sounded like a particularly harrowing conversation with a Garden District matron from her house in Martha's Vineyard, where she had been ensconced since the storm. Apparently she wanted reassurance about the availability of holiday shellfish. "Yes, ma'am, we'll have oysters for Christmas," he said over and over again. "We have them right now . . . Yes ma'am, the crabmeat is pretty, yes ma'am." This went on for so long the line wound up and down the aisles and Buddy was running back and forth behind the counter trying to fill each order with the phone tucked beneath his chin, frantically wrapping and taping and marking each package. I got so worried he was going to have a heart attack I wanted to snatch the phone from him and hang up on the woman myself. (Which is why I have not been a proud member of the service industry since I manned the counter at McDonald's at fourteen, in a martyrous attempt to pay for the dent I had put in my mother's car.)

My parents, my cousin Frances, and John's children were all planning to stay in the house for Christmas itself, which meant that we needed to buy more beds, sheets, towels, and at least one TV for my TV-junkie parents. I had already started sprucing up the place—Blair Dupré had told me he knew of a guy who might finally be able to repair the still-leaking sunroom roof. He was available, which should have been the first red flag, but he ran the hose over everything for a long time when he finished, and when there were no leaks, we were so grateful John cooked him a big breakfast with homemade biscuits and the sausage from Kentucky M.T.'s parents send us every year for Christmas. The rug man had been keeping the custom-made sisal for the sunroom floor in his warehouse—on a high shelf, thank God— since a month or two before the storm and he was more than ready to get rid of it. So we laid it down and hung pictures and installed the matchstick blinds and two days later it rained and the whole thing was covered in irreparable brown spots from at least twice as many

leaks as there'd been before the guy had started. Apparently a garden hose is not the equivalent of a New Orleans rainstorm. I was about to have the kind of "house fit" I hadn't thrown since before Katrina, and then the man who was finally laying the marble tile in my bathroom told me to "get over it, it's only a rug," and I realized he was right. I was just very lucky that the furniture had somehow escaped the leaks, and anyway, when Frances arrived she had a new poodle in tow who confused the rug with a giant piece of newspaper, adding more spots of a slightly more sulfurous hue.

Since the benches for the front parlor were being upholstered and we had no other furniture to put in there, I filled the whole room with a Christmas tree so big we had to cut it up with a chainsaw when it was time to take it out; I wired satsumas and enormous Louisiana lemons to the wreaths out front, and filled every big bowl I could get my hands on with more citrus of the season. The "front steps" were still poured concrete risers waiting for the actual limestone, my parents' bed was delivered about ten minutes after their own arrival, and the "chandeliers" in both parlors and the dining room were bare bulbs hanging by a wire. But my good friend, the extraordinarily talented John Alexander had painted us an amazing oil—I call it a "still-life on acid"—featuring: skittering shrimp, dozens of oysters, a redfish, a catfish, and a crab; a watchful turkey buzzard, one of my beloved crows, and an ibis; along with garlic bulbs, grape clusters, and even a few stalks of cotton in the background. We hung it over the dining room mantel where it reminded me of the Audubon crow and crab that I loved so much. It was also more than enough to divert attention, at least briefly, from the bare bulbs and the spotted rug, and I camouflaged everything else that was wrong or unfinished with lots of magnolia branches from what was left of the tree outside. Benton had told me that it likely wouldn't last another year, so I accepted its parting gifts with gratitude.

On Christmas Eve, we went to Elizabeth's, just as we had always gone to her parents' house when we were growing up, and on Christmas Day, everyone came to us. Since the youngest child at the table was hardly a child anymore—Lizzy, who had been barely a year old when I arrived in New Orleans, was now fifteen—I spoiled us with grown-up food. We had roast duck, braised red cabbage with bacon, and butternut squash with white truffles. We also had a gorgeous wheel of Stilton, but sadly we couldn't linger over it because I had gotten a tad too ambitious and planned a big bash for Christmas night, just as my mother had for at least twenty years before me. There were dozens of photographs of McGee and Elizabeth and M.T. and me, all dressed up year after year, playing with my new toys from my very extravagant grandmother, and drinking sparkling Catawba juice (which came in a bottle thrillingly like Champagne) while our parents in their own Christmas finery (Daddy in his red Christmas vest, Burrell in his maroon velvet jacket) drank the real thing. I even served much the same menu: country ham with rolls and my mother's homemade hot mustard; dressing balls, and more hot spinach dip, though I replaced her seafood Newburg with a local specialty, crawfish Cardinale.

By the end of the night, John was playing the piano and Roger was playing the guitar, and we all had a wonderful time at our first Christmas on First Street. But it dawned on me that I had been trying to cram twenty years worth of G.E.–style holiday moments into a single season, and I had to laugh at myself.

14

URING CHRISTMAS, THREE more plumbing disasters had occurred. When my mother tried to take a bath in her luxuriously appointed guest bathroom, the hot water never got hot, which we later discovered was because the plumbers had hooked the hot water pipe to the cold water handle and vice versa. While we waited for Wellington, she gave my bathtub its virgin run, and when she drained the water, part of the kitchen ceiling below fell in—the drain, it turned out, had never been hooked up to any pipe at all. Next came the ceiling in the second-floor guest room—enormous dripping cracks appeared after the fourth or fifth time the third-floor shower was used. Eddie, who had laid the tile in that bathroom himself ("I've laid tile more than most tile guys," were the exact words I remembered him telling me) had not sealed the space between the tile and the tub, so water leaked right through. It had been an interesting trial run.

January brought Dupré's team back to repaint all the ceilings, while Joe Wallis continued working outside, where I was beginning

to think he might stay forever. He had finished most of the work on the house itself, but I was waiting on a carpenter to replace the hideous metal door of the former garage, which, on Ben's plans at least, was now called a studio (read nice-looking toolshed), with a pair of windows, and he would need to paint that, along with a wooden fence that would one day be erected around the air-conditioning units. Also, my metalworker had decided to move to the comparatively dry mountains of North Carolina after the storm, so once I found someone to fill in all the many wide gaps in the iron fence that surrounded the entire yard, Joe would need to paint it too. I loved having Joe around—not only is he entertaining as hell and full of cosmic questions ("Why is it that every time a human sees a spider they want to step on it, no matter what kind it is?" he asked me after I'd squashed what I was convinced had been a brown recluse), he turned me on to the best of the new Mexican food stands, Chapparal Patio, which had begun life a month or so after Katrina in the bed of a pickup truck. Now it had moved to the cashier's booth of an abandoned gas station that was a quick roundtrip ride on Joe's scooter, and we availed ourselves of the *tacos al carbon* and *tacos al pastor*, the slow-roasted pork with rice and beans, or the avocado quesadillas for lunch nearly every day.

The influx of Mexican laborers immediately after the storm had literally saved the city. Joe (and every other contractor in New Orleans, paint or otherwise) would have gone out of business had it not been for the Mexicans he was able to hire, and I would never have been able to get the main roof of our house replaced. One of the more felicitous benefits of their presence was the fact that authentic Mexican cuisine now seemed destined to mix right into the Creole melting pot (Creole cuisine, a mix of African, French, and Spanish elements, with an occasional dash of Italian thrown in, reflects the founding cultures of New Orleans). One of my very best days was spent with Donald

Link and Stephen Stryjewski sampling the delicious offerings of what Donald referred to as "restaurant row," the long line of Mexican food stands that remained in the parking lot of Lowe's building supply for more than a year after the storm. We ate every kind of taco known to man, from tongue to chorizo to fried *camarones*, and sampled at least a dozen different *chalupas* and *tamales*. Every time I turned on the TV and saw either one of those idiot evil twins, Lou Dobbs and Tom Tancredo, ranting and raving about the perils of immigration, I wanted to make like Elvis and shoot the screen.

January also brought an influx of a different kind—lots of out-of-towners came in for the Rebirth New Orleans fundraiser, and they were suitably impressed by the powerful post-Katrina shows mounted at the Ogden, where we had a cocktail party for them the night before the big event, and they were completely floored by the level of John Besh's cooking at the brunch the next morning. He knocked himself—and everyone else—out with tables full of crawfish tortellini with fresh peas and country ham, the best grillades and cheese grits I have ever tasted, fried oysters with a creamy caviar sauce, sublime gumbo, and eggs sardou. That night, the Rebirth Brass Band played during cocktails, a handful of wildly beaded and feathered Mardi Gras Indians danced us into dinner, and as people took their seats, the gospel choir from the flooded Dillard University (whose temporary campus was now the Hilton Riverside that was also the venue for our event) sang two numbers that did not leave a dry eye in the house. As soon as the tables were filled and the first course was served, we reminded people why they were there with a powerful video shot in Katrina's aftermath by Phinizy Percy, the former bad boy of First and Chestnut and now a gifted cameraman.

Though Wynton Marsalis was officially Walter's and my co-host, Wynton does not fly. He'd performed at concert at Lincoln Center the night before, which meant he was still en route from Manhattan

until the evening was almost over, but it turned out not to matter a bit. Irvin Mayfield, a protégé of both Wynton and his father, Ellis Marsalis (the great jazz pianist who, as a teacher at the New Orleans Center for the Creative Arts, had mentored almost every great musician, including Harry Connick Jr. and Terence Blanchard, to come out of the city in the last three decades), agreed to take the stage. Irvin played a down-and-dirty blues tune on his trumpet, Ellis played his signature ballads, and by the time the dancing had begun (and yet another band had taken the stage), everyone in the ballroom had been well reminded of why New Orleans must be saved.

In February, a truly crazy person arrived at the house on First Street in the form of Daniel Brown, a mason whom my new stone supplier had recommended to lay the rest of the stone, including, finally, the steps. Since he was based in Shreveport, more than three hours to the west of us, he was an even-more-expensive-than-usual proposition—he and his laborers had to be housed for days at a time. But workers, masons in particular, were still in frustratingly short supply (Mexicans, apparently, did not have much experience laying limestone), so I was happy to get him, and when I first laid eyes on him I thought he might be yet another benignly entertaining character. He had salt-and-pepper gray hair and chocolate brown skin, wore stacked cowboy boots and tight jeans, and he kept his long ponytail tucked beneath either a battered straw cowboy hat or a coonskin cap. When I stuck out my hand to greet him, the first thing out of his mouth was the news that he was a direct descendant of Davy Crockett, and the second was the declaration that he was the smartest person that he knew. I have no idea how many people Daniel knows, and he may well be smart, but it was difficult to tell since he never, ever, let anyone else talk, and when he talked, which was all the time, it was always at the highest possible decibel level and about a half inch from your face so that it was impossible to actually listen to what he was saying.

He was also yet another person who refused to pay a lot of attention to Ben's plan, and when he did look at it, he subjected it to his own highly idiosyncratic interpretation of what should be done. Once when I had tried everything to get him to listen to me about a single important point on the very clearly drawn piece of paper that I kept waving in front of him, I finally resorted to: "Daniel, if you don't stop talking right now and please, please listen to this one tiny thing I have just got to tell you, I am going to pick up that piece of stone down there and hit you over the head with it." Now, there is no way in the world I could have lifted the stone in question—it would have taken all three of his men. And my "threat" did not seem to faze him in the least bit, since not only did he refuse to shut up and look at the plan, he kept talking even louder. But when he sent me the bill for that week's work, it included a fat fee for "mental duress." He said his men, one of whom was named Bump and looked as though his other job may have been bumping people off, hence his name, were deeply religious and that I had offended them by addressing their boss in that way, and that further, I had made them all afraid for their lives.

When that particular missive came over the fax machine, I sat in my office a long time and questioned whether any of it—the house, the city, everything—was worth it. Daniel was abusive to his men, he'd been fairly abusive to me—one morning when I was on a deadline and couldn't come down the exact instant he demanded, he said later he knew it was because I was drunk. He was a maniac who claimed kinship with a Tennessee folk hero, and yet I was paralyzed at my desk trying to figure out if it were true, if I had really become the monster he described. This was not a good development. I had clutter in my head, there was rubble covering almost every inch of our yard, and in the city itself, great piles of debris were everywhere, along with more than 100,000 flooded-and-abandoned cars and 20,000 boats, including a yellow one in a tree I passed every time

I drove to the airport. The mayor had yet to negotiate a contract for their removal, but he had found time to tell us that Katrina was divine providence for going to war in Iraq as well as the black-on-black crime rate that had for so long afflicted the city. There was so much left to do in New Orleans as a whole, and when I read Daniel's fax I honestly didn't think I could cope for another minute with even our little corner of the place.

In my childhood, I had spent part of every summer with my grandparents in Nashville, in the manicured enclave of Belle Meade. I knew and loved and was related to a lot of people there; I could maybe even buy back one of our family houses. There was no crime to speak of, it had a really nice airport and a good bookstore; the economy was thriving. I could live anywhere, after all, and surely there were plenty of law firms.

But then I started thinking about the food, and how there really wasn't much in Nashville that was worth eating—certainly nothing of the caliber that Donald and Ken and Besh and so many others were turning out in New Orleans every day—nor were there any oyster bars or Mexican food stands or drive-through daiquiri shops. Then there was the fact that it was a little too clean in spirit (middle Tennessee has long been known as the "buckle" of the Bible belt), as well as in fact—as much as I had been decrying it lately, I liked a bit of grit around. I even liked a bit of danger. In *The Correspondence of Shelby Foote and Walker Percy*, there's a letter from Walker to Shelby about a predicted hurricane, Carmen, which did not in fact hit. "Carmen missed us," Walker wrote. "Everybody disappointed. I noticed a certain exhilaration as she approached and a sadness as she went away. That's the degree of alienation! NOXIOUS particles everywhere! Only 150 MPH winds get rid of them!" In Nashville, I decided, there would be far too little exhilaration and too many noxious particles.

To exorcise myself of any remaining angst stemming from Dan-

iel's fax, I took a vigorous bike ride through the neighborhood, and about two blocks past Jackson Avenue, there it was, a dazzling white wedding dress, hanging, somehow, from the top of a charred chimney in the midst of what had until several months ago been a house. It was billowing beautifully in the breeze, and though I still have no idea how it got up there or why, it was so fantastical, so out of context and totally unexpected that I knew immediately it had to be a sign. When John got home that night there was no way to fully explain my celebratory mood, or what, exactly, I had managed to work through and come out of on the other side. I insisted that we get Elizabeth and head over to Lilette, where I dined on proper *boudin noir* accompanied by grainy Creole mustard, and a perfectly cooked piece of drum—two things I could not have found anywhere near Nashville, Tennessee.

15

DURING CARNIVAL, ELIZABETH and Katie and I rode together in the Iris Parade. We are not members of the krewe, the oldest and largest all-female carnival organization in the city, but Elizabeth has a friend who is and we are allowed to ride as paying guests. Every year we write our $400 check and buy our beads and trinkets, and then, for three exhausting hours, we are treated like rock stars by the crowds who clap and jump up and down and scream, begging us to throw them something as we make our way down St. Charles. Iris, while old, is not perhaps the most creative of krewes (one of the most entertaining of all the Mardi Gras parades is the hilariously sarcastic spectacle put on by the almost entirely female Krewe of Muses, a fairly new organization whose signature throws include miniature high-heeled shoes), and this year our outfits consisted of baggy green "satin" pants and a shapeless yellow top with a gold-sequined Bertha collar and matching mask. As in years past, we had no idea what we were supposed to be nor had we bothered to inquire as to the typically amorphous theme of our double-decker float.

We rode to have fun, and we always did. A year earlier we had made it a mere six blocks before we ran out of refreshments and were forced to call John for emergency supplies. As the parade slowly rounded the corner at Napoleon and St. Charles, our float mates threw out everything from beads to Barbies, while we waited with open arms to catch the only incoming items, three six packs of Bud Lite. John, who had once ridden several miles of his krewe's parade while hanging upside down from his harness—without realizing it—understood our predicament and was happy to oblige.

I love watching parades almost as much as riding in them. There is no way not to get competitive over the beads and doubloons and plastic "to-go" cups as they fly through the air, and my three painted-and-glittered coconuts, the highly coveted throw of the Krewe of Zulu, the historic African-American krewe whose parade Louis Armstrong once reigned over, occupy a prominent spot in my library. The balls, on the other hand, are devoid of even a shred of exuberance or even much beauty to speak of. They take place in the ballrooms of chain hotels or the Municipal Auditorium (temporarily out of commission since being flooded by Katrina) and resemble an arduous religious rite more than the Cinderella-style balls of one's childhood dreams. When I attended my first one I had visions of the entertainments favored by the extravagant eighteenth- and nineteenth-century sugar planters on the River Road, who were, for a brief period, the wealthiest people in the nation. They served food on plates of solid gold while tropical birds flew beneath spun silk nets draped atop allees of citrus trees. Even in Greenville, where I was a page at the Delta Debutante Ball, Daddy and I had our portrait made beneath one of the dyed-pink birds in cages that hung from the country club ceiling and completely cracked my father up. (Later, when I declined to make my actual debut, he got surprisingly sentimental on me: "Come on, we could pose beneath those birds again.")

Instead, I found myself in a velvet evening gown, sitting in an extremely uncomfortable metal folding chair in a surprisingly sparsely decorated room, watching young women, including the "queen," who is required to attend "scepter class" of all things and who is dragging at least $10,000 worth of beaded finery around the floor, promenading endlessly and curtsying to the masked king. There is usually an incomprehensible tableau put on by men in tights and all manner of other drag, who are also in charge of calling out the names of the predesignated women in the audience who are the only ones then allowed to dance. Throughout most of this ordeal you cannot get a drink, and no food, on gold plates or otherwise, is served until after midnight and then only if you have been invited to the queen's breakfast. The menu is always comprised of watery powdered eggs and bland grits, accompanied by greasy link sausages and undercooked bacon, all served buffet style from steam trays—a far cry from the breakfast menu in the "holiday feasts" section of the *The Picayune Creole Cookbook* of 1901, which included broiled trout with "Sauce à la Tartare," potatoes "à la Duchesse, creamed chicken," "omelette aux confitures," batter cakes with Louisiana (meaning cane) syrup and "fresh butter," along with *café au lait*.

I'm sure that if I had grown up in this byzantine tradition, or if I had an intimate connection to any of the "royalty" involved (as I would later with Katie), it might be slightly more fun, but, I suspected, not much. Still, in the interest of being a good, or at least curious, citizen during the first post-Katrina Mardi Gras season, I convinced John that we should attend at least one ball. None of the trappings had changed much since my first outing a dozen years earlier, but a significant sea change in sentiment was revealed as I stood in line at the lone bar with a lawyer I know, a man who has been intricately involved in Carnival and all its attendant hoopla from the time he was a young boy, when he donned the pages' attire of wig

and tights and tunic and helped the various queens with their trains. We kissed hello and he surveyed the scene, and then he looked back at me, whom he does not know at all well, and said, "You know, this is why there is no business in New Orleans." He may have been overstating the case slightly, which was all the more remarkable given who he was, but I almost fell over. I also thought briefly of one of my neighbors, who had yet to repair the crumbling brick sidewalks rimming his vast property and which I tripped over at least once a week, but who had no problem finding the motivation and the resources to erect a tent and throw an enormous dinner-dance for his daughter, the soon-to-be-crowned queen of one of the most socially prominent krewes, in his overgrown backyard.

The good news was that my lawyer buddy's priorities were not the only ones that were changing. There were by now as many activist groups as Mardi Gras krewes, including the extremely effective Citizens for a Greater New Orleans, whose leader was the same woman who had earlier expressed surprise that I had not tried to join the garden club. These particular "Citizens" had forced the legislature to consolidate the twenty-four separate entities charged with the maintenance of our levees (now there are two, stocked with engineers rather than know-nothing political cronies who had for years ignored warnings of leaks) and to replace the city's eleven tax assessors with one. It was the kind of arcane-sounding stuff that barely made the national newspapers, but here its implications were enormous—and not only because we finally got the kind of levee board we needed. That group and others like it were clear evidence that the complacency that had for so long gnawed at what was left of the city's institutions, as well as the utter disregard for the future, were all but gone. I rarely made it through the Langenstein's parking lot without a petition being shoved in front of me; early on, self-appointed leaders began driving rebuilding efforts in their decimated neighborhoods,

without a modicum of guidance from our mayor and before a single federal dollar materialized.

Nobody I knew paid much attention to Lent. Most people had already lived with enough deprivation. So the night before Easter we were given what amounted to a post-Lenten feast, when Donald and Stephen presided over the grand opening of Cochon. It was almost six months to the day past the scheduled opening date during the previous October, which, in these times of severe labor shortages and skyrocketing construction costs, was still nothing short of amazing. The food was amazing too. My parents were in town, so we took a table for four and started off with crawfish pies and fried *boudin* balls, pork ribs dotted with diced watermelon pickle, and oysters dressed with butter and red pepper and roasted in the wood-fired oven. Next came ham hocks and braised greens, brisket with horseradish potato salad, roasted red fish, and Donald's grandfather's rabbit and dumplings that John pronounced "a chicken pot pie gone right." The prevailing theme was lard, and everyone agreed it was a good one.

On Easter morning, we all attended services at the St. Charles Avenue Presbyterian Church, where we had at last become members and where, this particular year, the talk of resurrection was especially meaningful. While evacuated in Houston, a handful of members dreamed up RHINO (Rebuilding Hope in New Orleans), and as soon as the church reopened its doors, thirty volunteers a week started pouring in from all over the country to help gut and rebuild hundreds of houses. The whole congregation seemed energized and it was impossible not to be affected.

A week or so later, when devastating tornadoes hit Dyersburg, I was hopeful that the skittish Rose would be motivated to return home, but shortly thereafter, FEMA extended the deadline for stopping the free rent, and as long as she and Thomas had the use of the two-bedroom apartment, I could tell she wasn't budging. Roseanna

was back in her house, and Frankie was heading home with her children at the end of the school year. I had talked Joe Wallis, who owns rental property on Delachaise Street, into getting one of the bigger apartments fixed up for her. He had one for Rose too, but when she told us the closets weren't big enough I knew we had lost her, maybe for good.

Easter also brought progress in the yard, in the form of my own personal savior, Russell Plessy, a second-generation mason and friend of Blair and Billy Dupré, who could not have been more opposite from Daniel Brown. An ardent fisherman who wore a tiny gold trout on a chain around his neck, Russell was so soft-spoken I had to lean into him to hear anything he said. We sat on the front porch and after he looked carefully at the long-neglected plans spread out in front of him, he said he could not only finish the job but he would fix everything both previous masons had done wrong, no problem.

With most of the hardscape finished, I could attend to the more rewarding and less expensive task of picking out trees and plants to fill in what had been, for well over a year now, not much more than a very messy muddy field bounded by the holly hedge we'd planted before the storm and punctuated by the fine new oak in the back corner. Benton and I drove across the lake to a vast nursery in the wild, owned by three generations of plant people. We trudged around for hours, picking out and tagging sweet bay magnolias, Japanese plums, gardenias and Japonica camellias, a hard-to-find loblolly bay, seven sweet olives to line the brick drive, and six sasanqua camellias for the front of the house. In the greenhouse, I then picked out a truckload of giant white swamp lilies and deep-blue agapanthus lilies, and by the time we were done it was almost dark. I knew I was getting way more attentive service than Benton usually provides his clients—or than most of them wanted—but we both needed a respite

of sorts. I couldn't wait for the chance to walk around in a rare un-blemished natural setting, and Benton, as usual, was in need of the ad hoc (and ultimately unsuccessful) marriage counseling I had been providing. Guys like Benton and Joe (whose own wife had left him for several weeks during the winter) had been all but killing them-selves, working nonstop since the storm, and their personal lives had suffered tremendously.

At the end of May we planted the trees, which was the good news. The bad news was that crime was back with a vengeance. In a city in where less than half the population had returned, the killings were already back up to their grim pre-Katrina rate. I received an email copy of one of the routine "urgent alerts" sent to our neighborhood security patrol, advising them to be on the lookout for a "gang of ap-proximately five African-American teenagers, aged fifteen to sixteen years old," who were further described as "armed and very danger-ous." I had visions of some out-of-hand kids on bicycles carrying cap guns and pocketknives until a few days later when the paper carried the story of the "massacre" of five African-American teenagers, one of whom was barely sixteen, shot less than a dozen blocks from our house by what was believed to be a rival drug-dealing gang.

While the gangs reestablished old turf (the only real but heart-breaking difference between the old gangs and the new was that a lot of the older members stayed behind in Houston and ceded their corners to increasingly younger men), some of the same professional looters on the scene right after the storm rolled through recovering neighborhoods with big trucks, stealing brand-new appliances and hauling off the heavy equipment of construction workers trying to make a living. Finally, the mayor established a juvenile curfew, and the governor, much less hesitant than in Katrina's immediate after-math, called out 300 National Guardsmen and 60 State Troopers,

and once again the slow-moving Humvees were crawling through the city, augmenting the beleaguered and seemingly ineffective New Orleans Police Department.

The National Guardsmen weren't the only folks to return. In June, I interviewed the remarkably sane doctor who heads one of the state-run mental health centers in town for a piece in *Newsweek*, and he told me that a staggering amount of homeless people had returned, despite the fact that only one shelter, the all-male Ozanam Inn that Antoine had favored, was up and running. "There are a number of people who have just wandered in here," he said. "It's kind of mysterious. One man who was just in here, it was hard to imagine where he was coming from, how he'd been surviving. These are people who have very few resources and not a lot here waiting for them, but this is home and they miss it, and the neighboring states and towns who've been supporting them are tired, so they're not going to stand in the way of their return."

When I left him, I thought, of course, of Antoine, and sure enough a week or so later, I got a call from Richard Sexton, a photographer for whom Antoine occasionally worked and whose patience with his habit and his many absences matched my own. Given his surly refusals to be "rescued" by me, Antoine told me later he'd been afraid to contact me directly, so he had shown up on Richard's doorstep with little explanation other than the fact that he was back. He did tell Richard that Cassandra was still in Texas, which we both regarded as excellent news, but before we were able to enjoy a warm reunion, he was arrested and tossed into jail. The storm destroyed a great many things, but the NOPD's computer system had not been among them, and Antoine had a long list of outstanding "attachments" to his rap sheet, showing that he had not, for example, paid the fines he had owed for years, or completed any of his probation requirements. After he disappeared, it took five days of calling the black hole that was now

Central Lockup to ascertain that he was really there. If Richard or I ever wanted to see him again, it was time to get Antoine a lawyer.

Earl Perry Jr. is a dandyish sort of fellow who in his spare time takes photographs of car races in places like Monte Carlo, but he is also intimately acquainted with the doings of the New Orleans Criminal Courthouse, and just the man for Antoine. Since, by the time Earl had negotiated Antoine's release, he had been in lockup for more than two weeks, and since it was now far more crowded and a whole lot hotter (the air conditioning had still not been repaired from the storm), it no longer provided the Betty Ford–like R&R Antoine had earlier not seemed to mind. There was also, said Earl, the fact that "Our local criminal aristocracy is not held in very high esteem by the foreign nationals currently visiting our jails," or, as he translated, "the Mexicans are beating the shit out of the likes of Antoine" and the petty crackheads he ran around with. Earl was hoping that Antoine might have finally been scared straight.

We all hoped so because in addition to posting bail, Earl had to personally vouch for Antoine in front of the judge, and I had to meet with the court officer who collects the fines so we could work out a payment plan for him, as well as with his probation officer, a Haitian Antoine loathed named Mr. Ernest, who would administer weekly drug tests and make sure he remained employed. Both gentlemen were clearly amazed by the fact that a well-dressed white woman accompanied by a real-live criminal attorney in a good-looking suit and titanium glasses had taken such an interest in Antoine, a fact that was not lost on Antoine either. He vowed, for the millionth time, to stay on the straight and narrow.

I was, of course, glad to see him, and within a week, our house and yard looked like an entirely different clean and organized place. I wanted to keep it that way, and I also hoped that Antoine might at last want a clean and organized place of his own. When I inter-

viewed the doctor for the *Newsweek* story on the dire mental health issues confronting the city, I had also talked to a homeless counselor who told me about a new facility for recovering addicts who could rent subsidized apartments with kitchenettes and private bathrooms in exchange for taking part in counseling programs and submitting to random drug testing. I had seen them and they were nice; when Antoine turned up, I had called her and she told she would help me get on the waiting list. But when I mentioned them to Antoine, he tried his hardest to act interested and said he'd definitely like to go see them—"soon"—but I knew it was a trip we'd never make. As long as the Ozanam Inn was still accepting folks for the night, Antoine had no intention of getting a place of his own.

Still, I was heartened. Sorting out his legal troubles was a definite step in the right direction, but it was trickier than I had thought. Less than a month after he had been released, he was picked up again, on his way back to the house after buying lunch for himself and Lisa, Elizabeth's efficient maid whose services I was sharing in Rose's absence. It had been a case of profiling pure and simple—two cops stopped him and asked him what he was up to while he walked down a public sidewalk carrying a paper bag filled with two hot sausage po-boys and couple of cans of Cokes. But when he showed his I.D., the dread attachments popped up again. It was true that the information in the computer had not been amended to include the terms of his current arrangement. But, as I also found out when I called the officer in charge of the fines, Antoine had not made a single payment since we'd been in his office, even though every time I paid him he assured me he was doing so.

At any rate, the two cops handcuffed the "prisoner" and threw him in the backseat and the only reason I even knew anything about it was because Antoine had insisted that they drop off Lisa's lunch before taking him downtown. Now that is precisely the kind of innate

sweetness and utter guilelessness that gets me about Antoine every time, so that when it came time to write another hefty check to Earl so that he could get him out, I didn't even mind, and thereafter started paying the weekly installments on the fines myself. It took me a while to make Antoine understand that I was paying him a little bit less so that I could send the money he owed to the courthouse and thus keep him from getting picked up again. But after a while, he got over being mad about that and we continued along in the same happy and highly dysfunctional existence together that we had enjoyed, with one longer-than-usual interruption that we never discussed, for the past decade.

~ 16 ~

ALL SUMMER, WE had been looking for a dog—the beagle
that I had always wanted and never been allowed to have—
in earnest. I couldn't understand why it was so hard to find a
beagle, which is bred for rabbit hunting after all, when the denizens of
the parishes of southwest Louisiana are so crazy about the sport that
an election was once postponed when it fell on the opening day of the
season. Apparently, Hurricane Rita had put the breeders there out of
business, so we turned to the newspaper. At one point we'd been on
our way to pick up one we'd found in the classifieds, but when I called
from the car the kid who answered said the ad had left out the fact
that theirs were miniatures, so we turned around. I wanted the same
sturdy animals I had seen growing up—one of the cotton farmers
near our house leased a fenced corner of one of his fields to a serious
rabbit hunter, and every day on the way to and from school I passed
the enormous doghouse, with dozens of adorable beagles lounging in
the sun atop its roof.

Finally, in August, I was in Chicago visiting Frances, and John

emailed me an ad. The guy selling beagle pups for $100 had a house in a little subdivision in River Ridge, right by the airport. John picked me up from my plane and we went right over. I knew we were in the right place when the breeder came out wearing nothing but a pair of shorts and proudly told us in his Cajun accent, "Me, I ain't had on shoes for three months, me." He made his barefooted way to a fenced-in side yard, whistled, and two tiny pups came waddling over from their respective mothers. I knew "the one" immediately, and after I reached over the fence and picked up his trembling little boy body the deal was done. The guy assured us the puppy had papers—"I just can't quite lay my hands on them"—and that he would eat anything, including the powdered eggs he'd been giving him. We had been poring through beagle books, all of which recommended expensive healthy stuff like Science Diet and Eukanuba, but this puppy seemed healthy as could be, so we paid the money and left with him, while the guy apologized profusely that the watermelon wine he'd been fermenting in his garage was not ready yet.

John drove and I held the dog in my lap where he stayed for the next two days, dozing and munching affectionately on my hand. While he chewed I told him the story of the beagle hunt I had embarked on at age seven after I had talked my father into buying me the Styrofoam pith helmet that had been on sale at the local A&P. I have no idea why I wanted it so badly or what in the world it was doing on the shelves of the grocery store, but as soon as we got home, I put it on and rode my bike all through the overgrown pecan grove near our house, looking up in hopes of finding beagles lolling in the branches like leopards. When our neighbor's teenage son Ephraim, on whom I had an intense crush, asked me what in the world I was doing, I solemnly explained that I was on a beagle safari. I do not have much faith that the puppy understood a word I was saying, but it wouldn't be the last time I talked to him at length. To me the story was con-

firmation that the dog was my destiny. At McGee's suggestion, we named him Henry, because he looks like one, and it is beyond ridiculous how much I love that dog.

To us, Henry's presence made the house on First Street complete. It wasn't technically complete of course—my father kept asking me if we had grass yet and I kept telling him no, we didn't have grass, and the concrete for the new sidewalks hadn't been poured and the garage door had still not been replaced by the windows and there was no fence around the air-conditioning units and the iron fence had been repaired but not painted. I had a new electrician but he had installed only half the outside lights and I hadn't seen him since January, and I had yet another plumber but he could not solve the problem of why rusty water was the only kind that poured into my fine and increasingly brown Waterworks bathtub. We'd thrown out the spotted rug in the sunroom, where the roof still leaked and there were not yet any curtains on the windows in the parlors or our bedroom or my office, but we'd gotten a chandelier for the dining room and gotten rid of the dangling bulbs in the parlors in favor of lamps, so that was something.

Joe had taken on so many jobs he was suddenly in short supply, and when I called him to find out where he had been hiding, the first thing he asked me was "You're not gonna cry are you?" in a tone that let me know he had been listening to a lot of clients cry lately. As Katrina's anniversary neared a lot of people were getting a tad jumpy. But Joe knew me well enough to know I was not going to cry, I just wanted him to come over, so he did, armed with his brushes and a couple of burritos from Chapparal Patio. Joe and I were family now, in this together, learning to take our silver linings wherever we can find them, including at a taco stand in the parking lot of an abandoned gas station.

On the last Saturday night in August, a year and a day since our

first dinner party with Byron and Cameron and Egan and the lobster spaghetti, the five of us gathered again. And this time, since neither of them was stuck in evacuation traffic on the way to the Delta, McGee and Elizabeth joined us.

John grilled skirt steak on the Weber we'd finally retrieved from the storage unit, and I made salsa verde and squash casserole and Cameron brought her famous pound cake. For the occasion, I'd bought some more Billecart-Salmon. Before we sat down, we went outside and toasted to friendship and love and the city we couldn't seem to leave and, finally to the house on First Street that was now my one true home. When I looked up, the stars were no longer visible, but that was okay. I knew that they were there.

Epilogue

O N JANUARY 17, 2007, almost a year and five months after Katrina hit, and five days before the manuscript of this book was due to my already long-suffering editor, there was a robbery at the house on First Street. John had an early business dinner and I had a late one, and there had been maybe an hour during which no one was home. John arrived first and found the kitchen window jimmied open; I was still at Stella!, the upscale sibling of Stanley, where we had enjoyed those first post-Katrina five-dollar hamburgers. When John called me on my cell phone, he told me all my jewelry was gone, and two TVs, but I could tell there was something else, something he was having a hard time coming out with. "Is it Henry?" I shrieked. "Henry's dead, isn't he?" When I started to cry, John reassured me that Henry was not only alive and well, the thief had locked him in the laundry room. We both managed to laugh briefly at that, knowing our ever-enthusiastic puppy had probably greeted the bad guy so joyously he had to lock him up in order to get

on with the business at hand. (To this day, Henry's nickname in the neighborhood is "The Burglar's Assistant.")

But the chuckle was short-lived. Henry was still with us, thank God, but my laptop was gone. When John finally came out and said it, I'm pretty sure I let out one of those low guttural moans, a sound not unlike that of a wounded cat. The implications of what I was hearing were enormous: I had backed up exactly one chapter of the whole book the old-fashioned way, by printing it out. Everything else was in my hard drive: my daily post-Katrina diary, the timeline I had put together from the hundreds of newspapers I'd kept piled up in my office (and recently thrown away), the other ten chapters of the book.

All I could think was what a total idiot I was, but I'd been spoiled. I've had computers melt down, blow up, and simply cease to turn on, but some geek could always retrieve my hard drive and everything was fine. It never occurred to me that somebody might just take the whole thing. I was so blindsided by losing more than a year's worth of work that I didn't even think about the stunningly beautiful 1920s diamond cuff that had been my great-grandmother's, or my grand-mother's yellow diamond ring my mother had given me on the night of the Rebirth New Orleans fundraiser, or the diamond chandelier earrings that were a gift from John when we got engaged. My heart sank to my knees as the valet brought my car around and I drove the seemingly interminable three miles home to the scene of the crime.

When I arrived, it was eleven o'clock; the Garden District Secu-rity officers were there along with a couple of officers from the Sixth District police station. In my office I noticed that the huge tote bag containing various notebooks and folders was missing, and the con-tents dumped on the floor. The deep rectangular tote, bearing the lavender logo of my good friend Mish, a Manhattan jeweler, was an ironic carrying case for a pile of earrings and rings and bracelets and

pearls, along with my laptop, and two twenty-six-inch flat screens. A bigger flat screen, far too unwieldy for the Mish bag, had been removed from the sunroom and left in front of the French doors the thief had departed through.

When a man named Dufossat, the lead detective on what was now officially a case, arrived, I excitedly pointed at the abandoned TV, which had already been dusted for fingerprints, along with the window the culprit had pried open and the counter he had climbed over to get inside. Fingerprints and a footprint were clearly visible but Dufossat was not nearly so impressed as I: "This ain't *CSI*, lady." Disheartened, I remembered that New Orleans, at this stage of the recovery, was still without a working crime lab. He took down a list of the stolen stuff and left with a promise to be in touch, but not before warning me that the laptop, which has little resale value, was probably already in a Dumpster.

It would have been easy to blame the whole damn thing on Eddie. One of the many, many items on his punch list that had never been punched was the installation of a security system. He had "a guy," he kept telling me, a wireless genius who would hook up everything from the burglar alarm and the doorbell to our sound system and computer network. This was the January before the storm—I was not yet on to the dangerously consistent inadequacies of Eddie's "guys" and, anyway, who was I to question a wireless genius? By March, when we moved a host of boxes into the finished parlors and there was still no progress on the security front, I started getting a little jittery. "Don't worry, he's coming," Eddie told me, referring to the wireless genius. "He's just really busy." Naturally, I assumed that the delay was due to his superior talent—clearly, he was swamped with huge jobs hooking up vital systems for sensitive clients, and we, understandably, were last on his list. Then Eddie told me his genius was a high school math teacher. "But he's a really smart guy."

In April, we had three appointments but they were all cancelled at the last minute. In May, I got worried when Elizabeth told me a math teacher at Lizzy's school, the same one that employed the genius, had recently been fired over some transgression the school refused to name.

In retrospect, of course, I cannot fathom why I didn't say, "Eddie, every security system under the sun is wireless. We don't need a genius"—especially not one who, in my imagination, had morphed into a child molester or worse. But I did not say that or anything remotely like it. We'd been at Elizabeth's for months, there was still no move-in date in sight, and Eddie was increasingly AWOL. At this point an alarm was the least of my problems.

But all that changed on the morning of January 18. John and Vasser and I were each in a frenzy of activity, making appointments with security companies, color-Xeroxing photos of my jewelry (the thing about serious jewelry is that you usually wear it to the kind of parties where your photograph is taken), making lists of pawnshops to visit.

Three days later we had a brand-new wireless security system complete with every conceivable bell and whistle, the installation of which had been almost as simple as writing the check, and an illustrated list of the missing jewelry along with the serial numbers of the TV and laptop. Vasser and I spent an entire day dropping it off, in the rain, at the dozens of pawnshops on our list, an unproductive and wholly depressing enterprise (there is nothing so grim as watching desperate people try to get a pitiful amount of money for everything from wedding rings to chainsaws), but we did deliver several to the sixth district headquarters, where someone, in turn, sent it to Crime Stoppers. A week later, a photo of my wrist sporting a particularly graphic gold bracelet appeared in the newspaper and was flashed on all four local news stations with information about the break-in. I

was in New York, meeting with my editor about our now-delayed manuscript, when Dufossat called to tell me he had a tip. Ecstatic, I asked him what it was, but he said the fax from the Crime Stoppers office was too hard to read, he'd have them resend it and call me right back.

This thrilling news was followed by eleven days of radio silence. I called Dufossat ten times a day and emailed him at least as many times. I could not fathom how we'd gone from "I'll call you in a few minutes" to no communication whatsoever—until I got an email from him explaining he'd had to take time off to rest up for the busy Mardi Gras week ahead. When I called him back I actually managed to contain myself. "What," I asked, "happened to the tip from Crime Stoppers?" Oh that, he said, and explained that they had never re-faxed it. "GODDAMN IT, DUFOSSAT," I screamed, silently, to myself, "GO GET THE GODDAMN THING." Out loud, I asked him to please go get it. He did, but after almost two weeks, the hot tip—a girl in a bar had heard a guy she knew talking about a Garden District "jewelry heist," she even knew his address—was stone cold. Dusfossat told me when he went to check on the house it had been vacated. "NO KIDDING, YOU EFFING LUNATIC," I screamed silently again, but at this point I was just entertaining myself. Clearly there was no point in saying anything to Dufossat, out loud or otherwise. My only solace was the note I'd received from the house's former owner, Phinizy Percy: "I just wanted to let you know of my deep compassion for you. Let us pray that these despicable criminals are apprehended, and soon!"

By this time, I had resigned myself to rewriting the whole book, but now I wanted my jewelry back. We hired a private detective who was very big but mostly bluster. I went to Houston for a family friend's birthday and spent a day perusing the seemingly endless number of pawnshops there. Nothing, anywhere, turned up, and my perfunc-

tory emails to Dufossat were met with feeble responses or none at all. In late spring the city's body count was back up, and the loss of my computer and the jewelry I could never afford to replace was hardly of paramount importance.

Then, six months later, I got an email from my friend Mish with a link to an eBay page featuring the earrings he'd made for me as a wedding present. He wouldn't be offended if I were selling them, he said politely, but he'd heard I'd been robbed and he thought perhaps someone else might have put them up for sale. I was amazed at the kismet: his boyfriend had been browsing the site and happened to see them almost the second they were offered by a dealer in Metairie, ten minutes away on the interstate. The dealer's name was Anton Feine, from Anton's Fine Jewelry, an establishment that had not come up in Vasser's and my pawnshop search, but when I pulled up outside the building it was clear what kind of operation Anton was running—there were more bars on the windows and doors than in most jails and two doors to be buzzed through before being allowed inside. Stupidly, I had called first. When I walked in, the prissy Anton, heavily bedecked in gold with a head of very badly dyed brown hair, was nervously flitting around while his sister, who looked like a gangster's moll, did all the talking. I couldn't see the earrings unless I paid for them, she said; further I'd have to leave the store until the police, whom I had called, arrived. I had no intention of doing any such thing and noted several conspicuous gaps in Anton's many display cases where items had been sold—or hidden—recently enough that they hadn't yet been replaced. When the Jefferson Parish deputy arrived, he took the earrings as "evidence" and gave me the number of a detective, Sergeant Martin Dunn, in the "pawnshop department." When I called Dunn from the car, he explained that the law required all pawnshop owners to take down the driver's license information of everybody they purchased items from and to

provide a complete inventory of the stuff. Anton had reported the earrings, along with: a platinum and diamond circle pin that had been my mother's; a platinum and sapphire straight line bracelet that had been my grandmother's—and my thirtieth birthday present; the antique gold cuff bracelet, the one circulated on the news that had been a gift from John after a particularly festive Rib Room lunch together; a sapphire, diamond, and ruby brooch in the shape of a butterfly; two pairs of gold hoops, and, finally, the diamond engagement earrings. It wasn't everything but it was a lot, and I was thrilled at the prospect of getting it back. But then Detective Dunn gave me the bad news: the law also states that pawnshop owners are not required to report who they sell their wares to or even keep track—they were only required to return the stuff they still possessed. Anton, of course, was already claiming that he'd sold every other piece and had no idea to whom. Further, even if I managed to find some of the pieces myself, the new owners were not required to give them back, unlike what happens when you buy, say, a stolen car. All I could figure was that there must be one hell of a pawnshop lobby in Baton Rouge.

Compared to Orleans Parish, Jefferson Parish, which for years was run by the iron hand of the late Sheriff Harry Lee, a Chinese-American country music singer with a penchant for straight talk and a merciless attitude toward the criminal element, was a model of efficiency. Within the week, Detective Dunn had called me to say the earrings had been photographed and logged and that I could come pick them up. He was on Anton's case, he said, but there was nothing he could really force him to do. Then he showed me the black-and-white Xeroxed copy of the driver's license belonging to Anton's seller, a twenty-year-old black male with dreadlocks, a tattoo of a cross on the bridge of his nose, and indecipherable words tattooed on each cheek. The likelihood of his having legal access to almost a hundred thousand dollars worth of estate jewelry was nil and Anton

surely would have known that the second he laid eyes on him. Even more disturbingly, I came to find out he has a handful of steady clients, including some "nice" Garden District ladies I know—and who also have to know perfectly well that they're buying hot goods.

Under prodding from the good Detective Dunn, Anton finally coughed up the butterfly brooch to keep me at bay, and because there is no recourse against him in the criminal courts, John filed a civil suit against him, though he was so cagy it took weeks to serve the papers. The seller (who may or not be the actual thief) is currently in jail for another crime and 1 am trying to figure out how to get to him to ask him where he might have sold the remaining stuff. I still haven't gotten around to replacing the TV in the kitchen, but as you can see, I did buy a new computer—on which I rewrote the manuscript—along with a backup hard drive, which I now use daily. Henry, who has grown into a fine, fine dog, continues to lick the face of everyone who comes in the door, though happily no one else has arrived through the kitchen window.